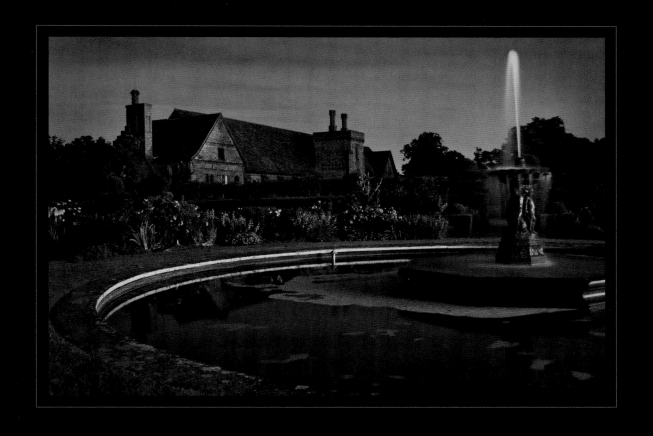

The English Garden at Night

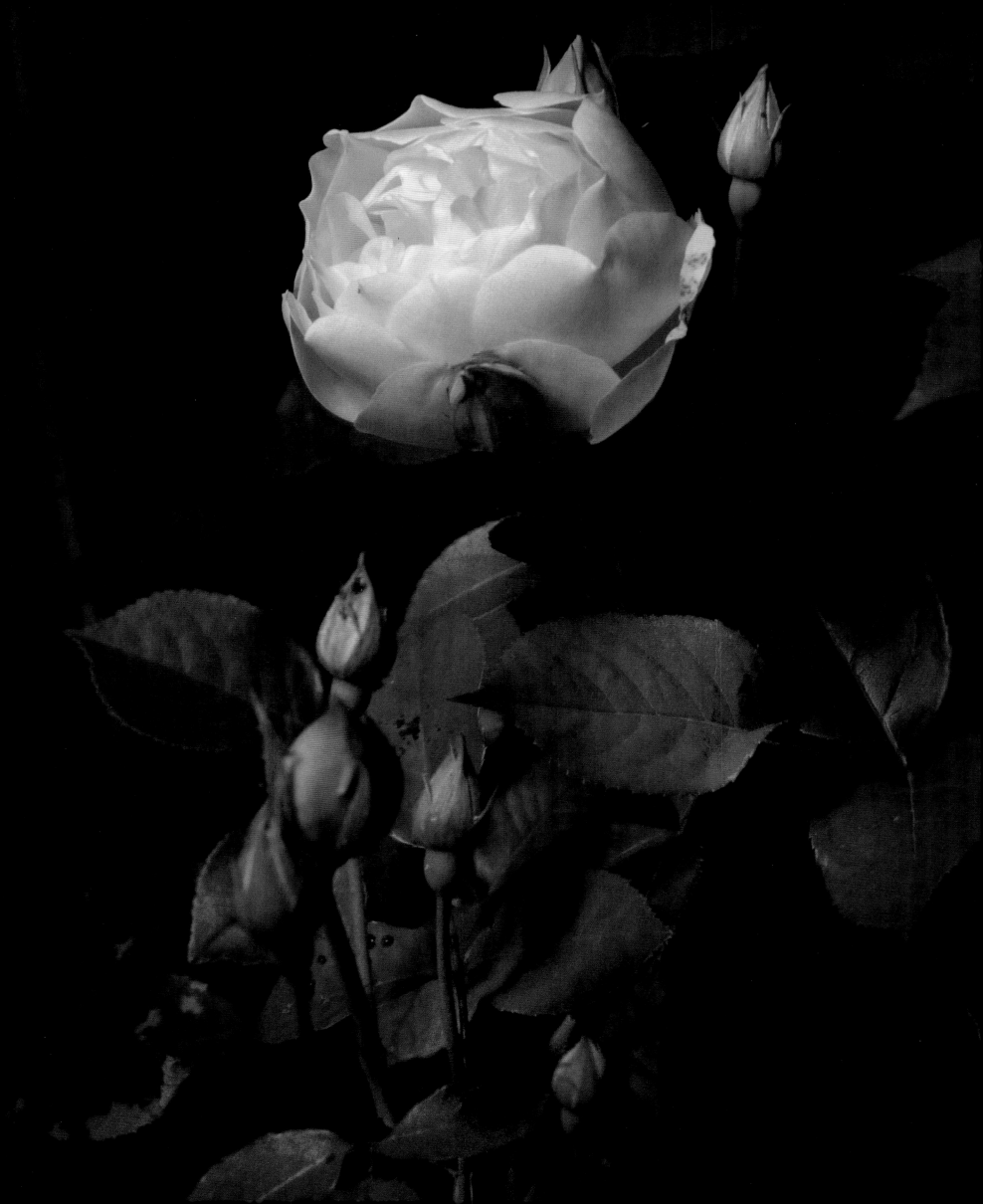

The English Garden at Night

LINDA RUTENBERG

WITH ROGER LEEON

INTRODUCTION BY CHRISTOPHER WOODWARD

VERVE
EDITIONS

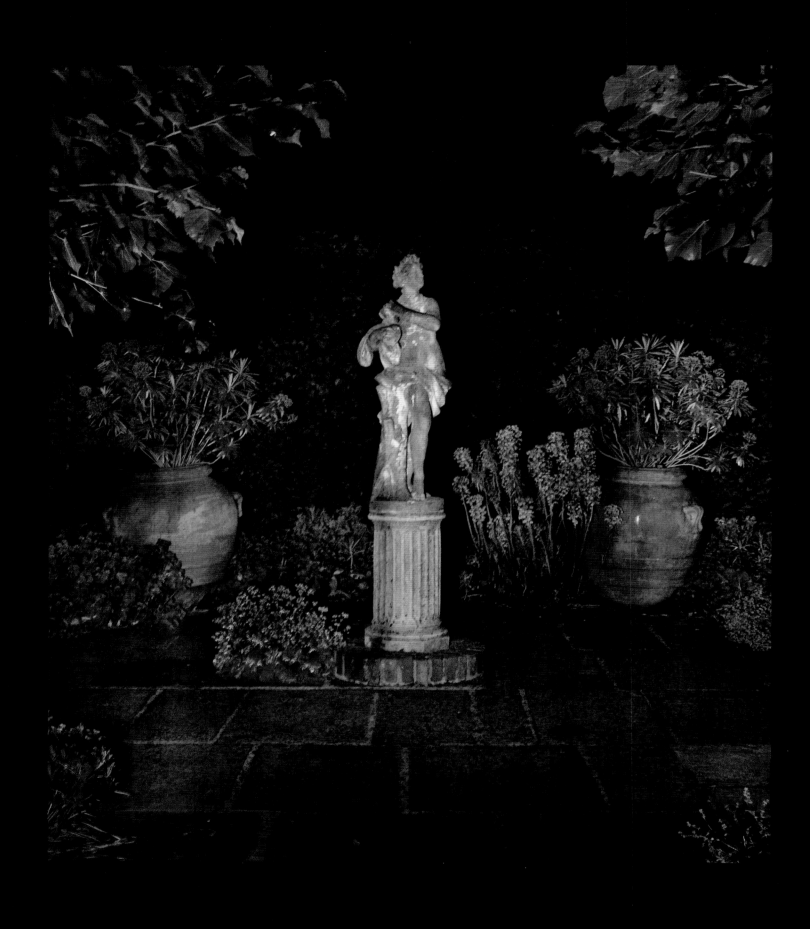

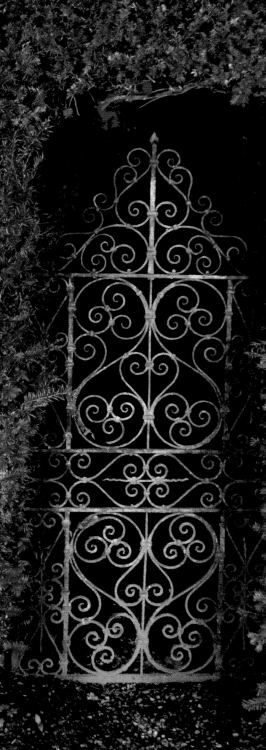

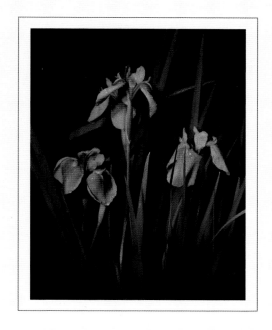

INTRODUCTION

CHRISTOPHER WOODWARD

'I COULD IMAGINE NOTHING MORE MYSTERIOUS than these black secret nights . . .' At the beginning of the Second World War Vita Sackville-West looked up at the sky above Sissinghurst. The black-out had begun, and she had checked that the windows on the estate cottages were taped up; walking silently between the cottages she realized that she was as invisible as a badger or a fox.

One night she could not sleep and she walked down to the lake: 'The moon gave no reflection into the darkened waters. The only things which gleamed and glowed were the water-lilies, whitely resting on the black pool. Taking the boat out, I cut the milky stalks of the lilies in the moonlight, and as I did so, drifting aeroplanes appeared over the lake, chased by the angular beams of searchlights, now lost, now found again; now roaring out, now silent, traceable only by their green and red lights sliding between the stars. A fox barked at them, like something in a fable curiously up to date. I tried to compose the fable for myself, something which would combine the fox, the lilies, and the white bodies of the young men up there aloft, but nothing neat would come to me although in that lonely hour I felt they were all invested with an extraordinary significance . . . The fox barked again, and carrying the inert lily buds I made my way across the field. The homely weapon of the scythe shone all along the blade where I had left it hanging among the fruit.'[1]

We go into gardens by night at moments of emotional intensity, or when we cannot put our emotions to bed as neatly as we extinguish the light.

A friend told me the story of moving to a new house when she was a schoolgirl. The garden was admired, and photographed, and its creator respected. Emma did not understand why her mother was not at ease. Then one day her mother came in to breakfast with an exhilarated brightness in her eyes and voice. There was mud under her fingernails, and her hair was bedraggled. During the night she had ripped out every plant in the garden. From then on she lived happily in her new house.

Linda Rutenberg tells us that she began to photograph gardens by night by accident: the Director of the International Garden Festival at Reford Gardens in Grand-Metis, Quebec, suggested that the early morning light would be best. She, in turn, asked if she could wander about and photograph the garden throughout the night, and into the morning.

But perhaps it is not a coincidence that it is a female artist who has first chosen gardens by night as her subject. In classic scenes in literature the protagonist in the garden by night is invariably a woman, whether it is the young heroine unable to sleep or the hostess who leaves the table and looks back at the silhouettes of the dinner guests.

Ten o'clock on a Friday night in September. I am helping to harvest lavender ten minutes' walk from the Houses of Parliament. Richard Reynolds, leader of the London guerrilla gardeners, has planted a field at a triangular traffic intersection. The gnarled trunks seem unaware of the incongruity, and the smell of the cut lavender is so strong that on the opposite side of the street pedestrians stop, confused. A taxi driver honks and sticks his thumb up.

Guerrilla gardeners dig or harvest in the dark because their activity is illegal. Similarly, according to media reports in the last summer drought, garden owners watered in the early hours in order to evade the hosepipe ban. But for centuries the principal reason to garden by night has been poverty: working men worked allotments or vegetable gardens at the end of their day in the factory or mine. The poet Shelley saw an embankment in Wales where men 'supported large families by cultivating small spots of sterile ground by

OPPOSITE: The Beech Hedge – Levens Hall Gardens
ABOVE: *Iris laevigata* Japanese water iris – Sissinghurst Castle Garden

moonlight'.[2] That necessity coincided with folklore: *The Old Farmer's Almanac* tells us which vegetables and bulbs to plant by moonlight.[3] Today we are advised to water our gardens by night: there is less evaporation. Indeed, two German scientists have published texts which suggest that weeding is more efficient by night. They argue that this is because there is no light to stimulate the weed seed at the moment of exposure.[4]

But gardening by night is most likely to be a modern lifestyle choice. We leave home for work in a rush, and for much of the year come home when it is dark. We visualize our gardens in the midday sunshine of May but we are more likely to see them – so the argument goes – looking out of the window with a glass of Chianti. From time to time exhibitors at the Chelsea Flower Show present a design for the urban garden by night, while magazines advertise a multiplicity of outdoor light fittings.

'I'm interested in gardening by night' is one of the most frequent queries we receive at the Garden Museum. In a library of three thousand books only one title is relevant: *Moon and Plant Growth* by Lili Kolisko (1936). It is a pamphlet with a plain green cover and the words printed in grave, emphatic capitals. Inside are dozens of graphs and photographs of tomatoes, maize and cabbage, each demonstrating the author's conclusion that vegetables are happiest when planted according to the lunar cycle: 'From the experiments of many years we can recommend with good conscience that tomatoes should be sown two days before the full moon.' She addresses us from the Biological Institute, River Gardens, Bray-on-Thames, Berkshire, where she 'will be pleased to show visitors her laboratory and experimental work'.

The dedication to Rudolf Steiner opens up a world far beyond the little Institute by the Thames: Lili and her husband Eugen – an innovator in child therapy – were two disciples who had fled from Germany in the 1930s. In 1924 Rudolf Steiner gave a series of lectures to farmers in Silesia who were dejected by the sterility of their soil. The lectures at the castle of Koberwitz began the organic movement – and, also, biodynamic gardening. The moon, he argued, influenced the growth of plants by its suction upon the waters of the earth.

Kolisko was determined to continue her mentor's philosophy of reconciling science with spirituality. She published several pamphlets in which she demonstrated the connection between the movements of the cosmos and physical phenomena on earth: *Jupiter and Tin*, *Saturn and Lead*, and *Gold and the Sun*. *Moon and Plant Growth* begins with a scientific controversy in nineteenth-century Germany. A Professor Fechner wished to show that the moon determined the tides, and even affected the imagination of man. A Professor Schleiden responded, angrily. In *Moonlight Phantasies of a Natural Philosopher* (*Mondscheinschwaermereien einens Naturforschers*, 1857) he declared that the moon was a 'weakling'. Only dreamers and fools were susceptible.

Lili Kolisko wished to reclaim the moon for gardeners. When the moon waxes, the earth exhales and it is time to plant. When it wanes, the earth inhales, and it is time to water and fertilize. I don't understand the graphs which prove her case but I like to think of Frau Kolisko in her greenhouses beside the Thames, the 'weakling' moon shining through the lichenous glass while she walks up and down between the plants with her clipboard like a kindly teacher walking between rows of desks.

Lunar gardening has been one of the phenomena of recent years. It is seen at its best at Waltham Place, a few miles from Bray, where Strilli Oppenheimer has created a garden in collaboration with Henk Gerritsen, the Dutch plantsman and designer, whose own garden at Priona in the Netherlands proposes a wilder, more passive realignment of our relationship with Nature. The farm shop at Waltham Place sells vegetables from their biodynamic kitchen garden, and washing and chopping them I hope that the tomatoes in Kolisko's black-and-white photographs were just as tasty a red.

The Romantic Movement was the first great age of moonlight. In 1797 Robert Thornton inherited a fortune and began the publication of a great florilegium, *The Temple of Flora*. The botanical plates were 'picturesque': that is, each plant had dramatic background scenery. Perhaps the most celebrated image is of a flower which blooms at night: 'The Night-Blowing Cereus'. The exotic cactus explodes beside a very English stream; on the far bank of the torrent is a ruined and ivy-mantled church tower with an owl watching us from the parapet; it is an image generic since Gray's *Elegy*. The church clock shows that it is three minutes after midnight. The flower and ruin were painted by Philip Reinagle (1749–1833) but for the moonlight and the scudding clouds Thornton commissioned a specialist: Abraham Pether (1756–1812), a scientist and painter dubbed 'Moonlight Pether' for the accuracy of his moonshine.

But why choose a ruin as the background for a cactus? *Selenicereus grandiflorus* blooms for a night, and then dies. It is a perfect flower for Romanticism. Symbolizing sudden flowering, early death, sex, and flight, it is a Shelley of the plant world.

It continues to be the cult flower of the night. In modern households its blooming is an event, with neighbours urgently invited to run over and watch. In Spanish-American households there will be a party for the *reina de la noche*. In Hawaii, it is said, there is a hedge planted by a missionary's wife in the 1840s which is half a mile in length: on a single night 5,000 blossoms open.

The contemporary botanical writer Peter Loewer describes his own experience: 'As darkness fell in our kitchen, the petals began to separate and by nine P.M. the flower was almost wide open and giving off a sweet, spicy scent that swept through the house like fog sweeping a London street. By midnight it was perfect. Hundreds of threadlike stamens, each topped by a dot of golden pollen, surrounded a long, thin pistil with a graceful many-fingered tip.' In the morning the perfume had gone, the petals were shapeless, and the stamens had begun to coagulate. 'It's so beautiful it deserves a burial', said his wife Jean.

Loewer's *The Evening Garden* (2002) is the best text on night gardens. He gives expert advice on how to design a garden for colour and smell in the temperate zones, but we also glimpse the wonders of night-time flora across the world. The Amazon water-lily opens its bloom fully at 3.30 A.M., for just a quarter of an hour; by dawn its bud sinks below the surface. The moonflower vine opens its white, Prom Queen buds at twilight as if 'in a nature film taken with time-lapse photography'.

Linda Rutenberg is not exotic in her subject-matter: indeed, on her journey through England during the summer of 2008 she chose to photograph icons of Englishness, from the seventeenth-century topiary at Levens Hall to the great gardens the Marchioness of Salisbury laid out at Hatfield in the 1970s. Levens, for example, was beloved by the watercolourists

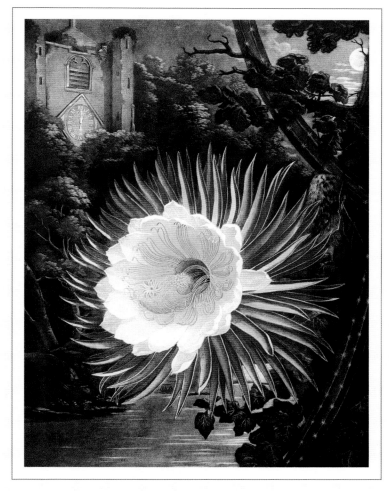

'The Night-Blowing Cereus', from *The Temple of Flora* by Robert Thornton, *c*. 1800

of the late nineteenth century: to artists such as George Samuel Elgood and Arthur Rowe yew was a perfect subject for their medium, dissolving into flecks of blue-grey under a grey sky. But Levens is transformed by Linda into a contrast of deep black sky and topiary as solid as a spectral castle.

In addition to lighting the plants using a torch, other light sources are accidental: a security light, a streetlight's flicker, or the glow of nearby cities. Looking through these images, it feels as if we are intruding: are we supposed to walk down this path, or through this gate? Perhaps the tall, scented stems do not care, and our uncertainty is a consequence of our ambivalence to gardens by night.

This book is not a record of the process of change in the night, of the cycles of temperature and humidity. Nor is it a record of wildlife: in contrast to the many programmes on television, there is no gleam of a badger's snout, no blinking baby bird, or hedgehog tiptoeing up to the window. It is much more challenging than that: it asks us to think about our relationship with the night – and to reconsider why we garden.

In recent years several writers have published books on our perception of the night. In *Night Haunts* (2007) Sukhdev Sandhu interviews Londoners who sleep during the day: cleaners and minicab drivers, graffiti-writers, foxhunters and nuns.[5] The distinguished Canadian poet Christopher Dewdney – who wrote the foreword to Linda's book *The Garden at Night* – has written a journey through the twelve hours by night, beginning with a magical description of

joining sunset-watchers in St Lucia. Each evening they wait for the green flash at the end of the world: that band of 'electric emerald green' which hovers momentarily above the horizon at sunset.[6] Finally, *At Day's Close* by the historian A. Roger Ekirch is a study of the experience of night in early modern Europe.[7]

Each writer wishes to define the identity of the night at a time when it is threatened by technology, commerce, and the allure of the 'twenty-four-hour city'. The American government has investigated drugs by which its soldiers can stay awake for seven days, Ekirch tells us, while the Russians put into space a vast mirror which would illuminate the northern rim of their continent during the dark winters. The night, he continues, is not a hiatus, or a period of 'no occupation but sleepe, feed and fart', as the Jacobean poet Thomas Middleton put it.[8] It has its own characters, its own customs.

In medieval and early modern times night was as solid a presence as an enemy army. The city gates were shut; inside the walls there was a curfew at nightfall and chains were stretched across the streets. In one city, Nuremberg, it is recorded that four hundred sets of chains were unwound each evening, pulled across at waist height in two or three bands of iron. Jews were locked in their ghettoes. Women who stepped outside exposed themselves to accusations of prostitution. Shutters were locked in each house: indeed, 'shutting in' was a euphemism for nightfall, as in the proverb 'men shut their doors against a setting sun'. It is a long way from night lights, decking, and hedgehogs sipping milk at the patio door.

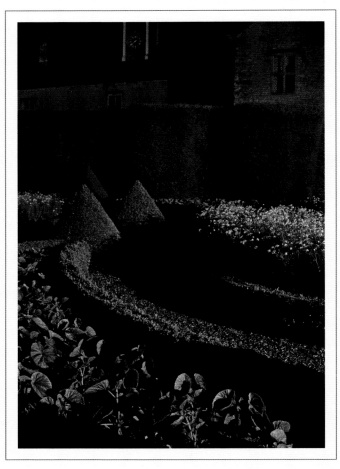

Levens Hall Gardens

Scholarship of the night is a new phenomenon. George Steiner noted that social historians have ignored the obvious fact that most people in history have spent much of their lives 'in varying degrees of opacity between sundown and morning'.[9] Similarly, Peter Loewer discovered that no one had ever written a book on gardens at night. Why not?

When I was asked to write this introduction I bought a small tent and a notebook with a cover of midnight blue. I would camp in fields and in gardens and study the night – or so I thought. On 21 June, the longest day of the year, I pitched the tent on the South Downs, selecting a spot at gazing distance from a wild orchid. But very quickly I fell asleep.

I made appointments to camp in friends' gardens but, again, each time I fell asleep as soon as night fell. I would wake in the pitch black hours with a muffled sense of guilt at my tiredness. Dewdney's book made me feel less guilty. Nature, he explains, thinks we should be asleep when it is dark. The brain judges day or night – and so whether to sleep or wake – by the light transmitted to the retina. Light stimulates the suprachiasmatic nucleus or 'SCN'; the SCN decides the release of hormones – in particular, melatonin. After two hours of darkness, Dewdney writes, 'melatonin floods the body like a velvet tide'. Melatonin tells our bodies to go to sleep. It is irresistible, and in this respect we are little different from flowers. There is a hormone named 'florigen' which tells a plant when to blossom, its leaves counting the hours of daylight until it is the moment to transmit a signal up through the stalk.

Perhaps this is one reason why so little has been written about gardening by night. We should be asleep, and it is unnatural to set an alarm clock to wake up to watch a lily open its blossom. After all, night flowers are blooming for their pollinators, not to entertain us.

The second bodily change at night is to our vision. In the various chapters on the subject the diagrams of the retina were incomprehensible when abstract on the page, so I took one book to the garden at Alnwick. Above the Great Cascade a triple arch leads into a walled kitchen garden, transformed by the Duchess of Northumberland into a garden with flowers of every colour. The garden had closed, and by the rose arbour a small, Peter-ish rabbit sprang over the hedge of dwarf box. Then he plopped back on top of the box, quivering lightly. He nosed closer, trusting and curious.

I wondered what he could see by night. Scientists explain that the eyes of animals are divided between long cells called 'rods' and short cells called 'cones'. Rods enable the animal to see shapes at night; cones to see colour in daytime. Nocturnal animals, such as owls, have only rods. Chickens have just cells: that's why they squat stupid, noisy and helpless on their roosts in the dark. Humans combine the two, but we have chosen to let our night vision become weaker and weaker. Our limited night vision explains why Vita Sackville-West saw the lily stalks as 'milky' and the lake as black, and why a garden designed for the night is invariably a white garden. As it becomes dark our eyes lose the ability to distinguish colours.

At Alnwick at half past seven the leaves in the arbour began to merge, the treillage changing from a ripple of individual leaves to a single, solid architectural form. Imperceptibly, green became black. Then red became black. At nine o'clock – this was the third week of August – blue and yellow petals

continued to glimmer. Suddenly, they were gone. At five past nine the gardens were nothing but black and white. A spider crawled inside a shining peony.

But it was the rooks that dominated the evening at Alnwick. There are several rookeries in the trees just beyond the old brick walls of the kitchen garden and at dusk rooks will fly out and back in a round-trip of several miles which no ornithologist can fully explain. They flew over and back time and time again, their wings jet black against a sky the colour of grey wet powder. As I peered into the folding petals of the peony their maddening, yelling caws broke up the silence. Perhaps it was the boniness of their voices, as hard as skeletons; perhaps it was their primordial profile, in its strong and urgent flight indifferent to the human achievement of a flower garden. I felt a sudden, lonely tug of mortality.

The rooks warn of a night that is timeless and unchanging. Ekirch lists the rituals of a medieval bedtime: the snuffing of candles, the sprinkling of herbs, the folding of counterpanes, the sequence of prayers. It seems cumbersome, but are we any different with our hot baths and herbal teas, our favourite programmes, or our meditation? Night is still a challenge, a chasm between days. One stumble, one sharp cry in the dark, and it is as deep as it must have seemed five hundred years ago.

There is a brilliant new book by Robert Pogue Harrison, Professor of Italian Literature at the University of Stanford: *Gardens: An Essay on the Human Condition*.[10] Why did Odysseus abandon Kalypso on her magical island, he asks, rejecting her gift of immortality? Because there was little for him to do in 'meadows growing soft with parsley and violets': he chose to return to his responsibilities at home. Mankind, suggests Harrison, cannot divest itself of care. Indeed, in Greek myth the first man is moulded into shape by the figure of *Cura*. Care is the curse of humanity and the vocation of the gardener. We call Arcadia a wilderness and pick up an axe; similarly, we find it difficult to enjoy gardens in which there is nothing for man to do. But Linda's photographs tell us to look, but not touch.

It could be argued that the greatest change in British gardens in the last ten years is a new naturalism. At a day-to-day level we are spraying less and mowing less – and soon we shall be spending much less. It is a consequence of the so-called 'Dutch Wave', which includes garden designers Piet Oudolf and Henk Gerritsen, of the 'right plant, right place' localism of Beth Chatto, and – above all – of the doubts and desires of ecology.

Linda's connection to naturalism is not necessarily in her choice of gardens: Great Dixter is Englishness at its most exotic, while Levens is a highpoint of structured planting. It is, rather, in the stance she has chosen. At night the gardener is no longer in control.

For Naturalism tells us that we cannot control Nature. In the 1970s Gilles Clément acquired a field in the Creuse Valley in the Limousin. His first act was to pitch a tent and for the first year he sat and slept, watching and learning. He observed orchids open and die, cattle graze and wander, and insects make new lives around the fall of an oak tree. Only then did he consider what he might do. That experience inspired his philosophy of *le jardin en mouvement*.

But – as with Odysseus in a natural paradise of parsley and violets – passive gardening continues to be a psychological and spiritual challenge. Richard Mabey has suggested that our greatest fear is not that we will destroy Nature: in fact, it is that Nature can survive without us. Irrelevance is man's greatest terror.

We had been at the cinema, and took a shortcut to the tube station. In the narrow old streets of Soho we quickly became lost. At the corner of a street were high railings over which red roses climbed, their blousy, dishevelled leaves lurid in the electric gleam. A thorn cut my thumb; the drop of blood was illuminated the same deep red. Through the railings there was the gleam of a pond, and a wheelbarrow.

In the strip-lit pallor of the tube journey the secret garden in Soho came to seem as unreal as the movie we had just seen, set one summer in the 1980s. I returned in the daytime, puzzled at the discovery of such a garden in a zone so familiar for its restaurants, bars, and cinemas. The Phoenix Garden is a community garden, and for a community garden it is very beautiful: the gardener has the authority to place nettles beside anemones. The vegetation is tall enough to be able to escape the city. But it is not the same garden as we had discovered in the night.

In these photographs familiar, crisp gardens become liquid, sensuous and mysterious; Sissinghurst is as immediate but as timeless as in that description by Vita Sackville-West. At the same time, their characters are recognizable under the cloak of night: Great Dixter is as jaunty and mischievous as its creator, Christopher Lloyd, while the old topiary and mottled stone of the garden at Levens seem an even happier pair than in the daytime. And as we turn the pages, our nostrils itch: at night, of course, our sense of smell increases at the same time as our colour range reduces. These are images of miraculous candour. Linda's photographs show us that every garden has a second life during the hours of darkness. By night, flowers are independent from us: free to breathe, free to move, and to bend towards each other.

But, ironically, this book reinforces the separation of day and night. We should be asleep at this moment, we realize. And if we go into the garden we must accept that we are observers – and that our passivity is a liberation from 'the vocation of care'.

The wife who escapes the Victorian dinner party and wanders through the garden is liberated precisely because she cannot prune, plant, or weed. Like her, we can only look, and imagine. Gardens by night should exist in the drowsy but hallucinatory light that shines between sleeping and waking. In the very best sense, this is a book for bedtime.

[1] 'Lilies and Lakes' from *Country Notes in Wartime*, quoted in *Vita's Other World* by Jane Brown (London: Viking), 1985, p. 140.

[2] *The Evening Garden* by Peter Loewer (Portland, Or.: Timber Press), 2002 p. 192.

[3] Ibid.

[4] Ibid., p. 193.

[5] *Night Haunts: A Journey through the London Night* by Sukhdev Sandhu (London: Artangel and Verson), 2007.

[6] *Acquainted with the Night* by Christopher Dewdney (London: Bloomsbury), 2005.

[7] *At Day's Close: A History of Night* by A. Roger Ekirch (London: Weidenfeld and Nicolson), 2005.

[8] Quoted in Ekirch, p. xxv.

[9] *George Steiner: A Reader* by George Steiner (New York: Oxford University Press), 1984, p. 351.

[10] University of Chicago Press, 2007.

OVERLEAF: *Tilia platyphyllos* 'Rubra' Red-twigged lime – The Lime Walk, Sissinghurst Castle Garden

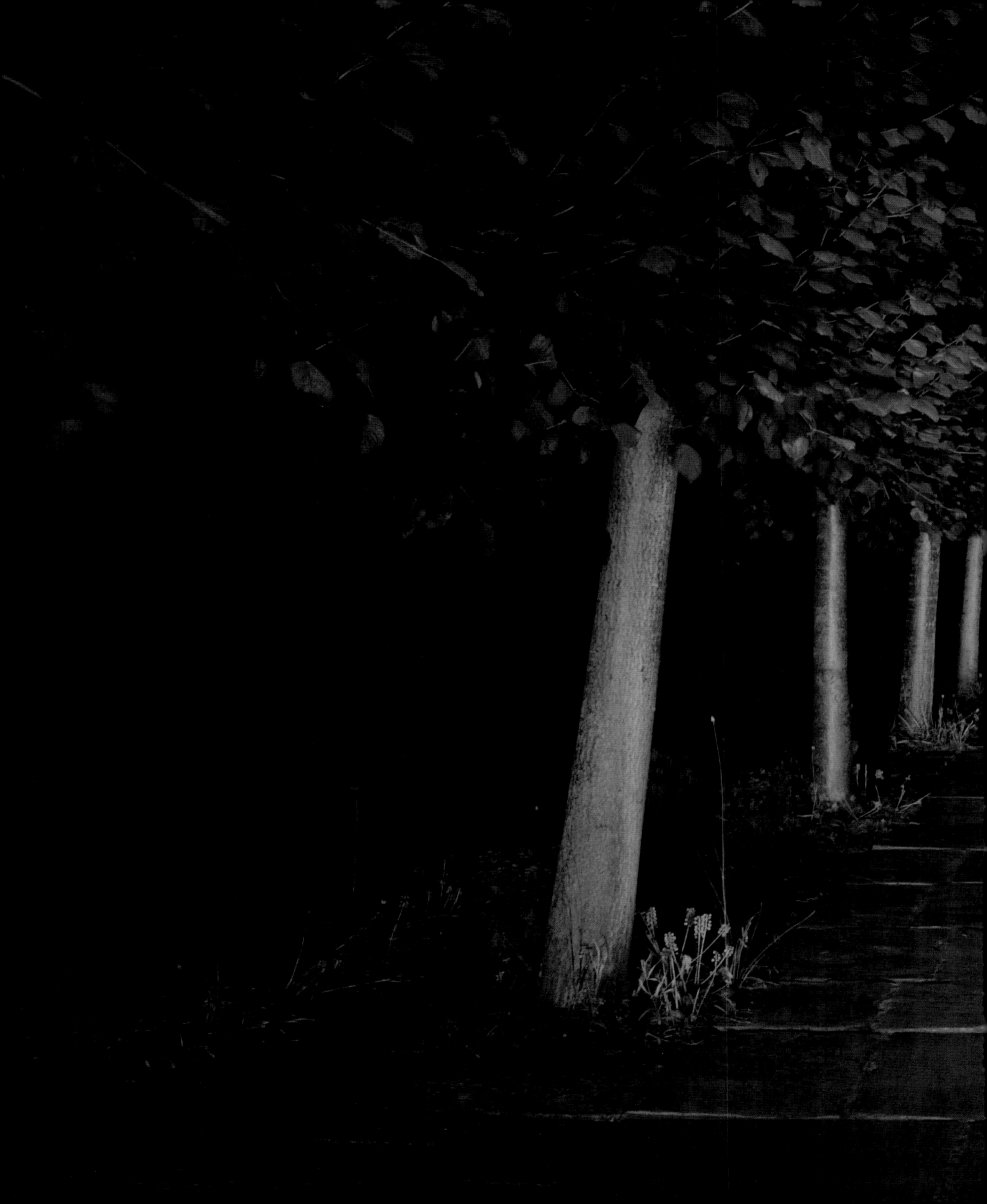

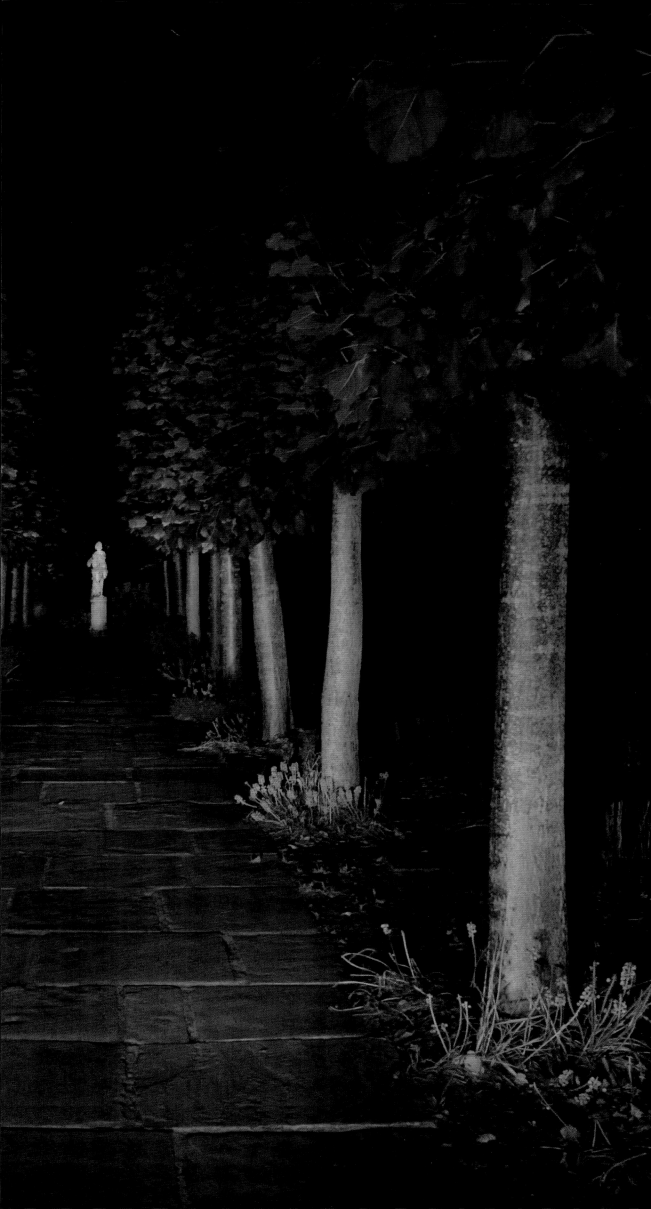

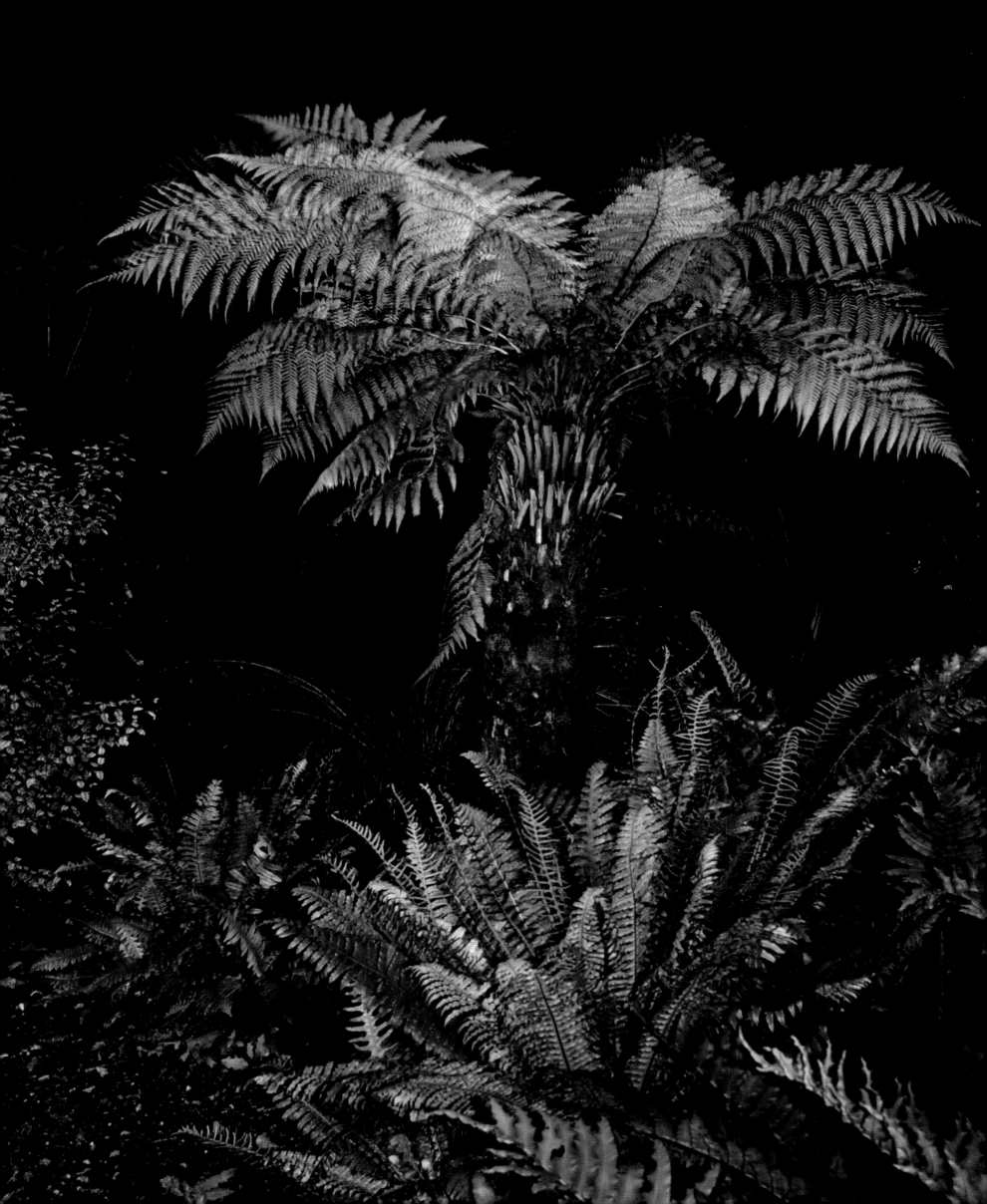

THE LOST GARDENS OF HELIGAN
CORNWALL

CANDY SMIT

'TRESPASSERS – KEEP OUT.' Twenty years ago this was the neglected sign upon a granite gatepost beside the Upper Lodge. I passed by it almost every day and it all looked so forlorn and uninviting that I was not even remotely curious to know what lay beyond. For some reason there was no arguing with this insubstantial barrier at the top end of the main drive to Heligan House.

Down the Mevagissey end it was a different story. For centuries there had been more or less legitimate routes up through the woods to Heligan; the locals had hunted, poached and scavenged while their children lived out their future childhood memories – filling baskets with scented flowers, juicy blackberries, and sweet chestnuts for roasting, making secret dens and precarious bridges over the millstream, and, as they grew, making love beneath the ancient boughs of glorious blooms amid the swaying bamboo.

We heard talk of this extraordinary 'jungle', where the main valley to the sea intersected a fabulous exotic rift. One day we ventured with our own children up a rabbit run, tangled with strapping brambles over our heads, shafts of sunlight drawing us on. Below, we glimpsed enormous palm trees and a swamp alive with giant rhubarb amid the chaos of rampant overgrowth; but further progress was impossible.

In 1989, somehow from all approaches and in every aspect, Heligan was inaccessible; its secrets woven tight, layer on layer back through the generations. Then, in January 1990, a great storm devastated much of the south-west, and the enormous oaks of Heligan's remaining shelterbelt were smashed across the forlorn and derelict garden. Even its total neglect was then submerged, but this savage, natural catastrophe prompted the re-awakening of Heligan. It was not planned – rather, an accident of fate. Down through time the very ground itself had absorbed so much pain, it finally offered a welcome to strangers and breathed a sigh of relief. Dawn broke. Impassioned volunteers gave the Lost Gardens of Heligan new life, treasuring its history, ever respectful of its spirit, but living their own adventure.

Now, every day, hundreds of visitors to 'The Nation's Favourite Garden' (BBC TV, 'Gardeners' World') become aware of something unexpected, they know not what, that makes each one stop long enough to listen to his heart, reach into his memory and long to return. Something of value that was lost is found.

But by night, Heligan still belongs to those who went before us. It beckons the souls of the gardeners who carried it through to an earlier, meticulous, golden hey-day, and departed into the abyss; those who dug and sowed and thinned and hoed, who prayed for sun and then for rain, who by their craft and effort gathered in the harvest year on year for the Victorian household of successive Squires Tremayne.

At the day's end we still damp down the embers in the old Head Gardener's office and shut the door quietly, but never lock it; for there must be no barrier between then and now, them and how – the understanding, rekindled passion, tireless devotion to the processes dictated by the soil and the seasons – productive harmony with nature.

Outside, ancient exotics still brood against the skyline, grown tall beyond any imaginings in that historic struggle through decades of overgrowth, through the plates of time riven with human joy and tragedy the whole world over. They cast some strange insubstantial memory back to prehistory, when dinosaurs trod this very ground before cultivation was ever conceived.

Imbibe this melancholy peace, the slumber of the dead, Heligan . . . 'Healing'; and knock gently on that half-open door before entering tomorrow.

OPPOSITE: *Dicksonia antarctica* Soft tree fern – The New Zealand Garden
ABOVE: The Grey Lady dances among the trees

ABOVE: The Mudmaid slumbers beside the Woodland Walk

OPPOSITE: *Echium pininana* Tree echium – The Jungle

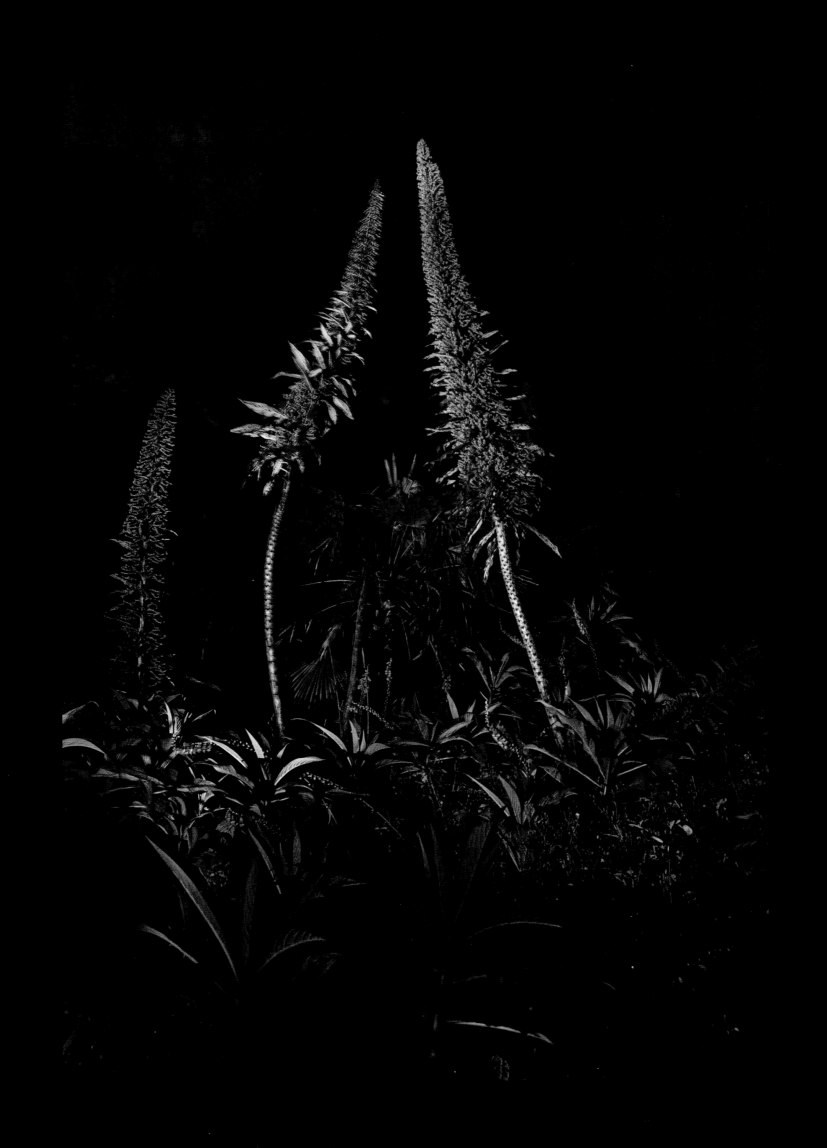

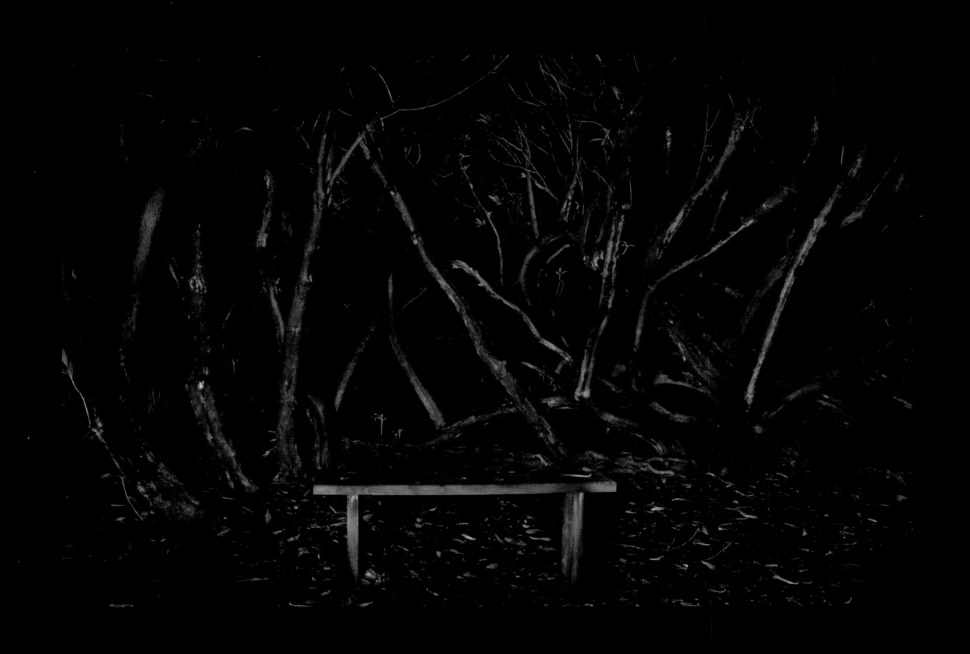

Inside the old 'Cornish Red' rhododendrons, behind Flora's Green

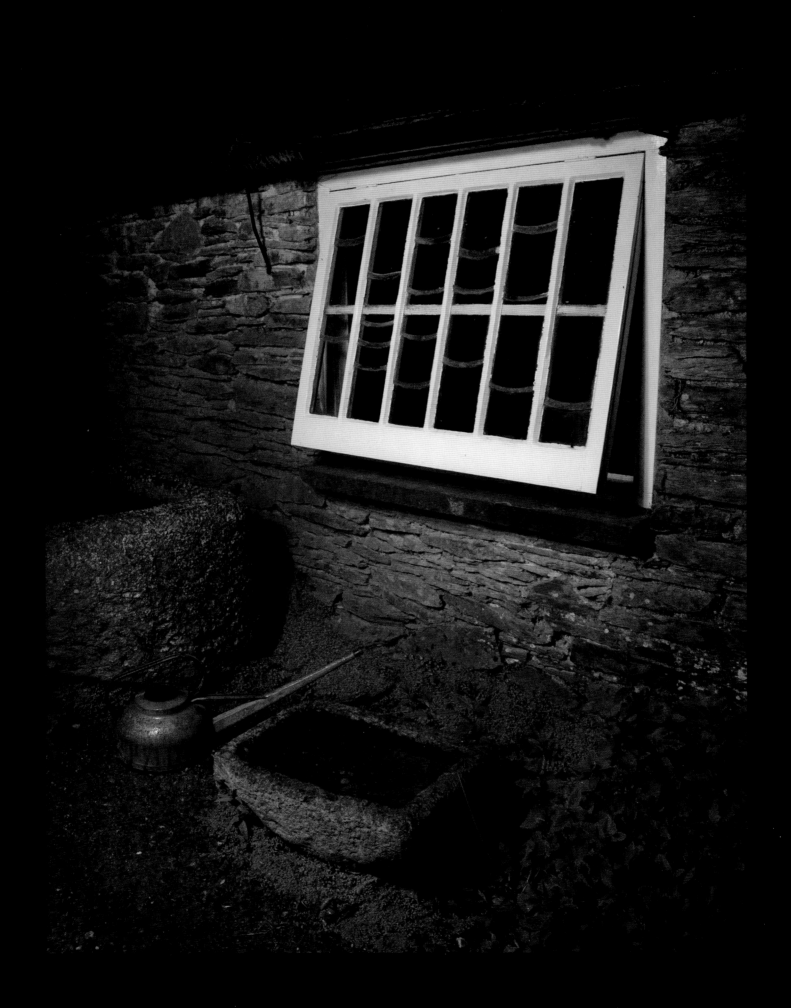

Stone troughs outside the old tool shed – The Melon Yard

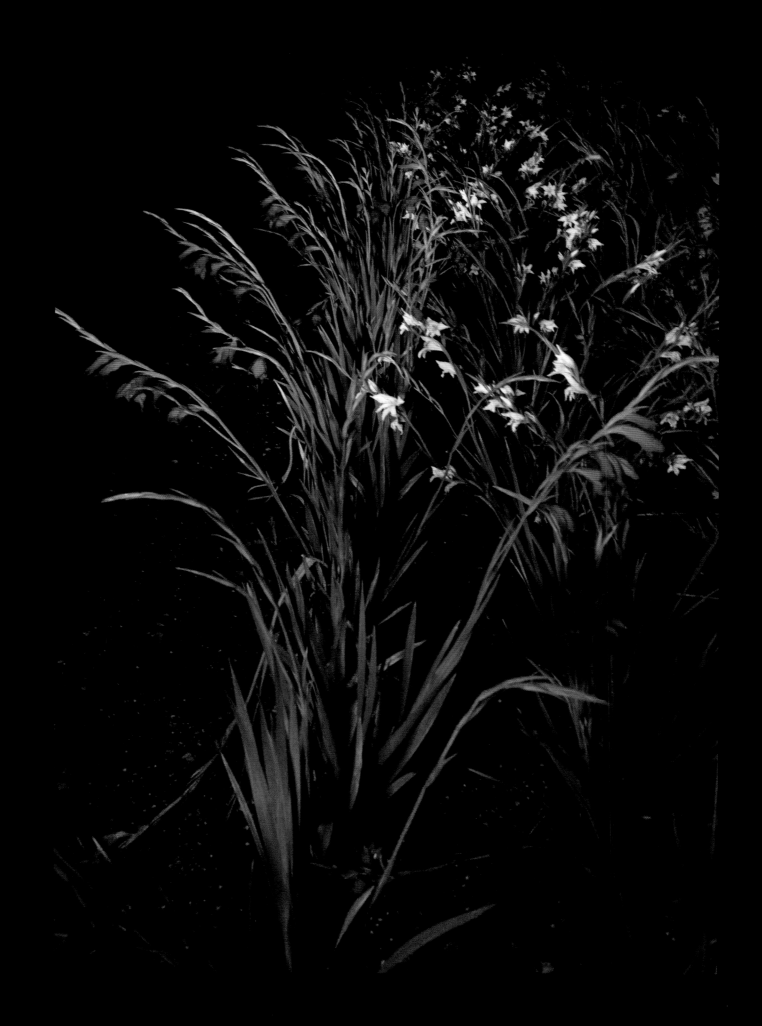

ABOVE: *Gladiolus ramosus* 'Robinetta' Gladiolus 'Robinetta' – The Vegetable Garden

OPPOSITE: *Cornus capitata* Bentham's cornel – Main drive to Heligan House

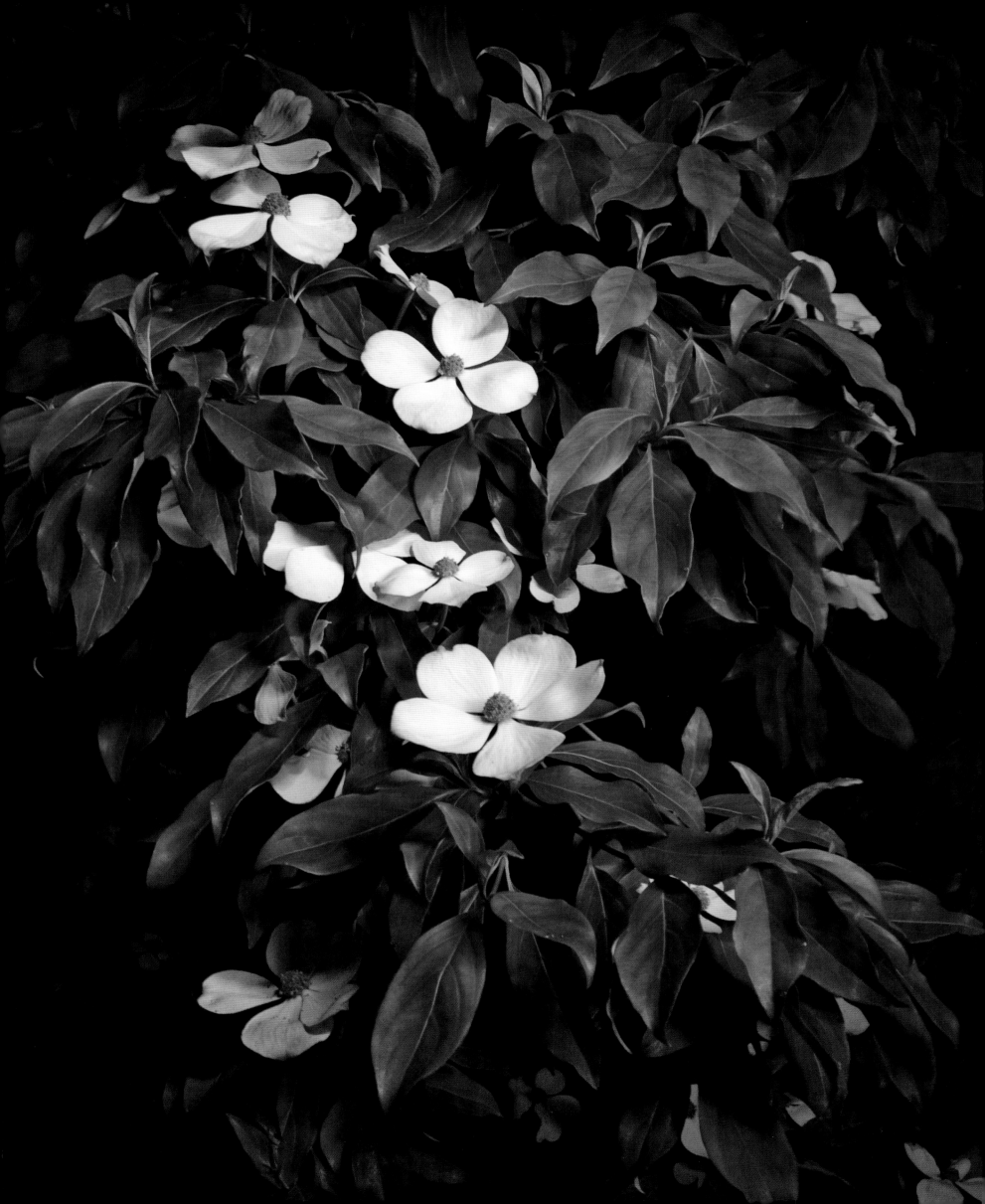

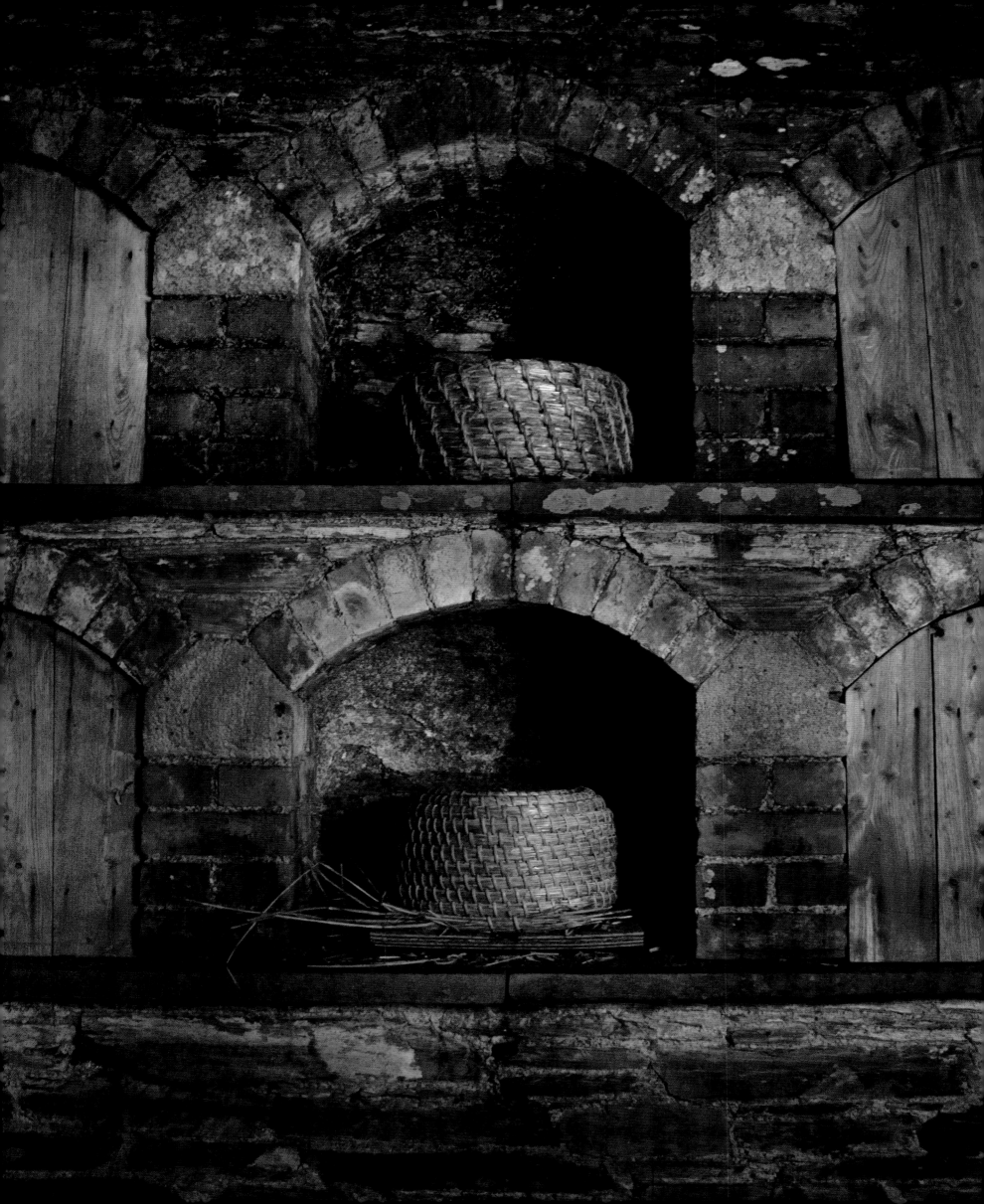

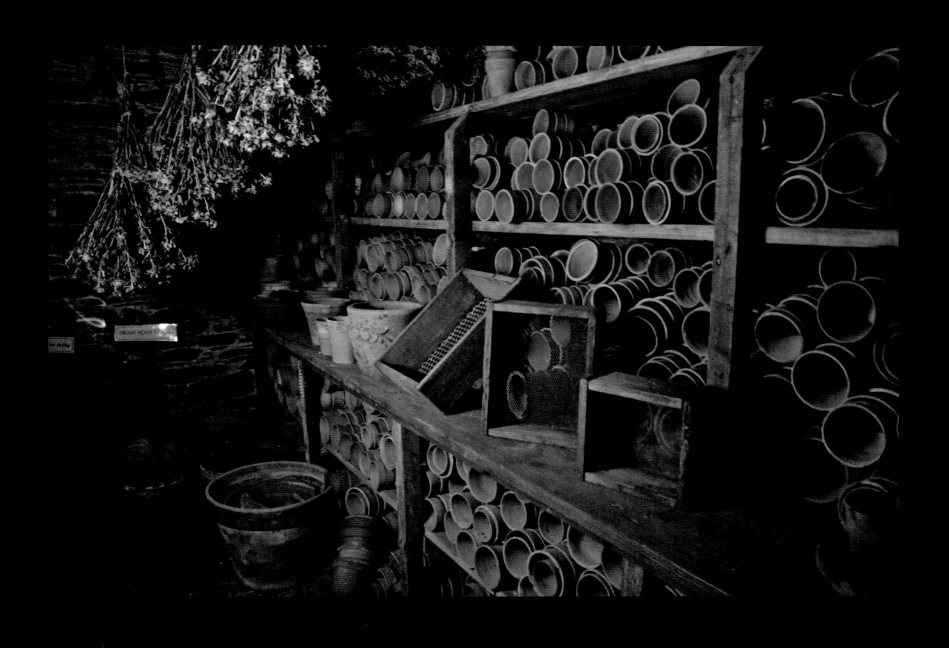

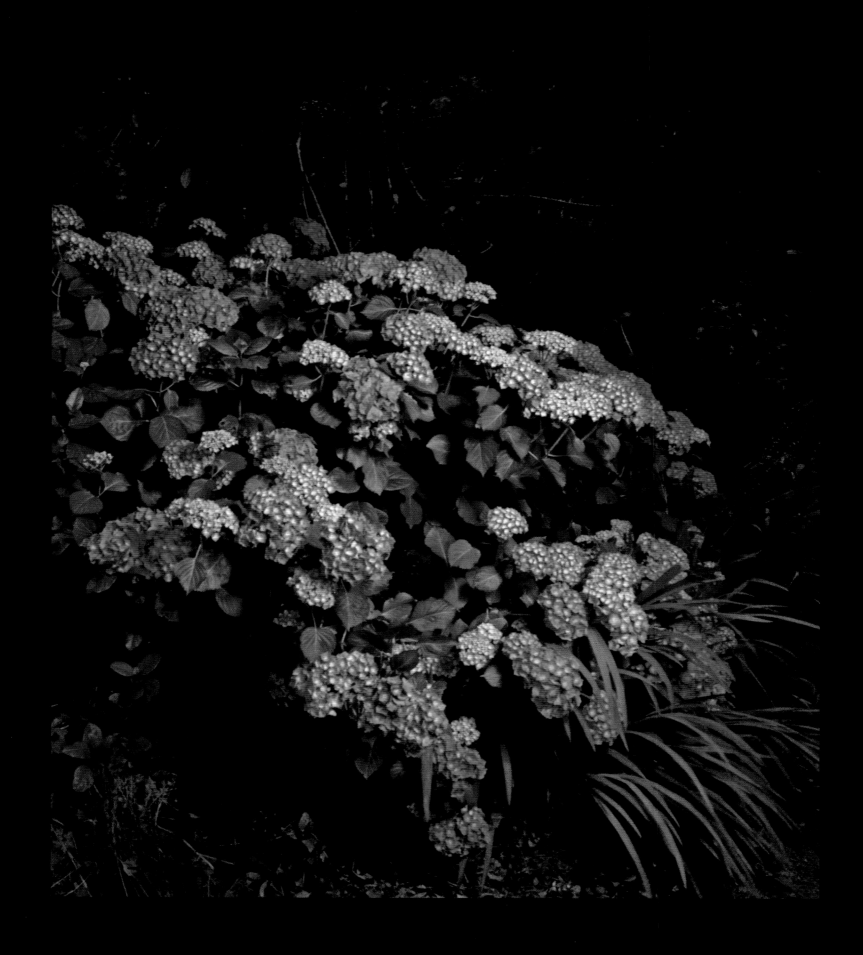

ABOVE: *Hydrangea macrophylla* Mophead hydrangea – The Eastern Ride
OPPOSITE: Fountain in the Northern Summerhouse

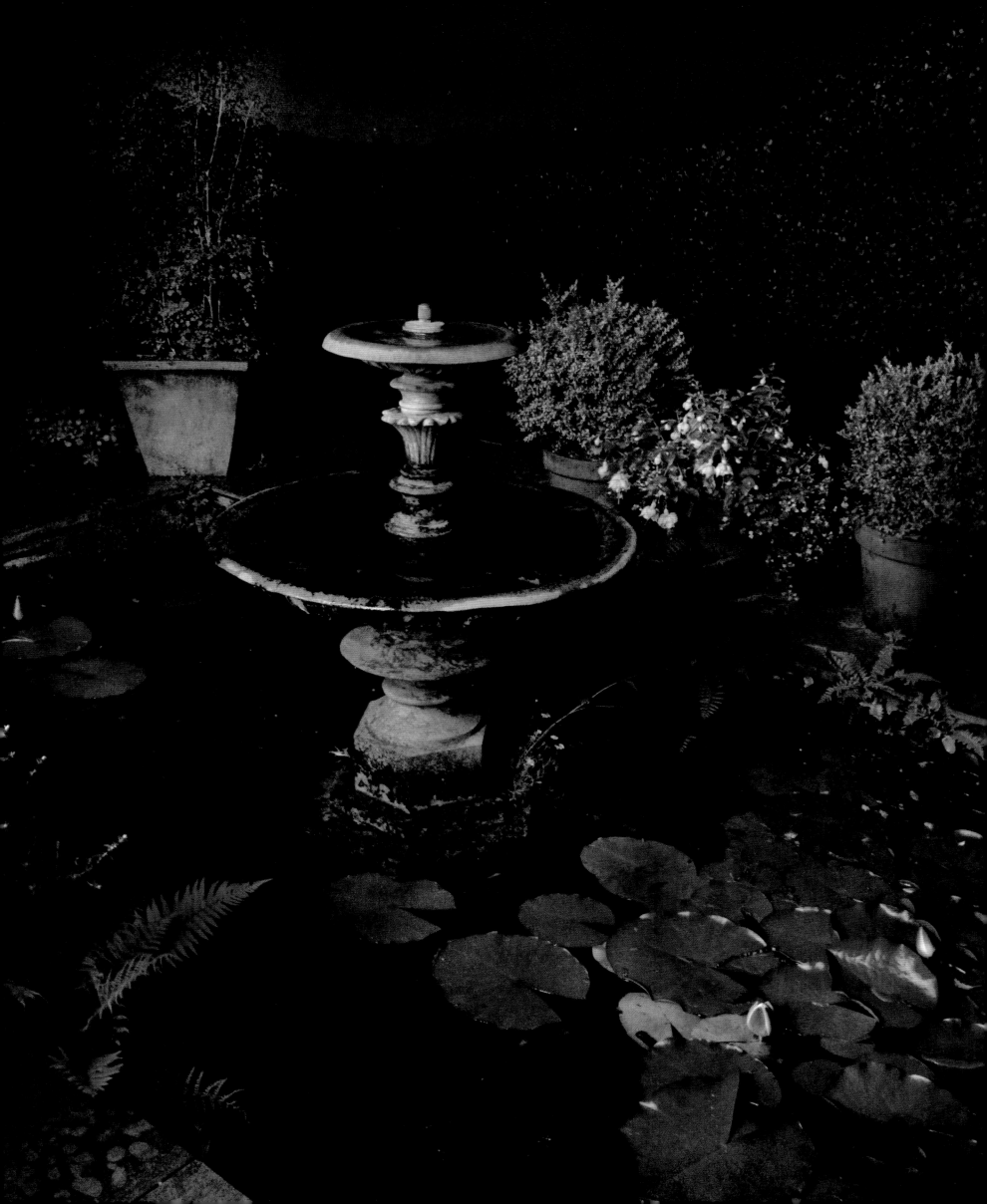

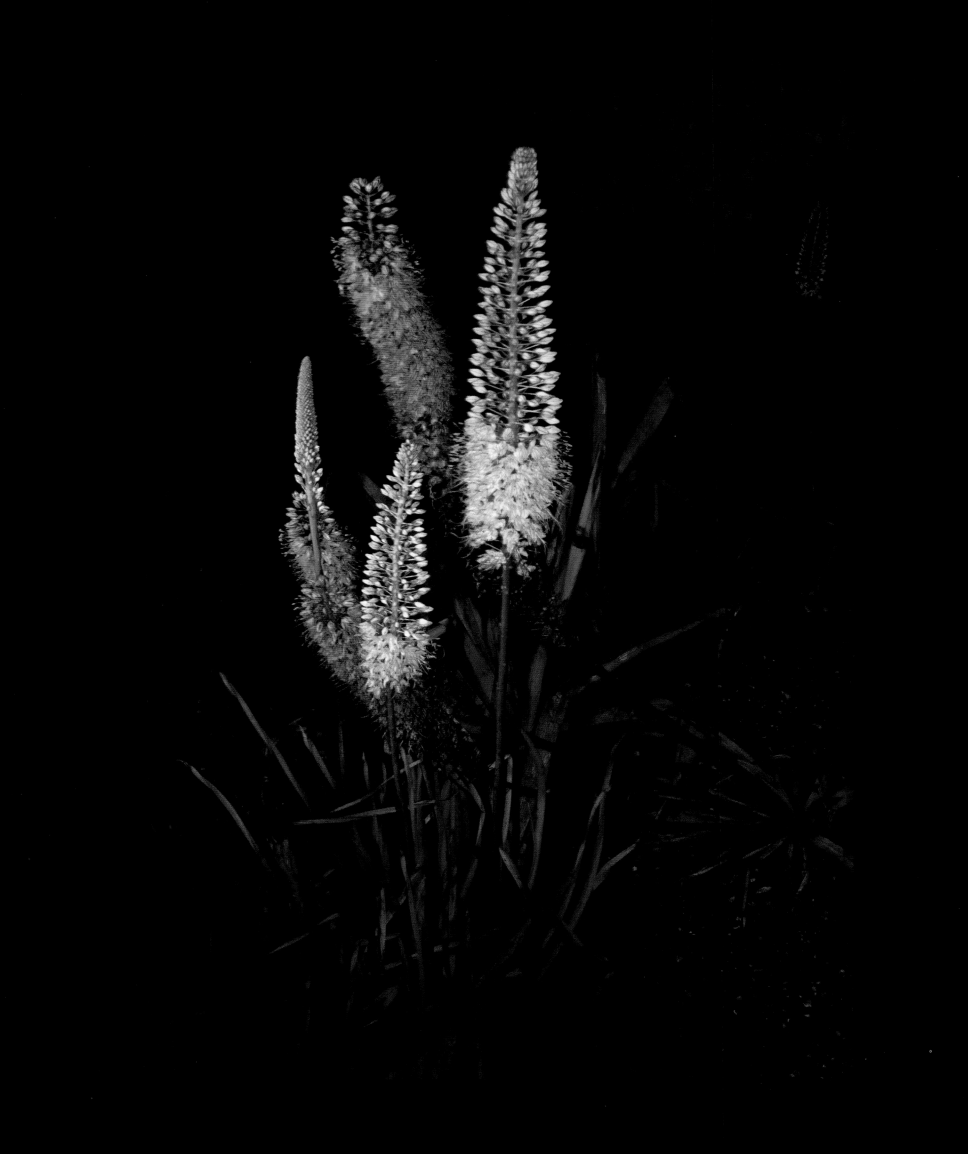

OPPOSITE: *Eremurus bungei* Foxtail lily – The Flower Garden
ABOVE: *Putto with a Dolphin*, in the pool – The Italian Garden

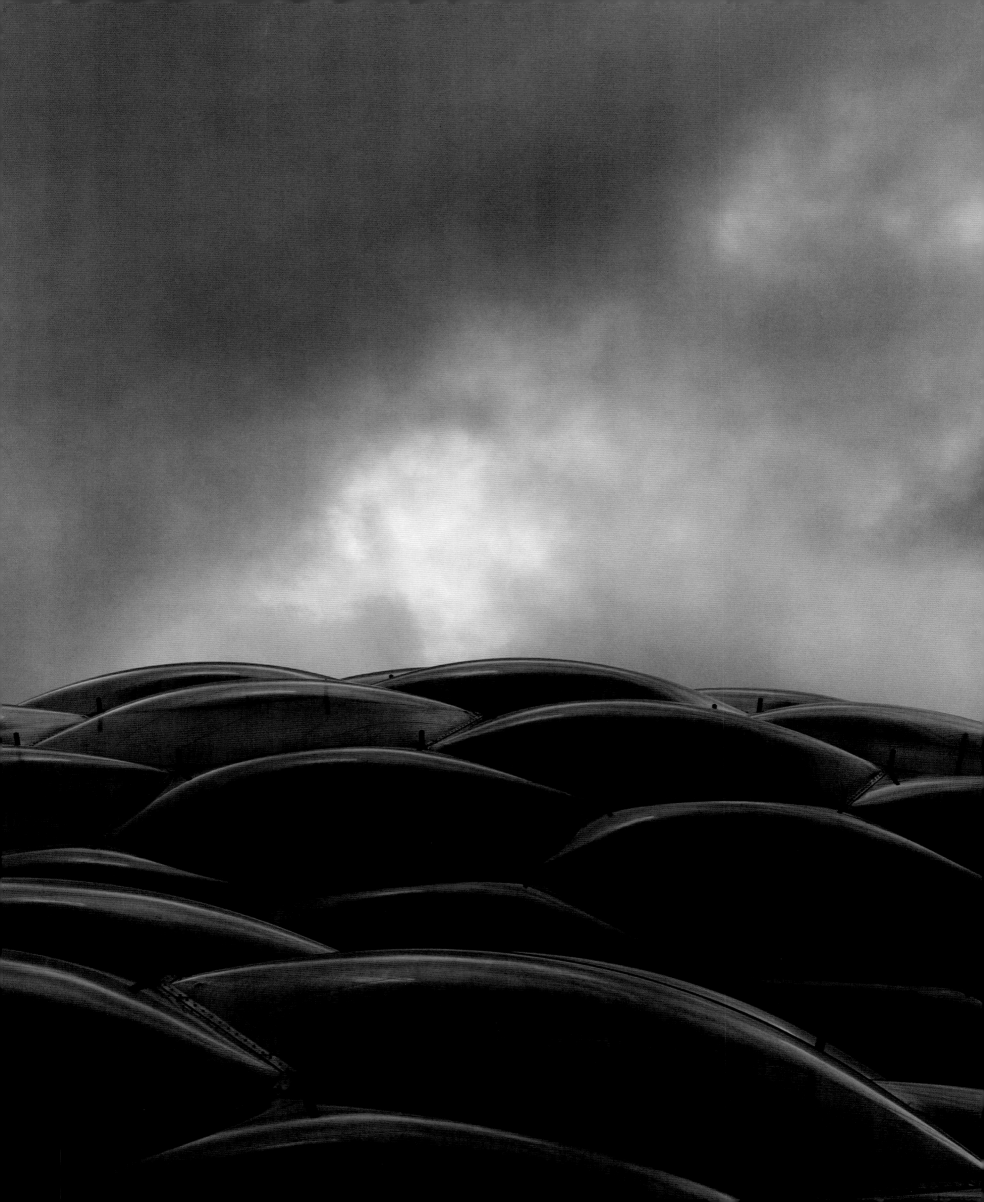

EDEN PROJECT
CORNWALL

TIM SMIT

SOMETIMES I COME HERE AND WATCH the buzzards reeling on the wind, catching the thermals with effortless grace. My eyes follow the contour of the pit edged in Atlantic woodland at one end and scrubby gorse for much of the rest. I do what I used to as a child, I make my eyes into tiny slits and my eyelashes create a soft-focus lens you can dream through. I hear the earth-moving monsters and I see the bleeding hillside where the minerals and ores leached livid greens and reds. I see the gloopy clay and I remember the rain, the ceaseless rain that nearly drowned our vision. I catch the smell of the loam made by our team in quantities beyond imagining to clothe our pit in a brown fertile mantle into which the horticulturists, like fevered ants, sowed and planted and laid a gauze of coir and hessian through which we drilled the shrubs and landscape plants that would stop our hillside world slipping into chaos at the bottom.

As I open my eyes wide I can see that planting, strong, verdant and ambitious, the scimitar-shaped beds mirroring the shape of the pit, filled with bold colour as they scythe down the hillside intersected by paths and promenades. The original brief had simply said, 'Picasso meets the Aztecs – go.' I knew what I meant, and luckily the landscape artists did too: not prissy and busy, but assured and vibrant, geometric but unpredictably so: a bold statement of a new civilization. And no right angles: 'Mondrian meets the Aztecs' wasn't what I was looking for.

My eyes sweep across the massive Biomes, beehive hexagons under a film of foil, shimmering like gossamer parachute silk. Inside the biggest, as the light begins to fade, you are assaulted by the dank smell of the jungle and the twittering of the birds as they jostle before roosting – and yes, let's be honest, the clank, clank, clank of the cockroaches as they venture out on their night patrols. The ants make no sound, but are everywhere. This jungle, sweaty as the best of them but missing the most obvious predators, has grown beyond our wildest imagining. Scientists are agog at the growth, but no-one ever hung around watching for that long; the jungle is an unforgiving place where senses are sharpened to the truth that life and death are separated by the thinnest of veneers. Here damp permeates everything and rots everything. Here today, gone tomorrow is a literal truth. Your demise is food. We try to capture that; the Rainforest Biome is of nature, yet not natural. It is the greatest hits of 'jungleness' with the bad bits edited out, and told in palatable chunks.

It is in the anonymity of this great forest with its lush plantings that you start to hear the rumour of the big questions. There can be no life on Earth, as we know it, without plants. Pretty is good, useful is even better, but essential? Eden isn't about a day out (although it is a damn fine day out, as it happens) or a collection gathered for amusement. It is connection we are after. You can admire it all you like, but if that is all you do it has been a massive waste of time. Eden is about life and understanding that we are part of the warp and weft of it. To lose that knowledge and respect for nature, to see it as something that is at our service, is to prove that the name we give ourselves – *Homo sapiens,* the wise human – is the greatest joke ever made. At this level Eden is either a Divine Comedy or a signpost to the 'Tree of Knowledge', the fruit of which got us into this mess in the first place. The choice is ours. Eat, or die.

OPPOSITE: Rainforest Biome roof
ABOVE: Sculptures by Tim Shaw in the Mediterranean Biome

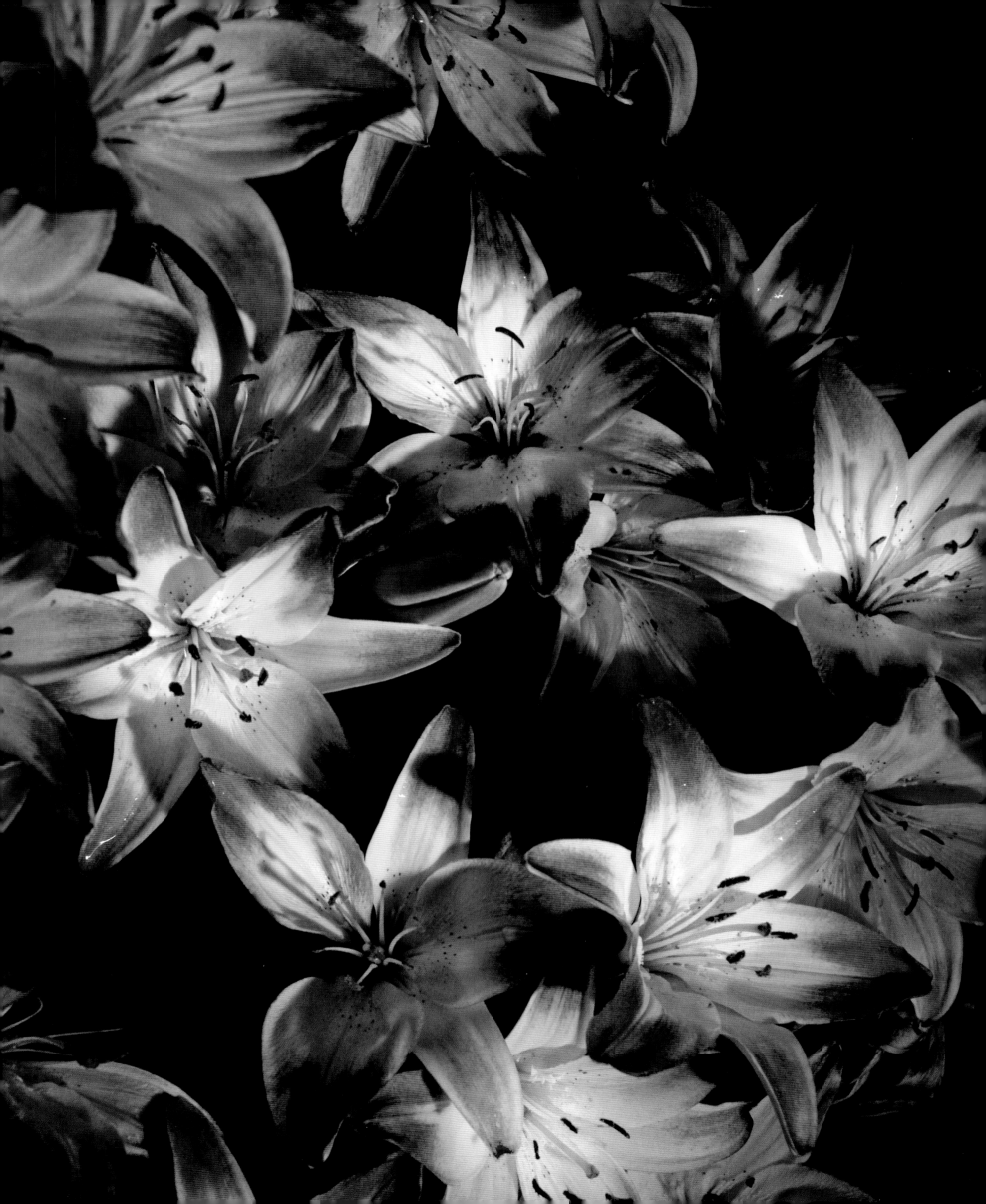

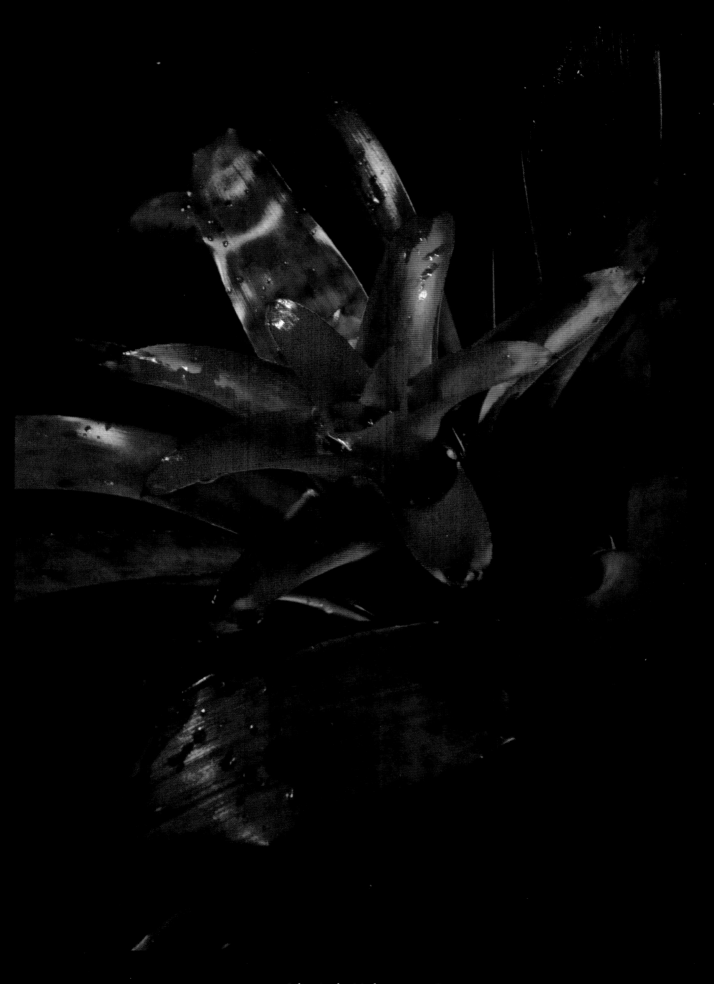

OPPOSITE: Lilies in the Mediterranean Biome
ABOVE: Bromeliad in the Rainforest Biome

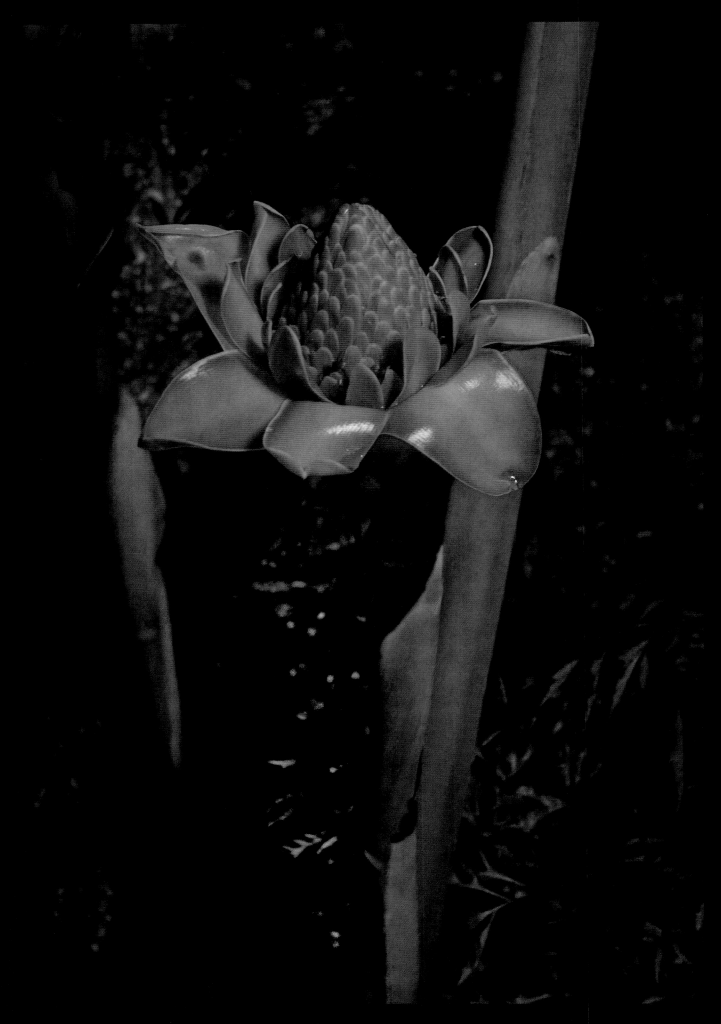

ABOVE: *Etlingera elatior* Torch ginger flower – The Rainforest Biome
OPPOSITE: Bromeliad in the Rainforest Biome

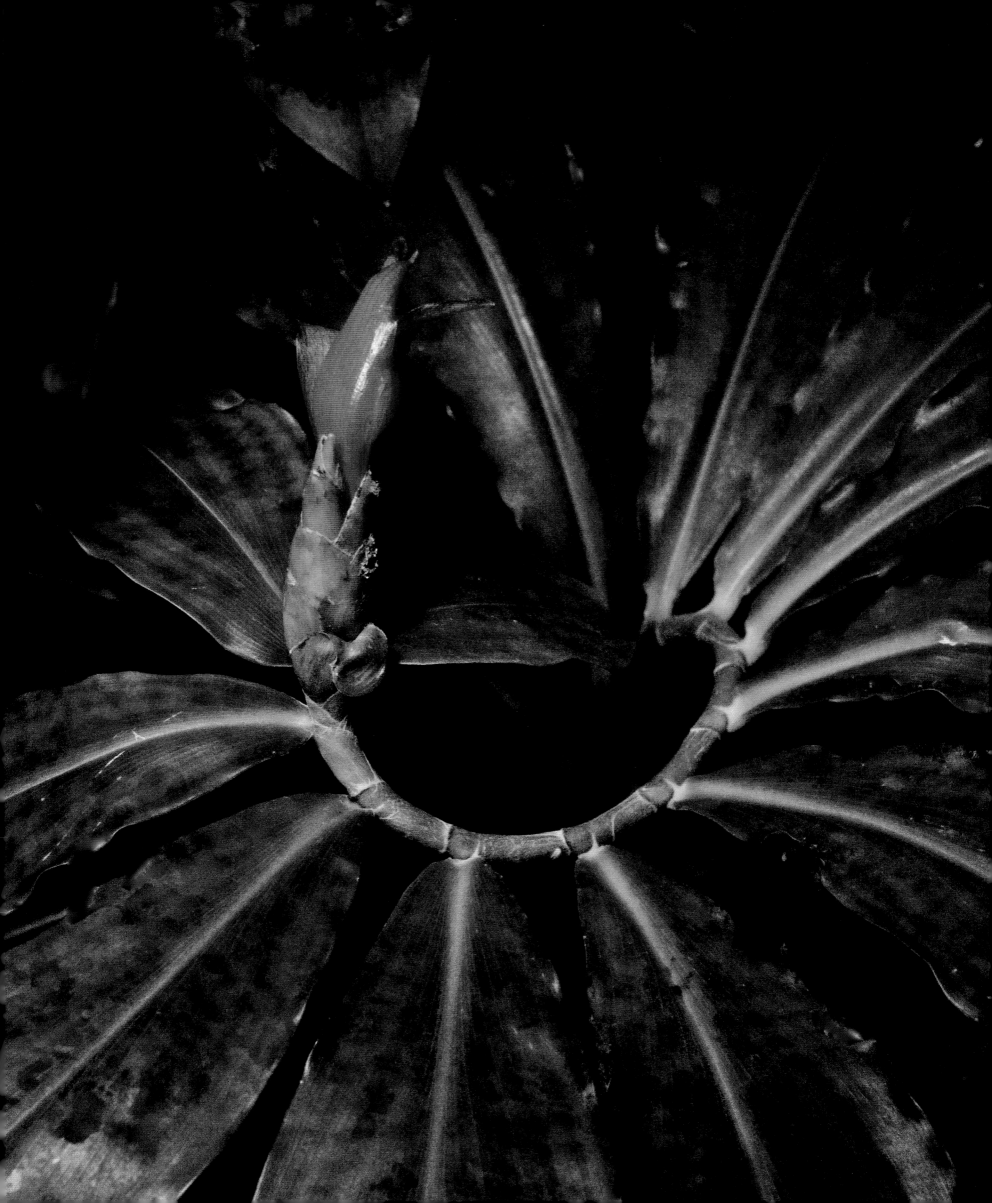

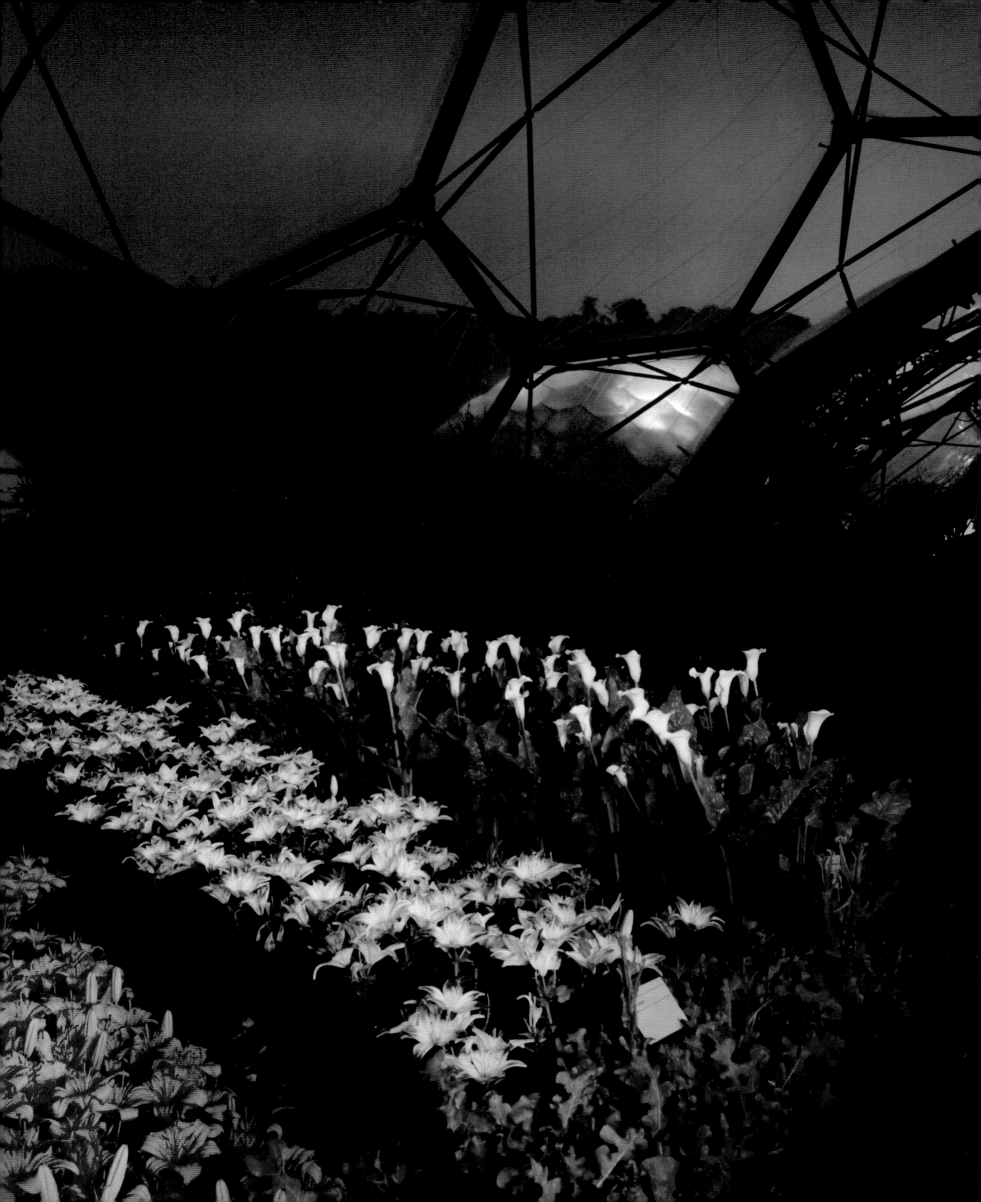

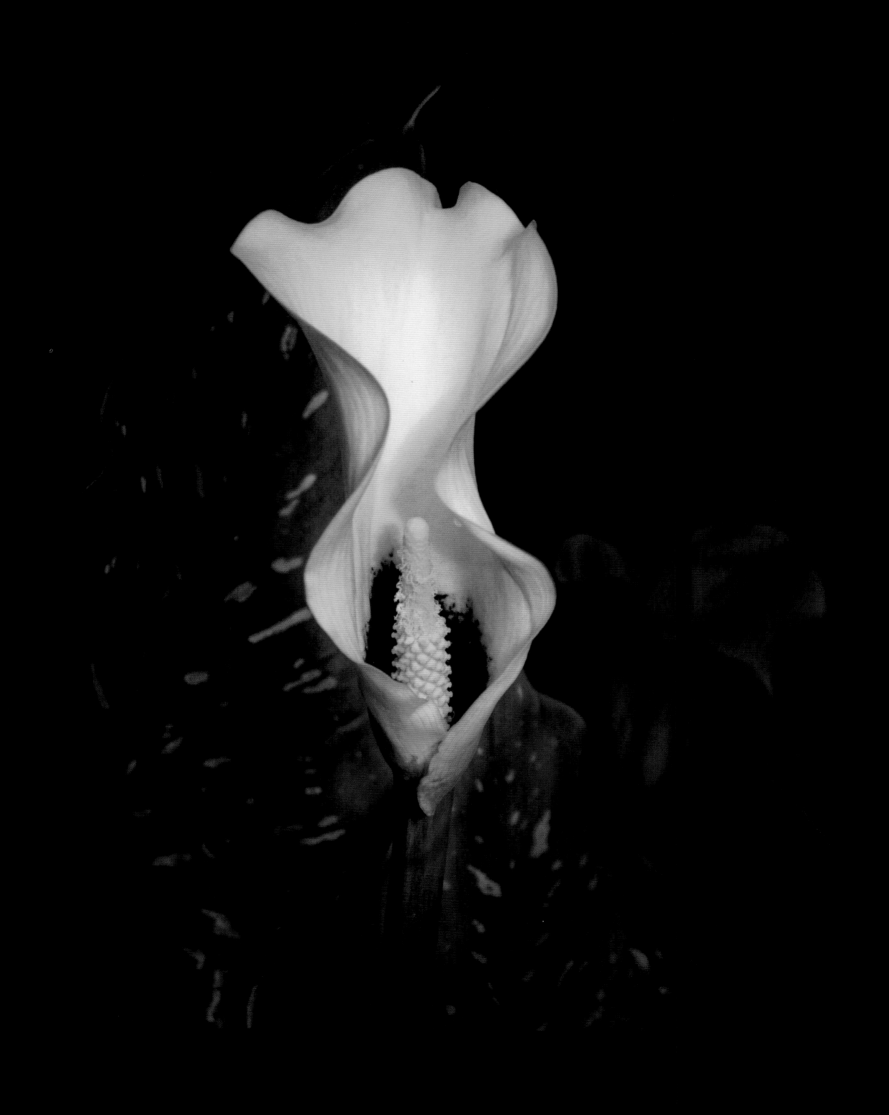

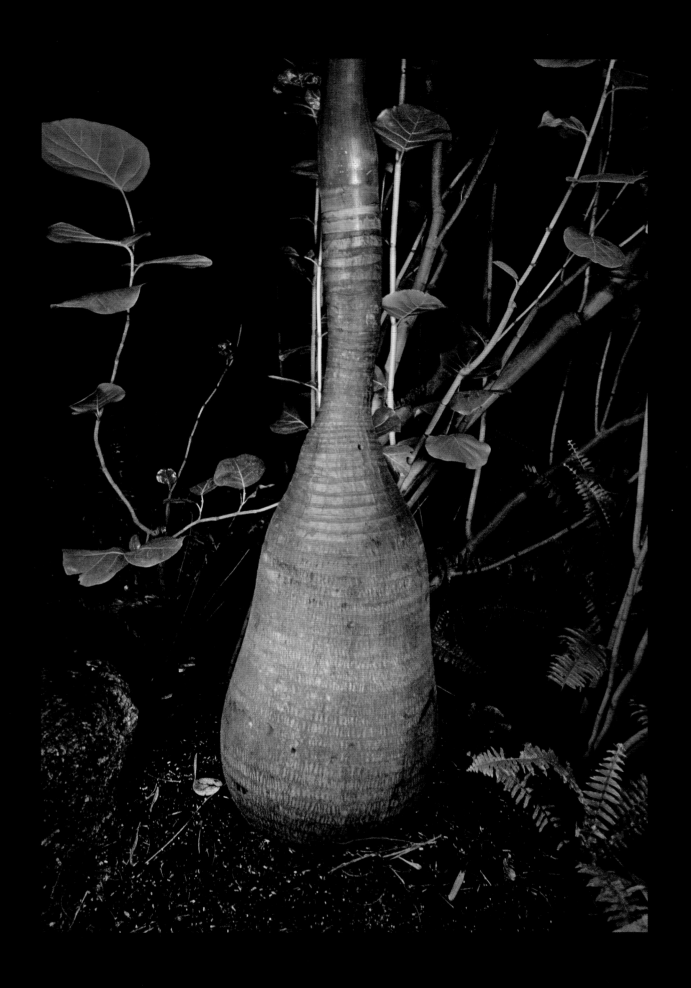

OPPOSITE: *Zantedeschia* Calla lily
ABOVE: Bottle palm trunk – The Rainforest Biome

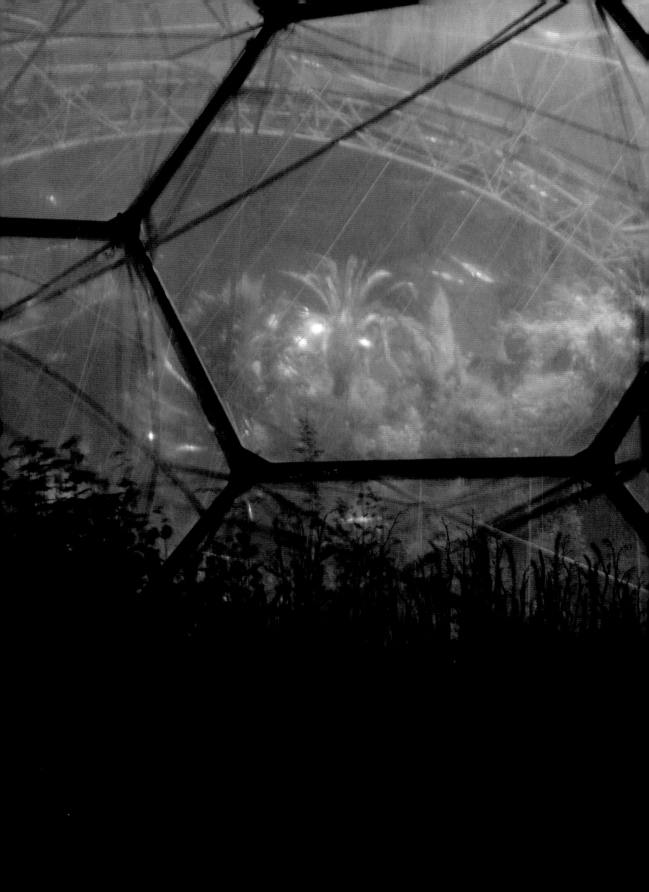

ABOVE: *Palma phoenix* Phoenix palm – The Mediterranean Biome
OPPOSITE: Parrotia trees with blue lights in the Garden Exhibit

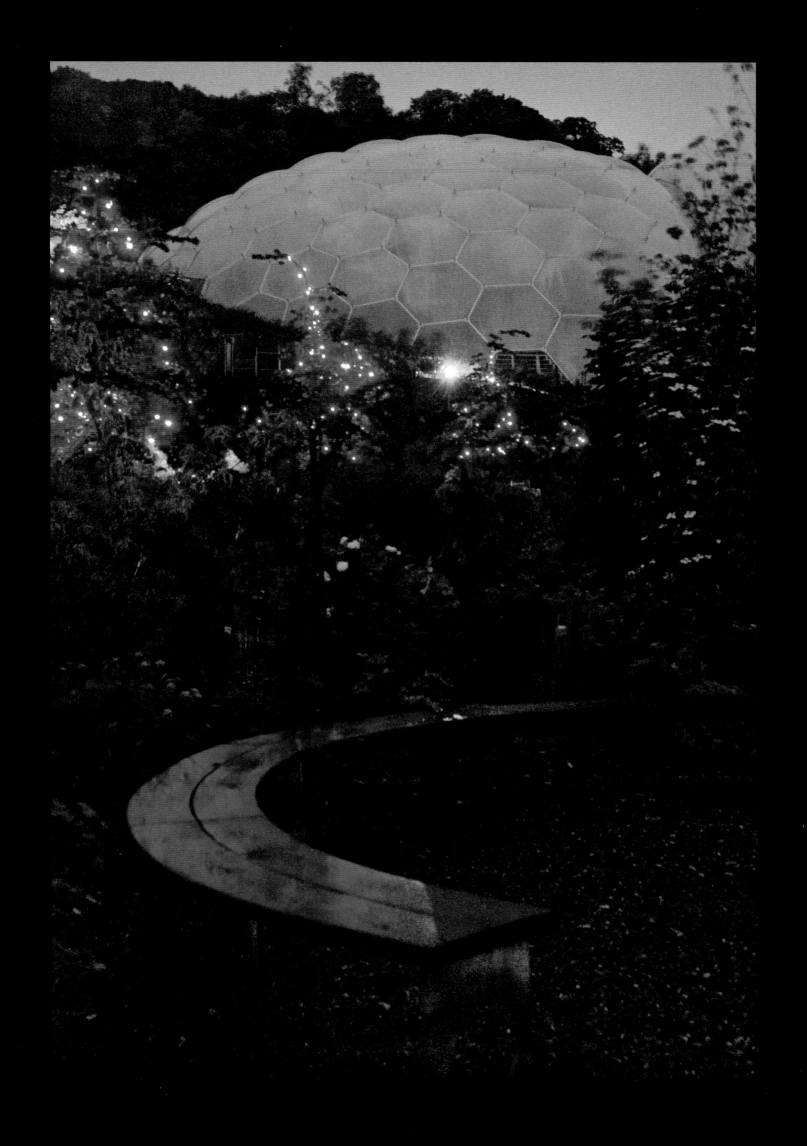

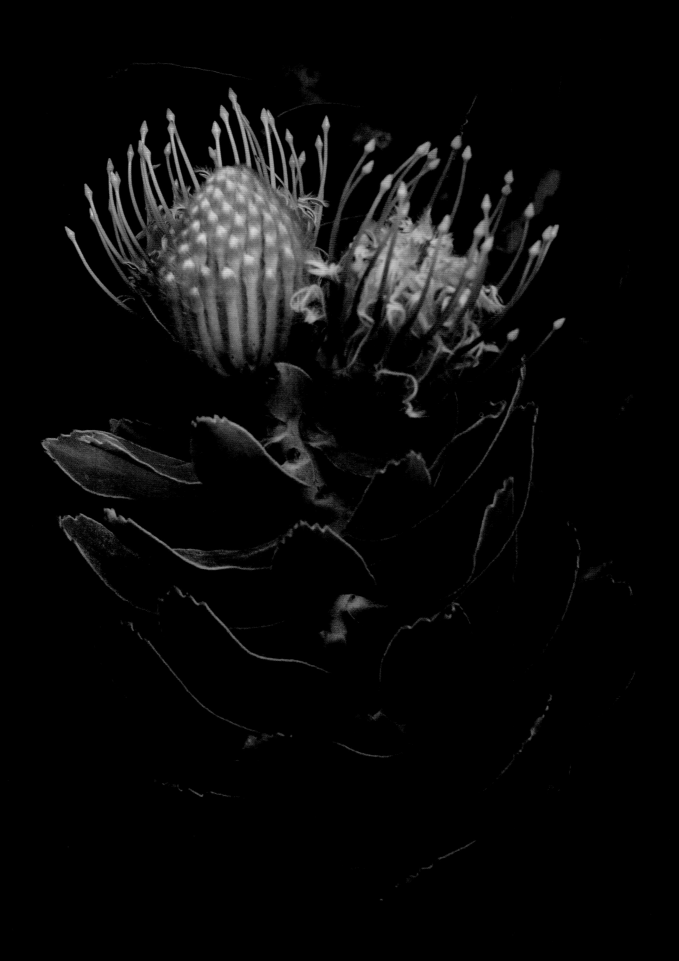

ABOVE: *Leucospermum* Pincushion flower

OPPOSITE: *Musa basjoo* Banana OVERLEAF: *Kniphofia* Red hot poker – The outdoor landscape

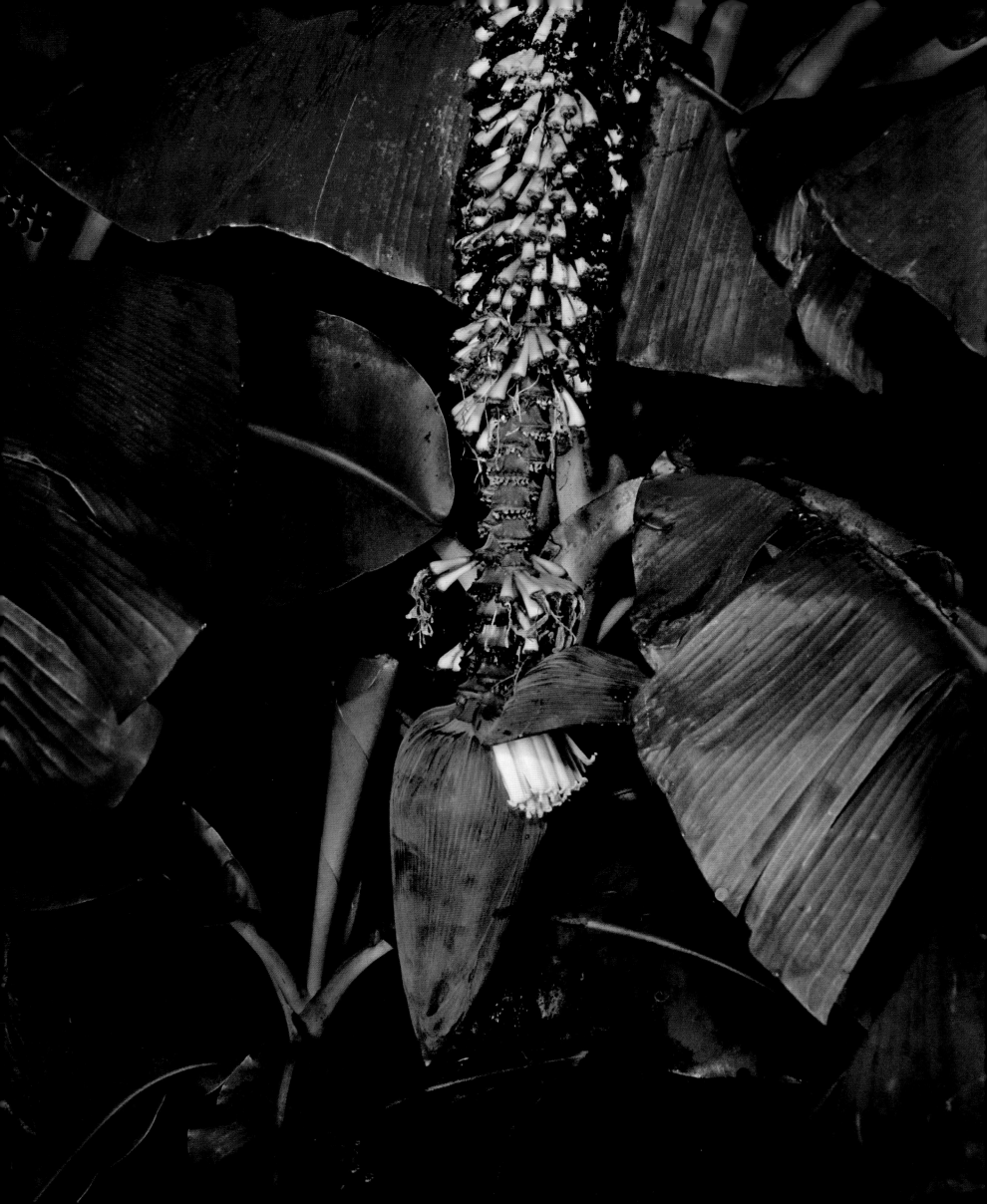

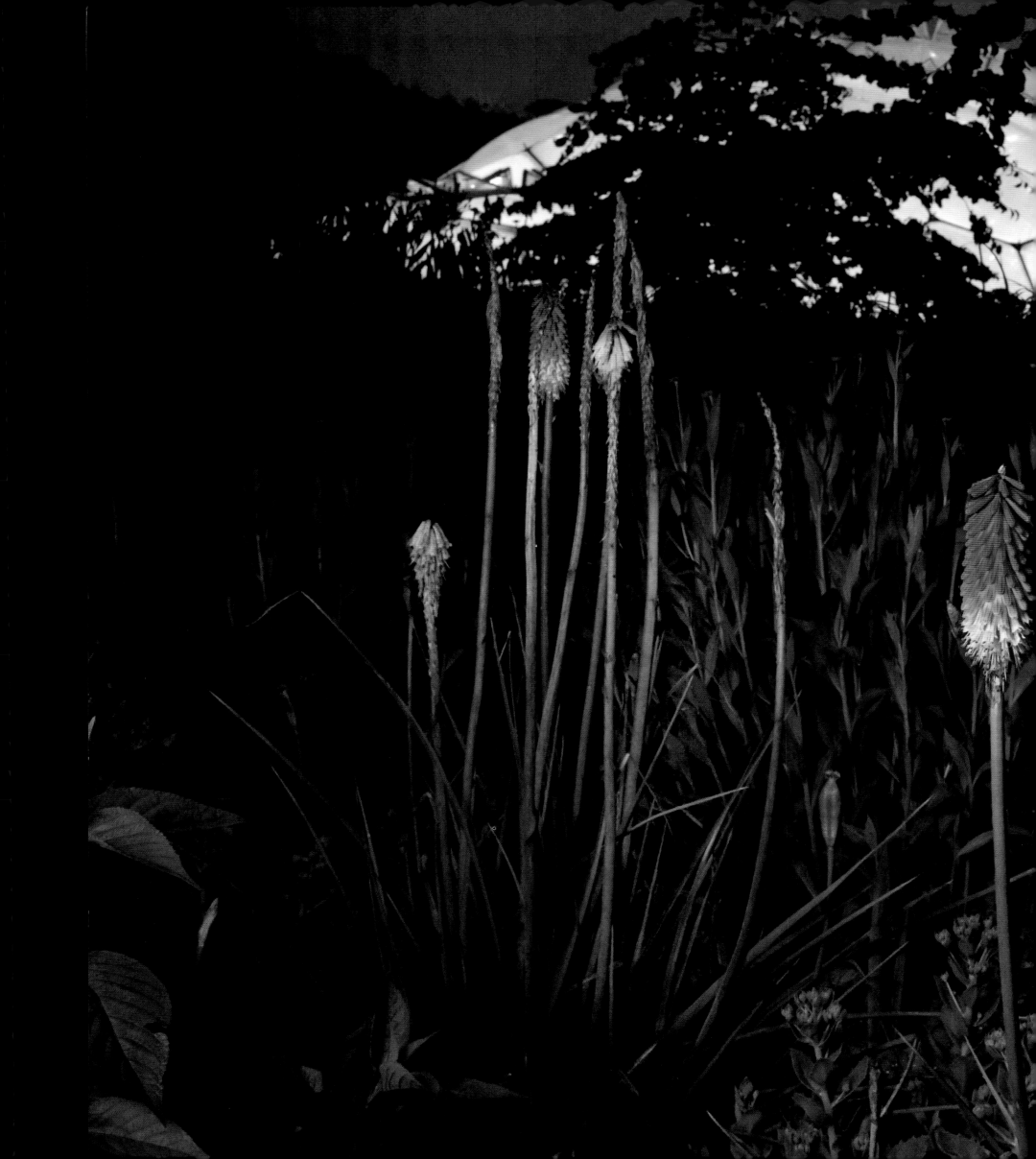

IT WAS ONE OF THOSE WARM, BEAUTIFUL NIGHTS WHEN

EVERYTHING SEEMS CARVED OF PRECIOUS STONES.... THE ROSES HE WAS GATHERING WERE

LIKE GLOWING RUBIES, AND THE LILIES HAD THE DULL LUSTRE OF PEARL.

EVERYTHING HAD TAKEN UPON ITSELF THE LOOK OF SOMETHING IMPERISHABLE . . .

WILLIAM BUTLER YEATS (1865–1939)

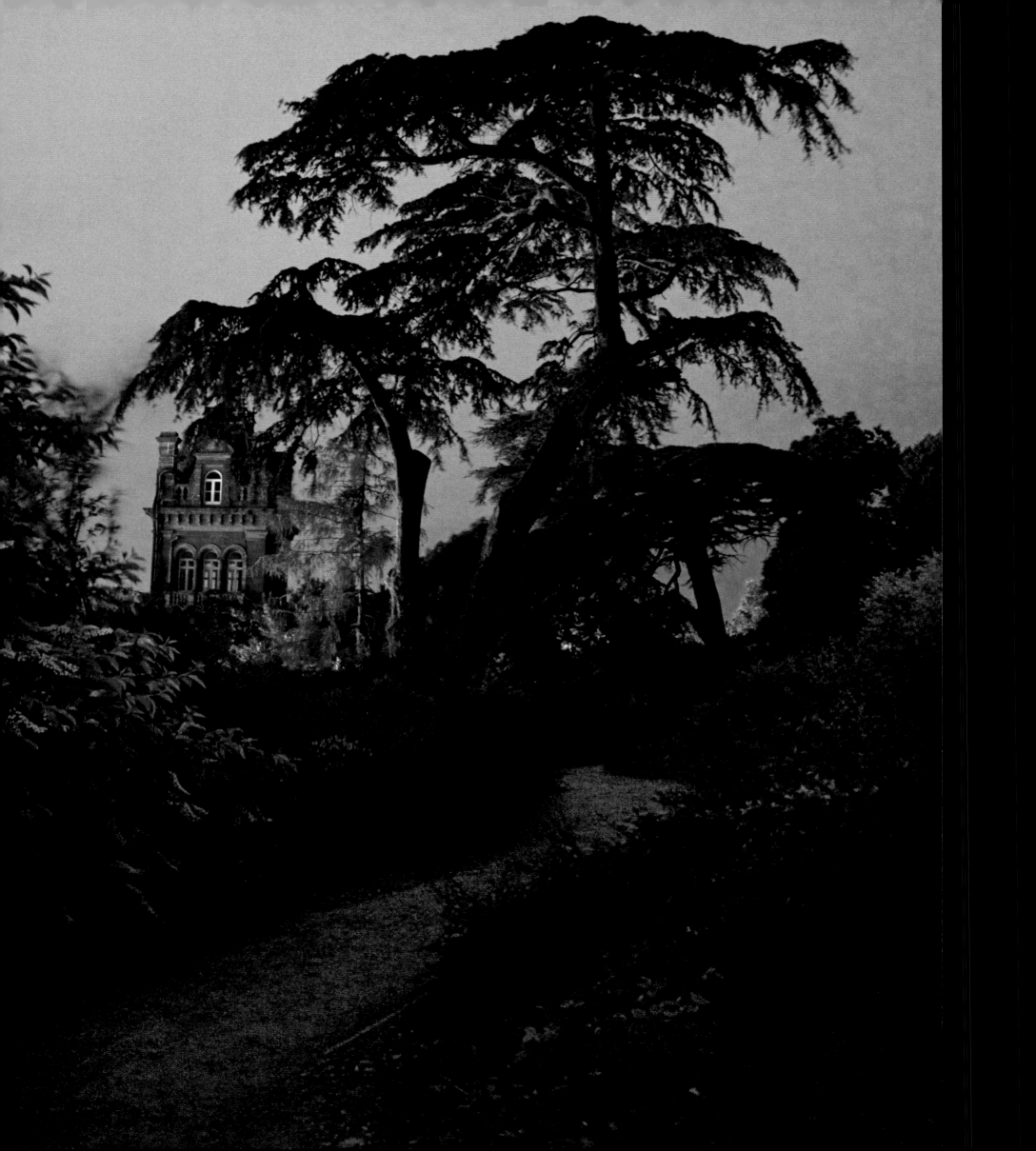

HESTERCOMBE GARDENS
SOMERSET

PHILIP WHITE

LAWRENCE FRICKER, writing in the *Journal of the Institute of Landscape Architecture* in 1963, described the owners of Hestercombe's eighteenth-century landscape garden as having 'created a very convincing evocation of Paschendale Ridge'. Lying smashed and broken by the majestic parkland trees felled for their timber value, the buildings and water features became subsumed under an impenetrable blanket of bramble and scrub. The valley was planted as commercial forestry and the landscape garden lay lost, and almost completely forgotten, until I rediscovered it in 1992 and started the long process of bringing back to life what is probably the most important surviving picturesque garden in England.

The devastation caused to this once noble landscape by the landowners, the Crown Estate, managed almost completely to obliterate Coplestone Warre Bampfylde's Arcadian idyll. Created between 1750 and his death in 1791, this magical valley with its temples, lakes, and cascades was designed as a series of framed views linked and embellished by a variety of textural contrasts between rough and smooth, the sublime and the beautiful, open and closed, dark and light, warm lawns and cool woods. What linked all these elements was the constant presence of water: gathered up in lakes; left to flow as gently purling streams; or propelled as dramatic cascades down vertiginous rock walls. Whether quiet and tranquil or noisy and energetic, the sound of water, close up or when heard from afar, is always present.

Highly regarded as an artist, albeit as a gentlemen amateur, Bampfylde counted amongst his friends a number of prominent landscape artists of the day, including George Lambert and John Inigo Richards, both of whom had started out as scene painters at Covent Garden. The influence of theatrical design is to be seen everywhere at Hestercombe, with the various buildings (or seats) within the garden providing the proscenium arch through which many of the great set-piece views were intended to be enjoyed. Surprise, as well as variety, was an

indispensable ingredient of the well-designed eighteenth-century garden, and Bampfylde managed to create a surprise around almost every corner. Perhaps the most dramatic of them all is the Great Cascade, the centrepiece of the garden. Discovered in a clearing in a 'thick wood', the cascade, constructed between 1762 and 1766, was described by Viscount Palmerston in 1787 as ' the most romantick and beautiful object from several parts of the Ground', and 'on the whole one of the best Things of the Mind I have seen in the territory of any private person'.

The eighteenth-century landscape is complemented by the even better-known formal garden designed and created by Edwin Lutyens and planted between 1904 and 1908 by Gertrude Jekyll for the Honourable Mr E. W. B. Portman and his wife. Widely recognized as the greatest surviving example of their famous collaboration and a high point of Arts and Crafts design, the garden appropriates the same water, stone, and views as its eighteenth-century neighbour but delivers its own unique vision. With distant views of blue 'Tuscan' hills, pergolas, rills, and Roman-style plunge pools, the garden echoes those of the Italian Renaissance – providing a further, unexpected link with the earlier landscape, whose inspiration was the seventeenth-century paintings of an idealized Roman Campagna by Claude Lorrain and Gaspard Dughet.

Lutyens's garden was also very nearly lost when in 1973 the owners, the Somerset County Council, decided to tarmac the Great Plat, at the centre of the garden, and convert it to a drill yard for the Somerset Fire Brigade. Saved by the determined efforts of the county architect, Bernard Adams, the formal garden was only the second garden in the country to be restored, and the first by a local authority. The garden opened in 1978 and in 1997 was joined with the landscape garden. Since 2003 both gardens have been under the management of the Hestercombe Gardens Trust and have been the subject of considerable further restoration funded by the Heritage Lottery Fund.

OPPOSITE: *Cedrus libani* Cedar of Lebanon – The Victorian shrubbery
ABOVE: *Solanum jasminoides* 'Album' Potato vine • *Stachys byzantina* 'Silver Carpet' Lamb's ears 'Silver Carpet' – The Chinese Gate, Dutch Garden Entrance

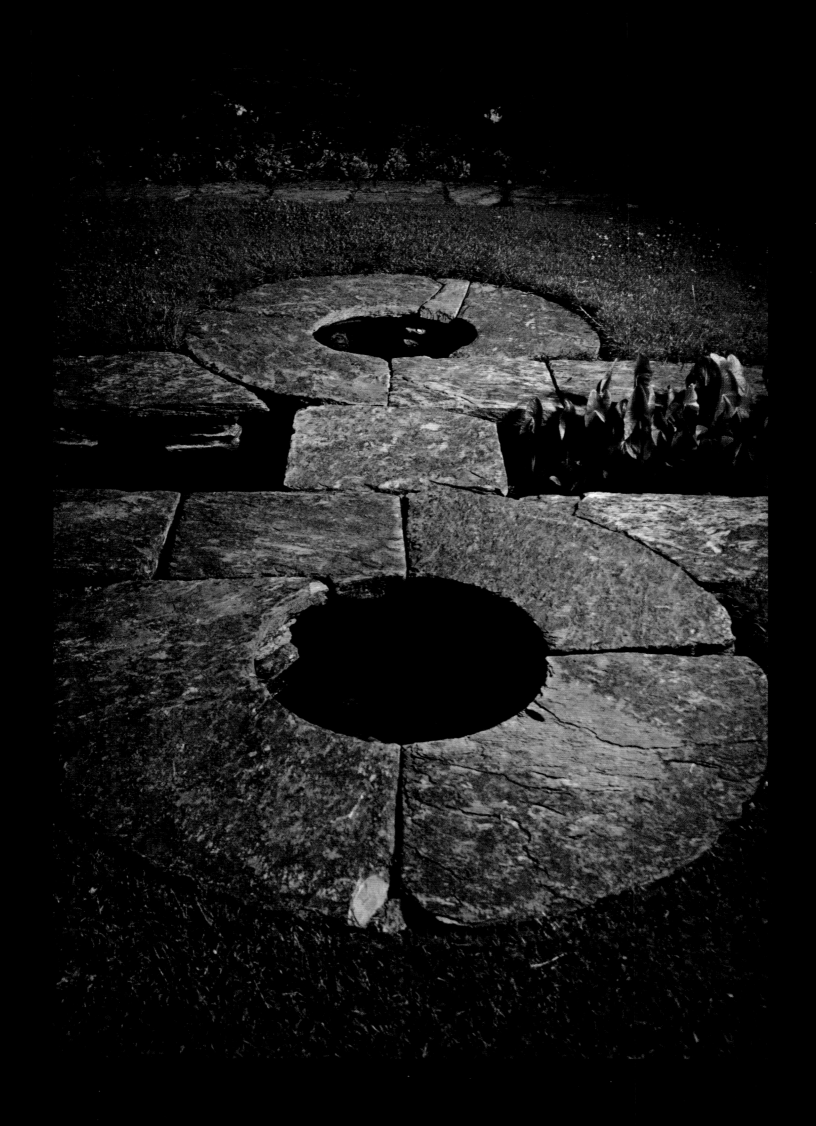

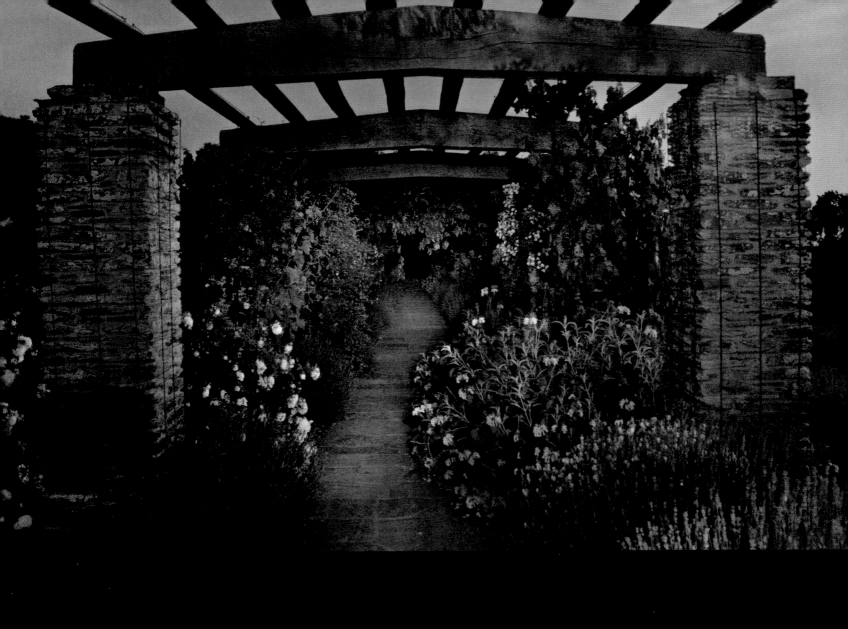

OPPOSITE: *Sagittaria latifolia* Japanese arrowhead – Side pools, West Rill

ABOVE: *Phlomis fruticosa* Jerusalem sage • *Lavendula angustifolia* 'Munstead' Munstead lavender • *Rosa* 'Mousseline' – The Pergola

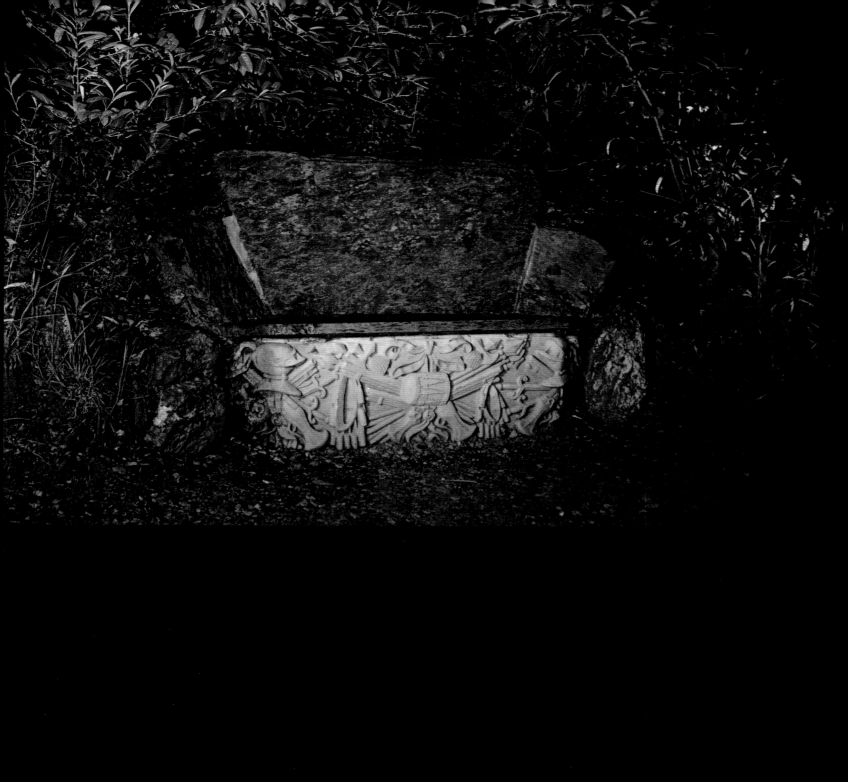

ABOVE: Trophy Seat

OPPOSITE: The Great Cascade

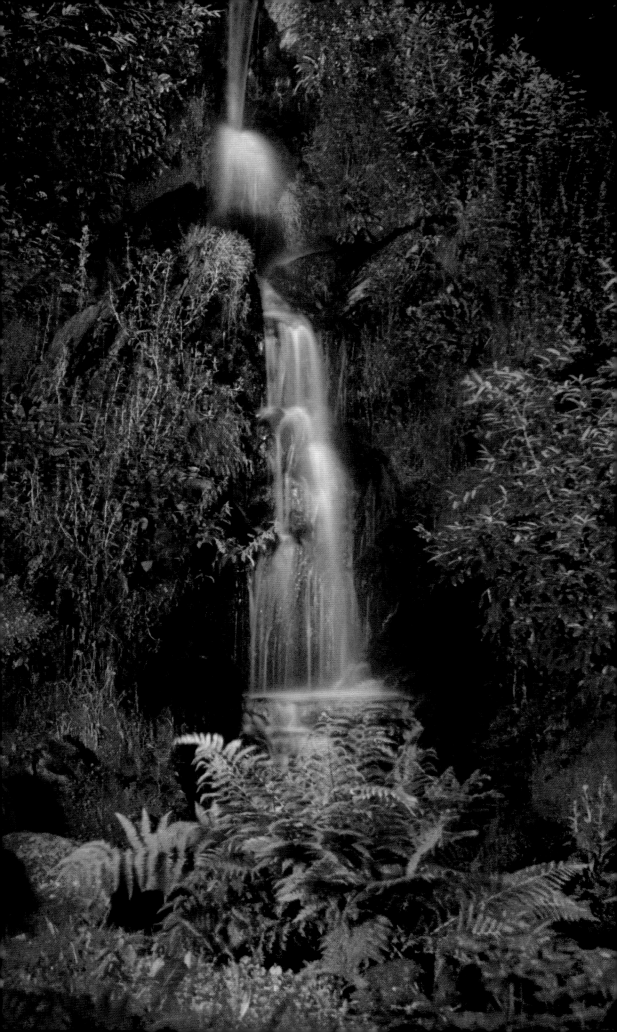

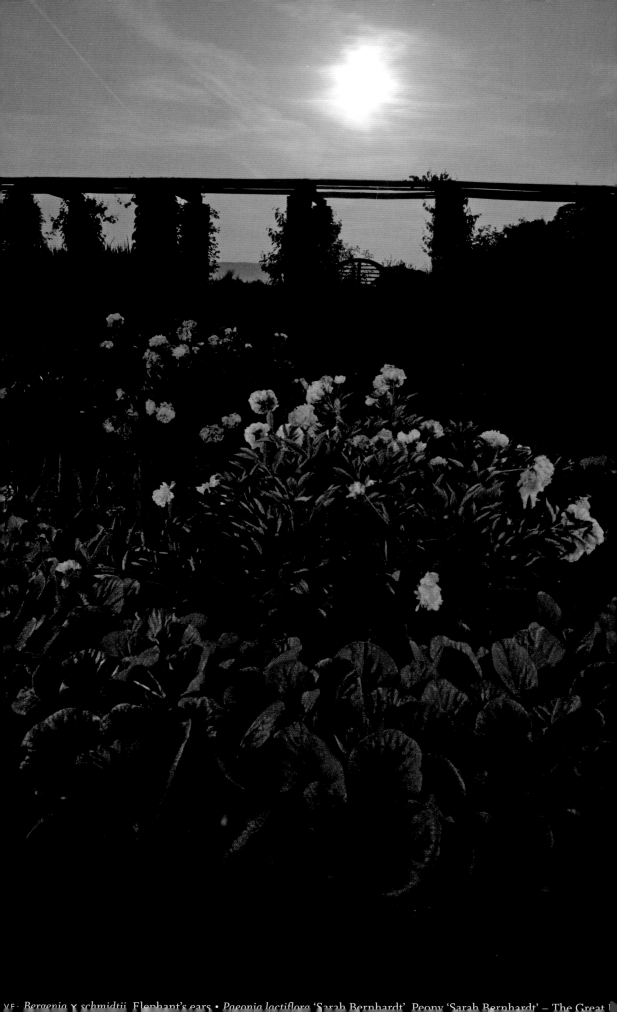

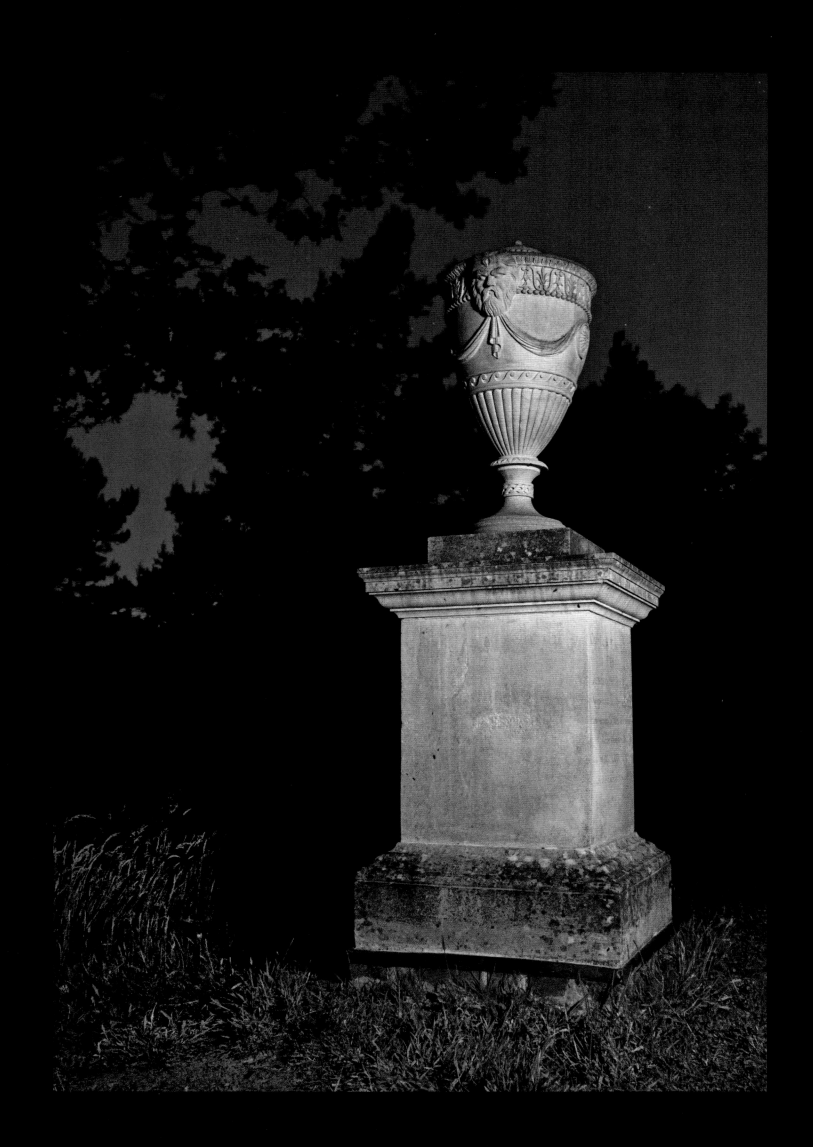

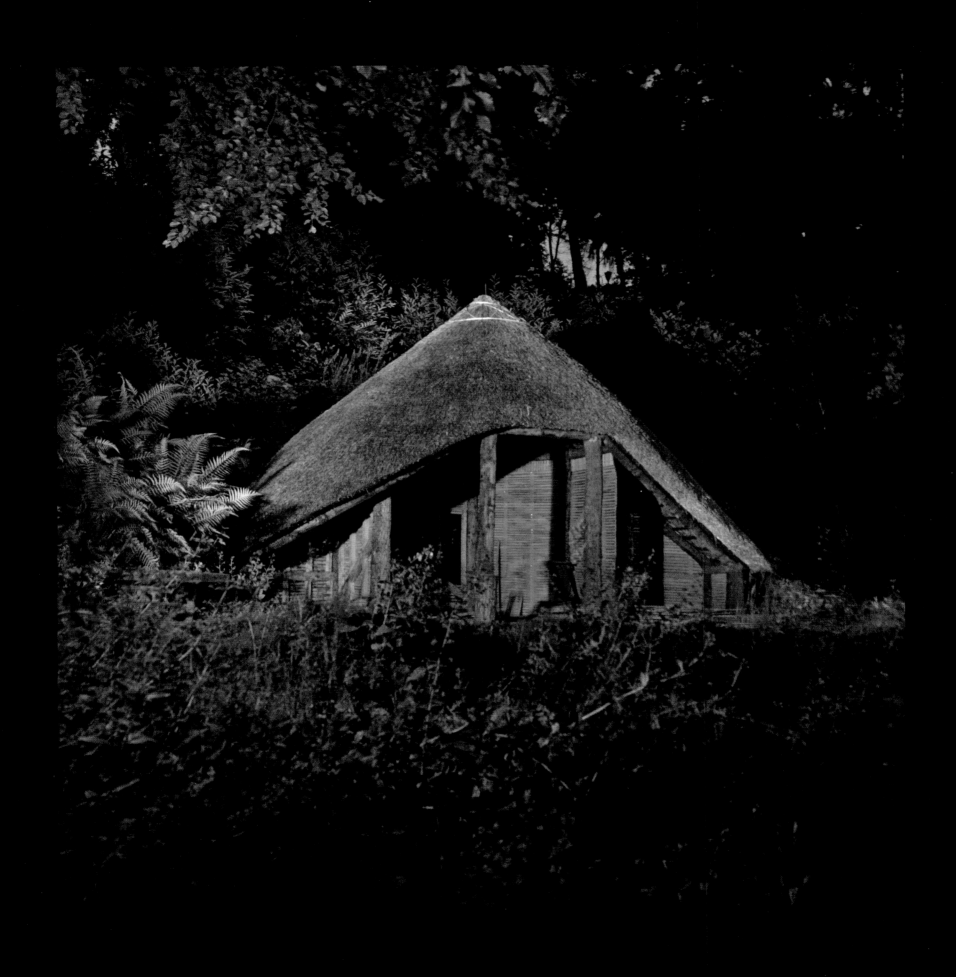

ABOVE: The Witch House
OPPOSITE: Wooden snake and rustic furniture – The Witch House

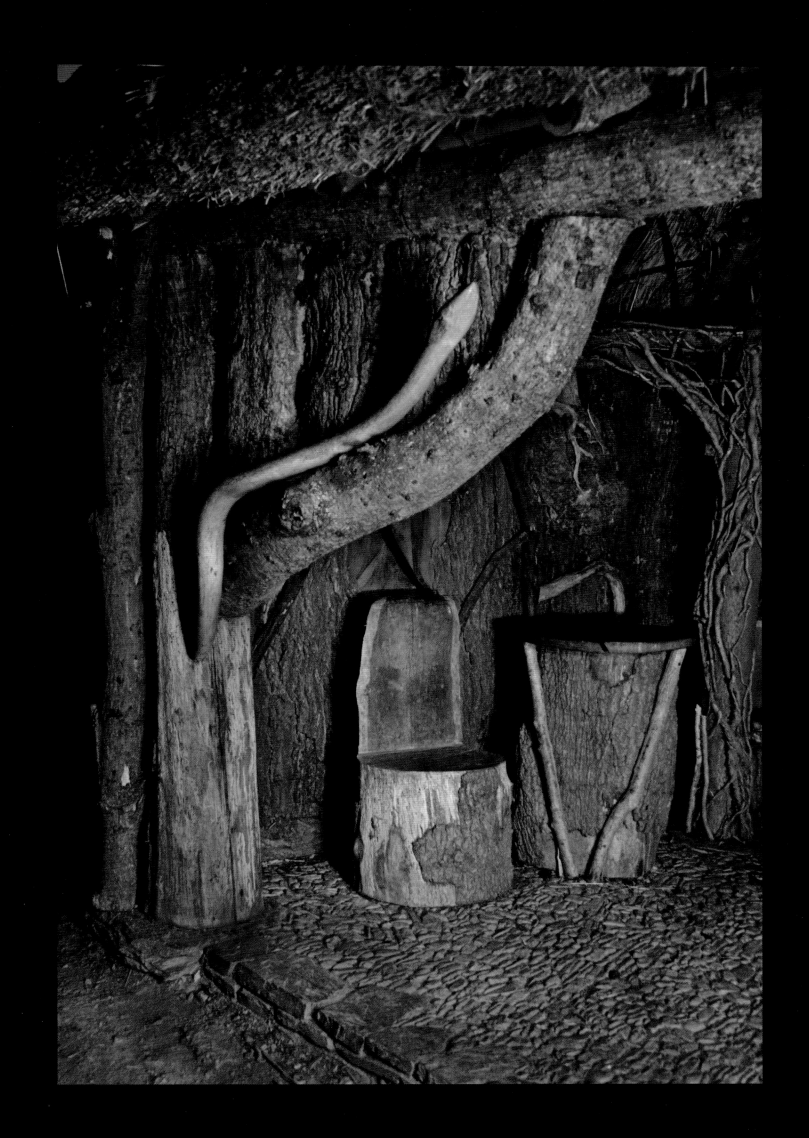

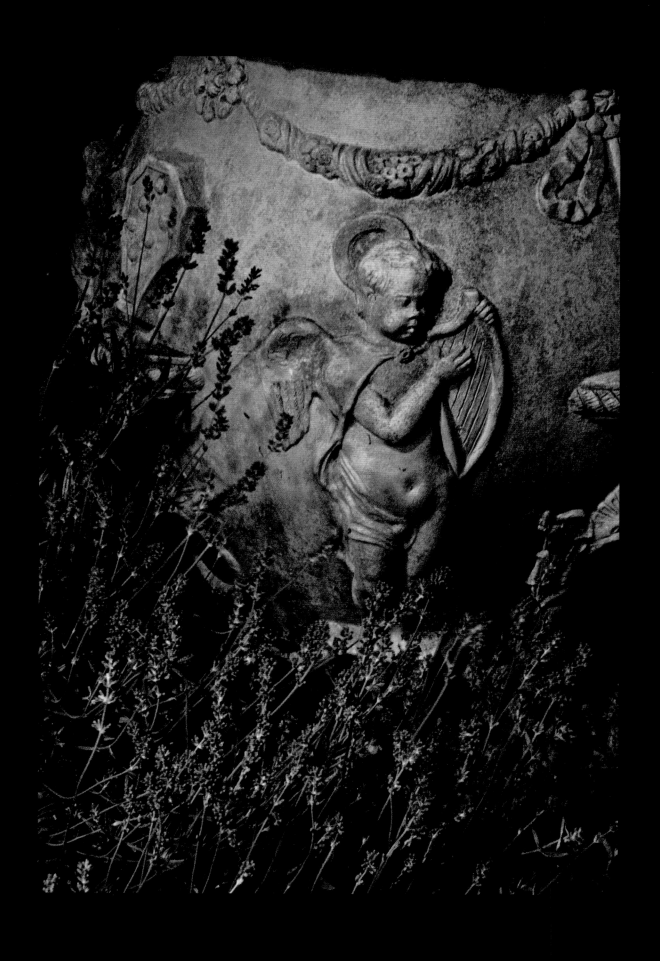

ABOVE: Urn and *Lavandula angustifolia* 'Munstead' Munstead lavender – The Dutch Garden
OPPOSITE: *Iris ensata* Japanese water iris – Mask and pool of the fountain, East Rill

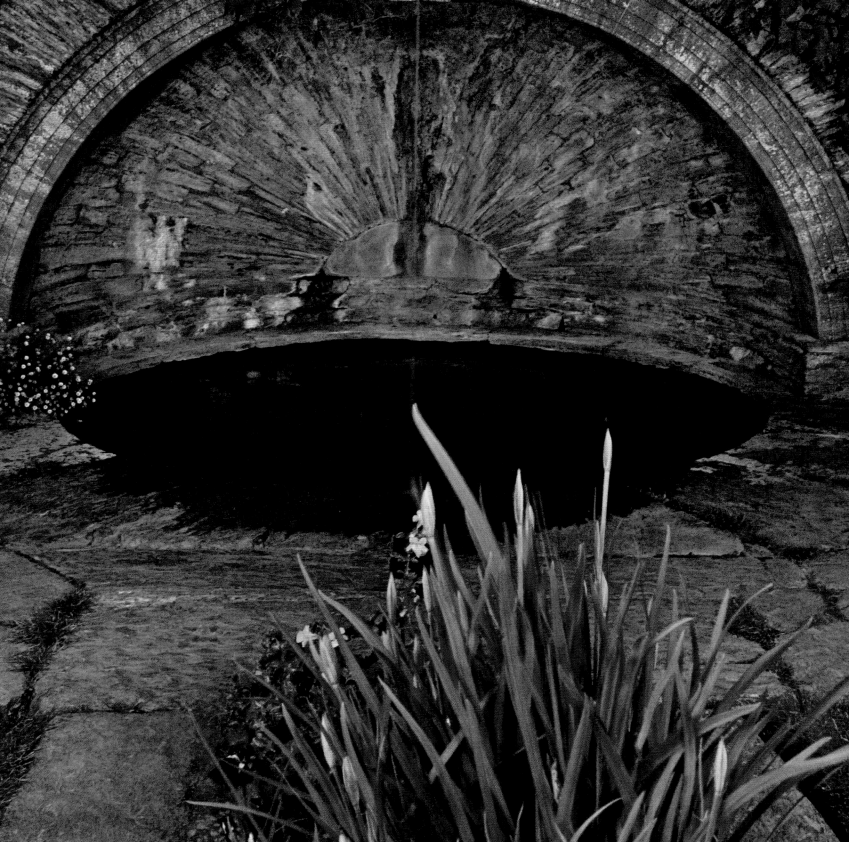

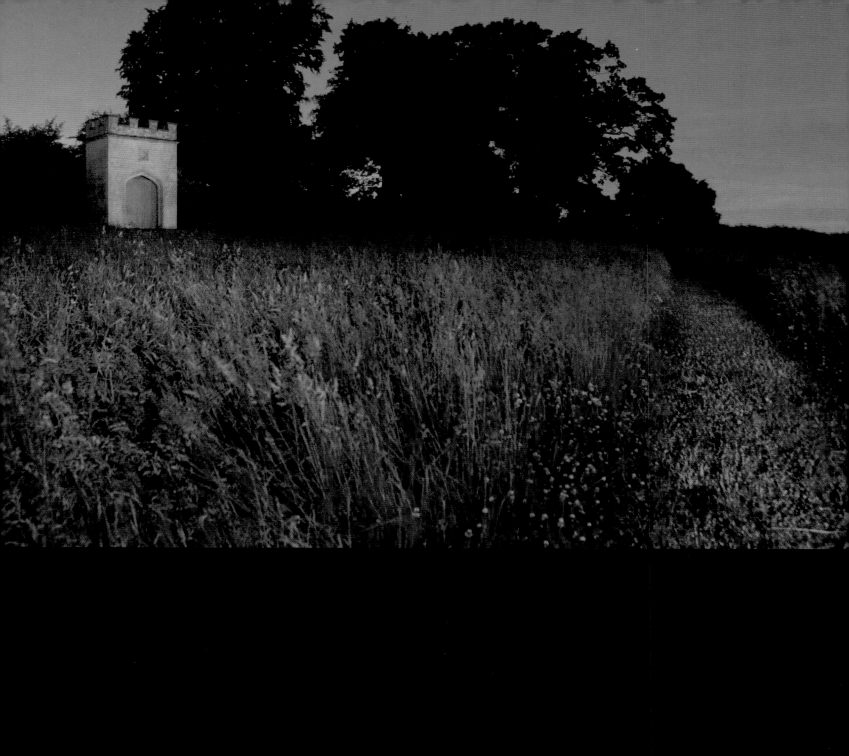

Wildflowers in the shadow of the Gothic tower

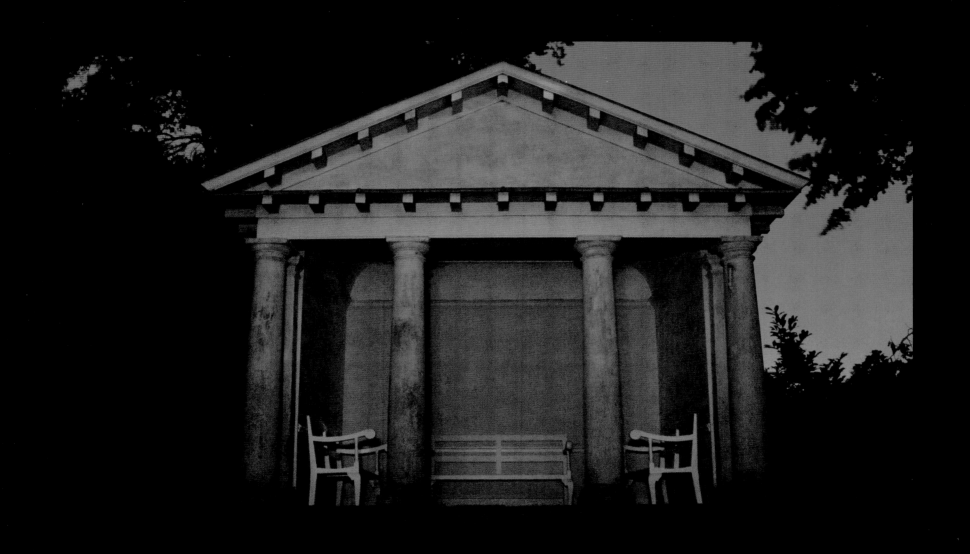

Temple Arbour

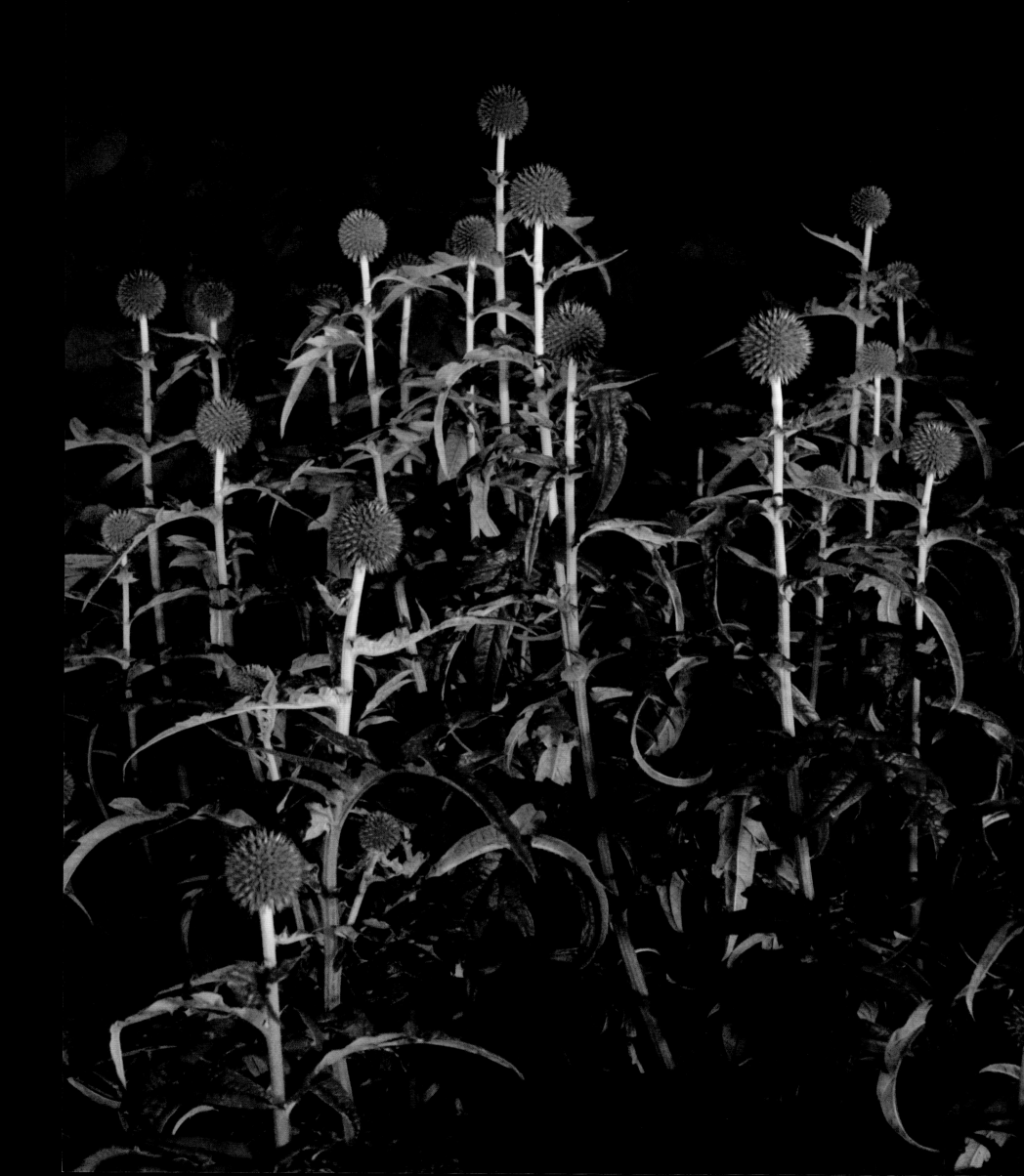

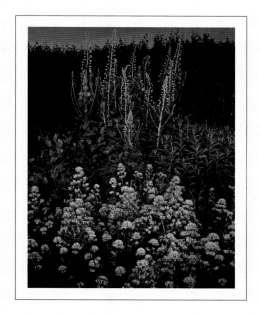

ROYAL HORTICULTURAL SOCIETY GARDEN AT WISLEY
SURREY

JIM GARDINER

THE ROYAL HORTICULTURAL SOCIETY have been responsible for their garden at Wisley since 1903. It is a garden of great diversity, demonstrating the art and craft of gardening and inspiring over 800,000 people to visit the 200-acre site each year.

Among the most appealing horticultural features are the Mixed Borders – two herbaceous borders 125 metres long leading towards our woodland garden on Battleston Hill, with the *Arch* by Henry Moore as its focal point.

Each month sees changes in atmosphere. In January on a bright and sunny morning, the grass crisp with frost, Wisley will reveal the last of the seed heads, adding an architectural quality to the scene. This changes in the early spring, with great activity on the borders – splitting herbaceous plants, forking, staking and mulching in readiness for the glorious displays of summer, when the borders are at their peak. They start with carefully choreographed drifts of colour, cool then hot as the season progresses, full of people and activity during the day but calm and still in the evening.

The special times on Battleston Hill are reserved for the early morning. The south-facing slopes are planted with Mediterranean plants, particularly *Cistus*, whose foliage is strongly scented as you brush past. Battleston also has a diverse range of scented magnolias, with the early-summer-flowering *Magnolia officinalis* var. *biloba* and *Magnolia sinensis* of particular interest.

The Portsmouth Field is where we carry out our Horticultural Plant Trials, where plants are evaluated for the Award of Garden Merit to determine which are the best for garden use. Midsummer is the most spectacular time to visit. Serried ranks of blue delphiniums vie for attention with sweet peas, irises or brightly coloured annuals.

Moving west through redwoods you arrive at the Jubilee Arboretum, with a twin avenue of *Tilia tomentosa* and *Prunus* 'Pandora'. Over 1,000 taxa of primarily deciduous trees are of interest throughout the year, for their stems, flower, fruit or leaf. Spring and autumn are the best times to visit, as for the Fruit Field. Over 700 varieties of apple form the backbone of the collection, which in May is full of blossom and in September full of fruit. Fruit is carefully gathered and displayed during our 'Taste of Autumn' show in October, when it can be tasted and also bought to appreciate the various flavours.

The shortening of the days and the cooler nights bring the last bright rays of colour before winter sets in. On Seven Acres, *Nyssa sylvatica* 'Wisley Bonfire' provides vibrant reds for a short period, while the *Liquidambar styraciflua* provides two months of colour.

The Rock Garden was constructed in 1910 by James Pulham and Son. It is on a significant scale and was built of sandstone. Pools and waterfalls are linked by streams, which eventually flow into the Long Ponds. Spring and early summer have the greatest diversity of colour. The Alpine Display House contains alpines in flower every day of the year. It also has one of the best views of the garden, with the Wild Garden and Alpine Meadow stretching out in front of you. The Glasshouse, opened by Her Majesty the Queen in June 2007, can also be seen from this spot.

The curvilinear structure is beautifully reflected in the Horseshoe Lake, especially during the clear, crisp days or evenings in winter. This £8 million project above all has been a real focus for me. It has been a huge team effort, with all staff involved to ensure its plant collections and the landscape in which it sits have been beautifully presented for everyone to see.

Wisley is indeed an inspirational garden. It fills me with a sense of pride when I walk through it, either on my own in the still of the morning or evening, or during the middle of the day when I share it with thousands of happy people who are visiting this magical place.

OPPOSITE: *Echinops bannaticus* Globe thistle – The Mixed Borders
ABOVE: *Delphinium* 'Fanfare' • *Artemisia ludoviciana* 'Valerie Finnis' Wormwood 'Valerie Finnis' – The Mixed Borders

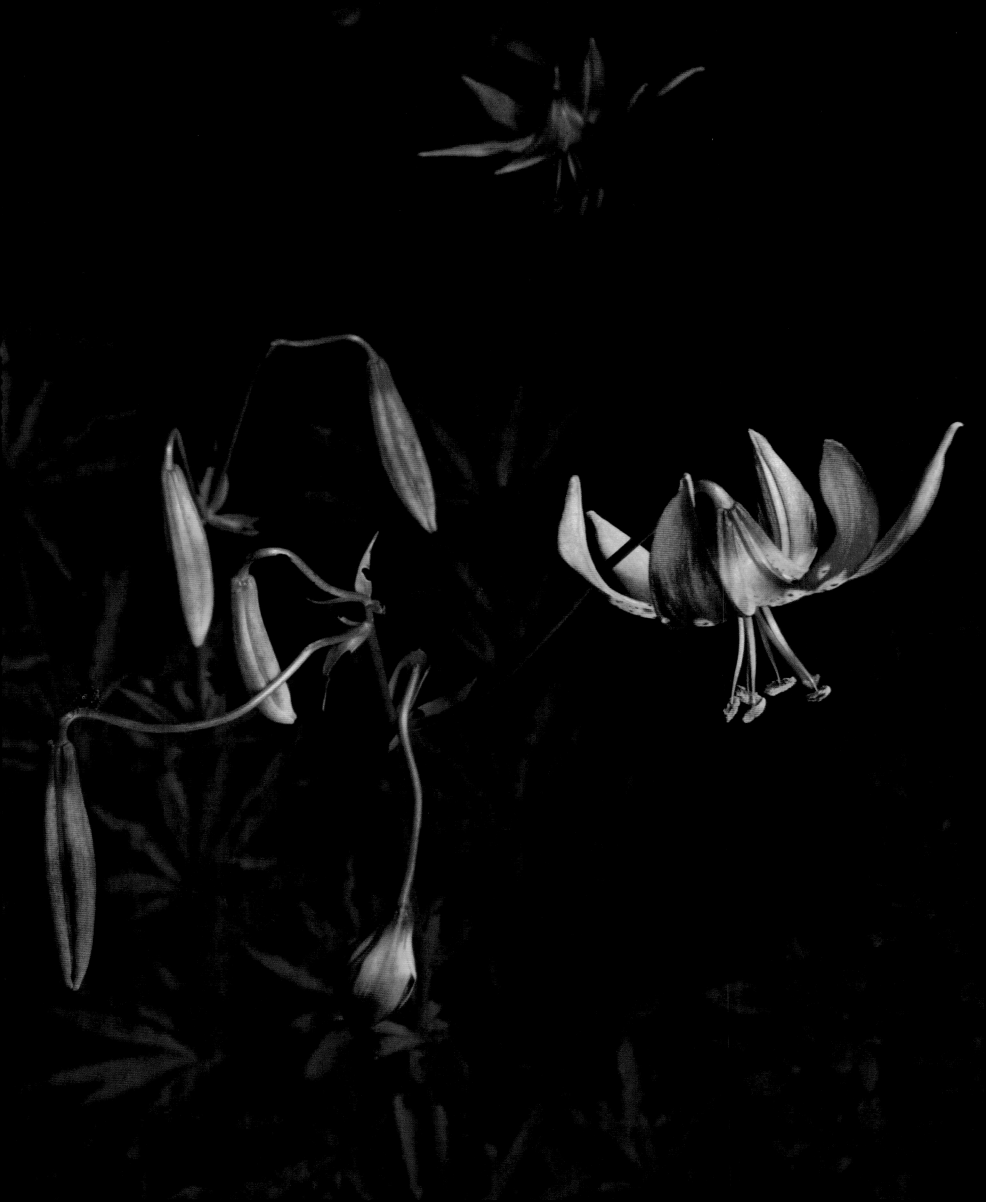

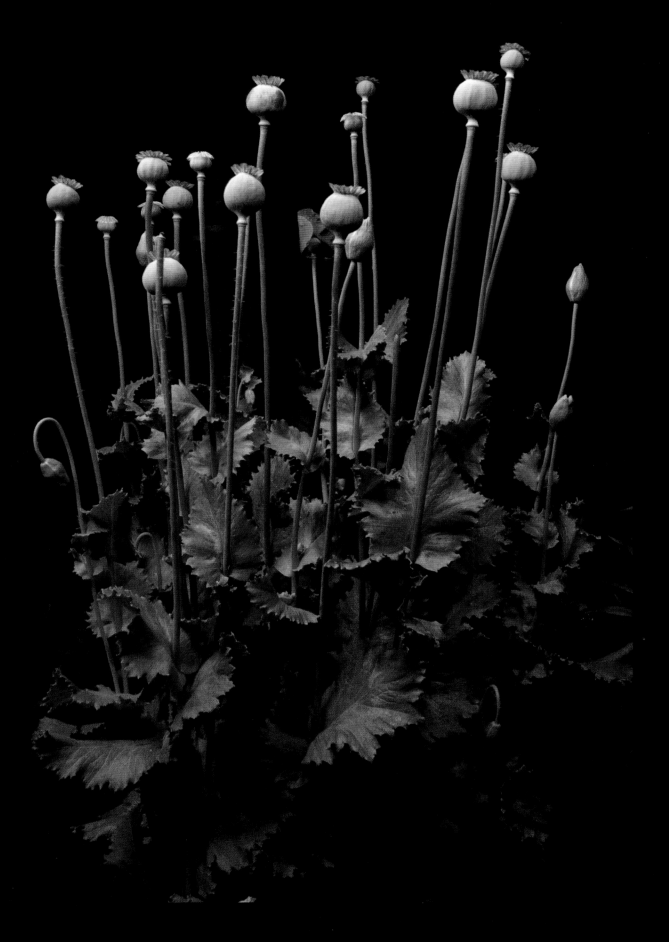

OPPOSITE: *Lilium* 'Silk Road' Silk Road lily – Battleston Hill
ABOVE: *Papaver orientale* Oriental poppy – Battleston Hill

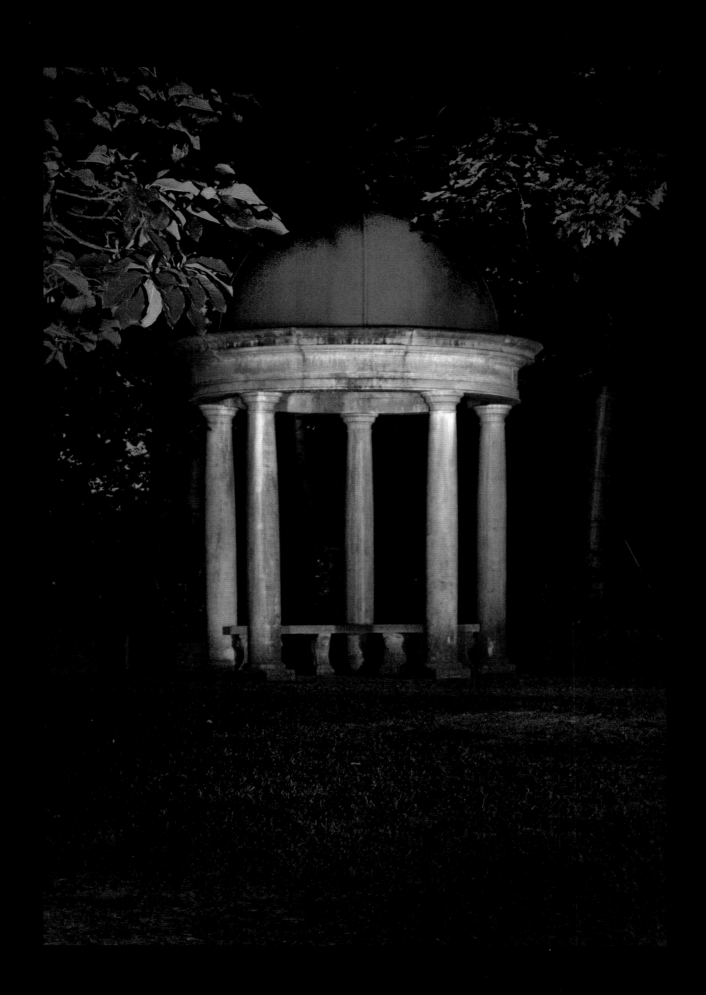

ABOVE: Doric Temple on Battleston Hill

OPPOSITE: *Yucca gloriosa* 'Variegata' Spanish dagger – The Monocot Borders

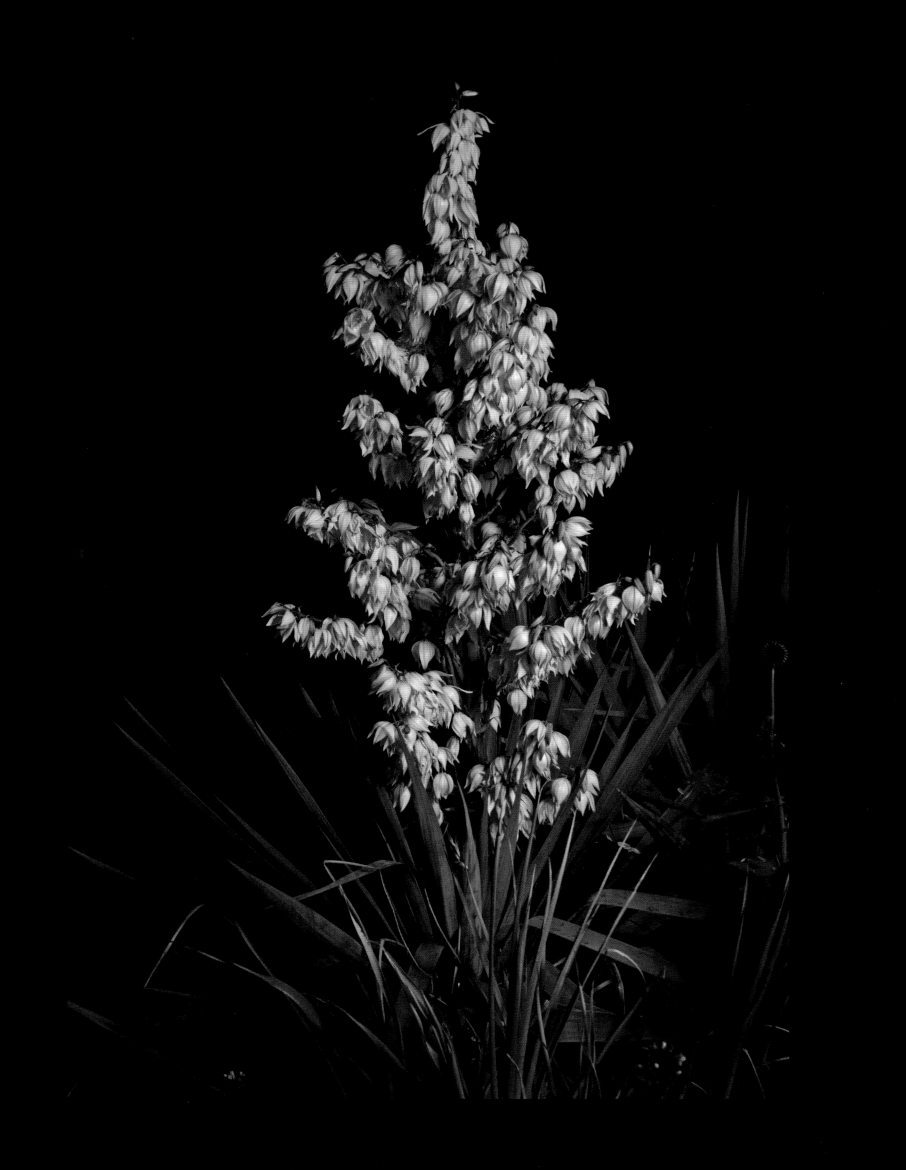

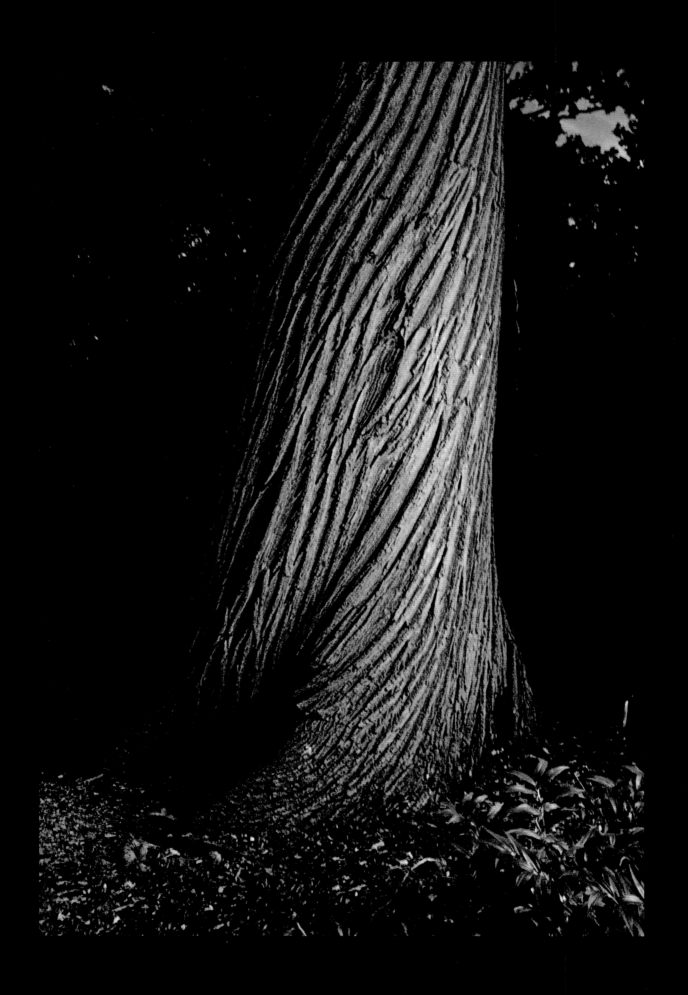

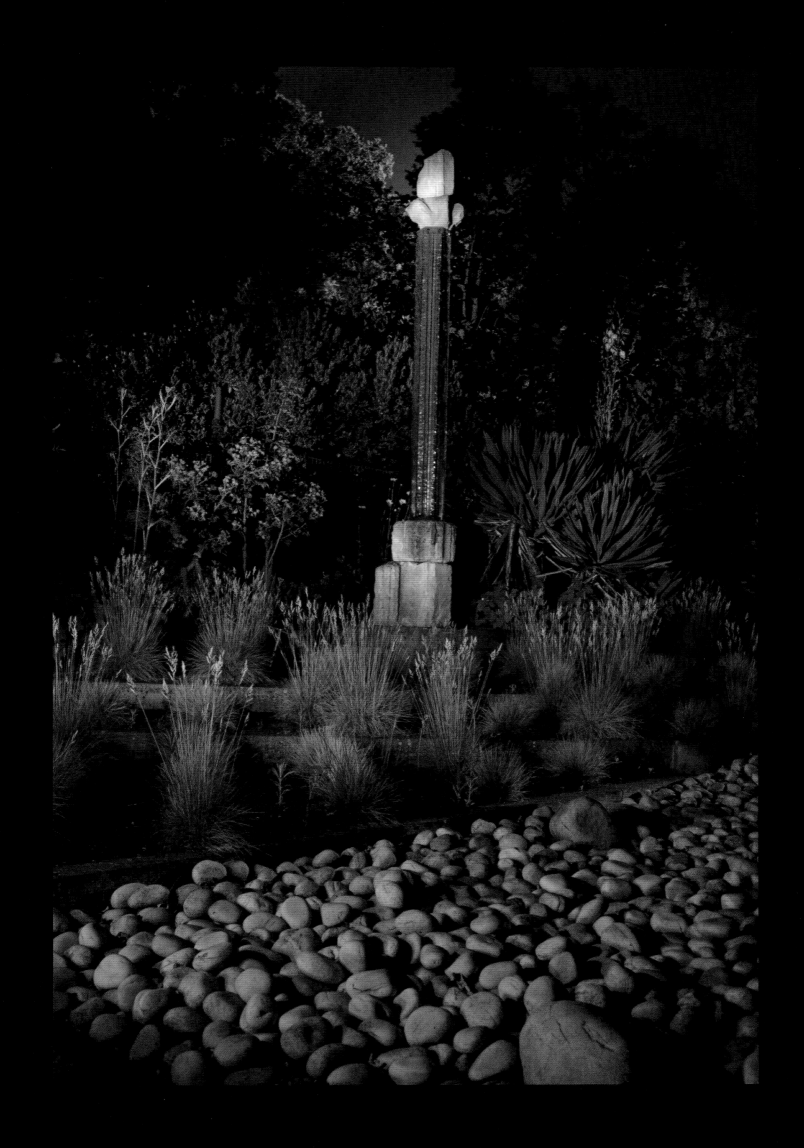

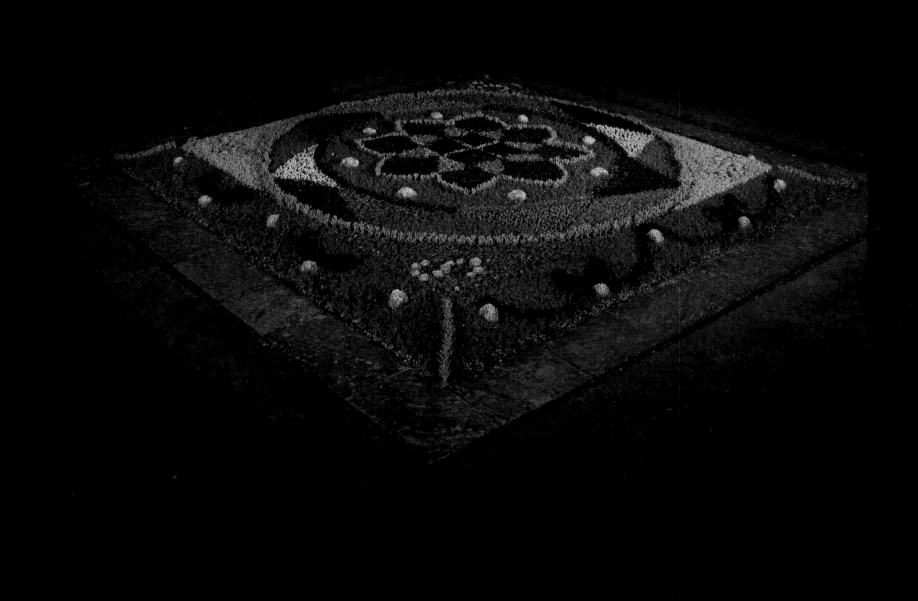

ABOVE: Carpet bedding

OPPOSITE: *Crassula coccinea* Stonecrop – The Alpine House

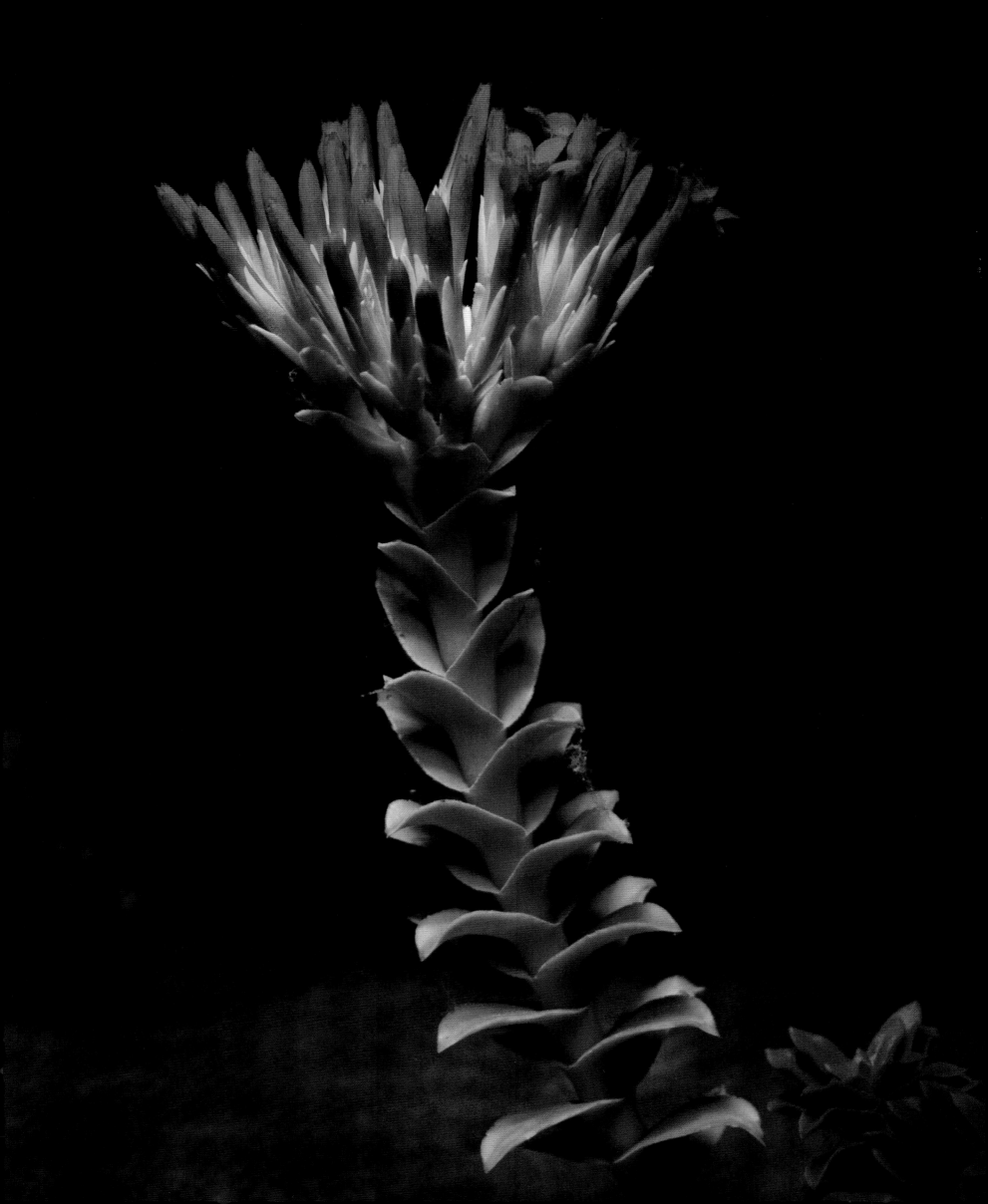

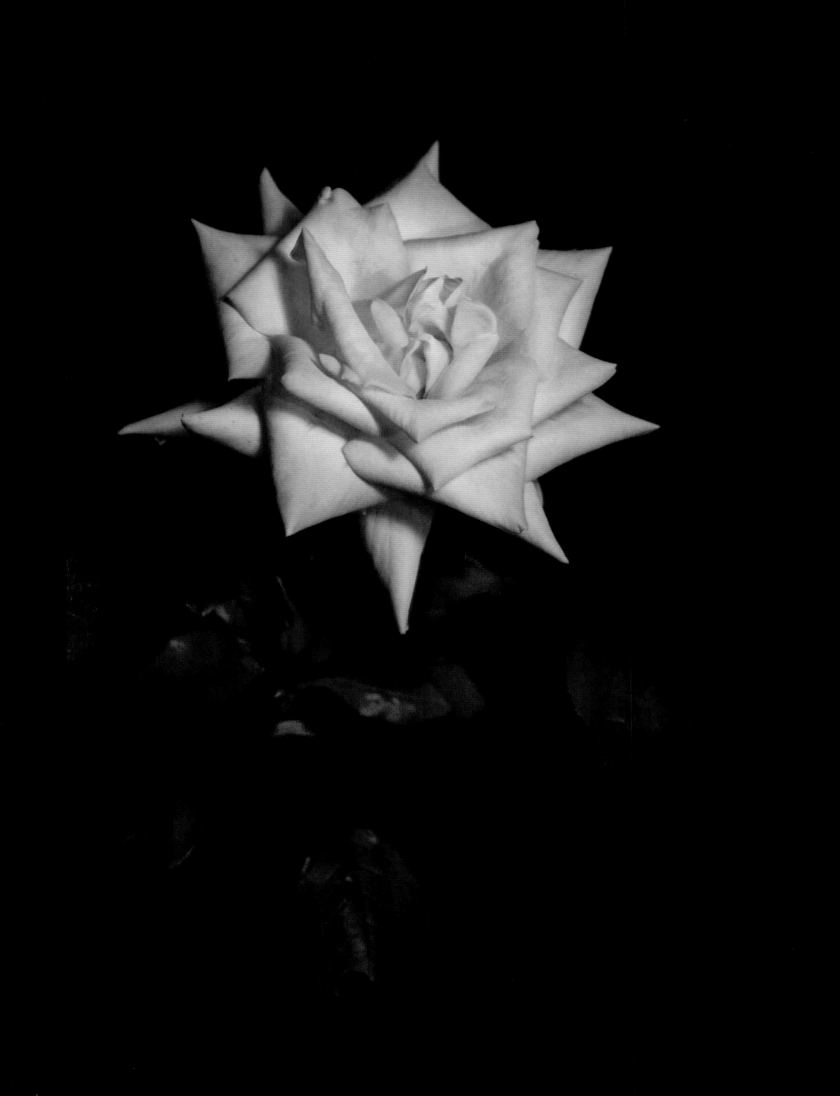

OPPOSITE: A rose
ABOVE: The Fruit Demonstration Garden

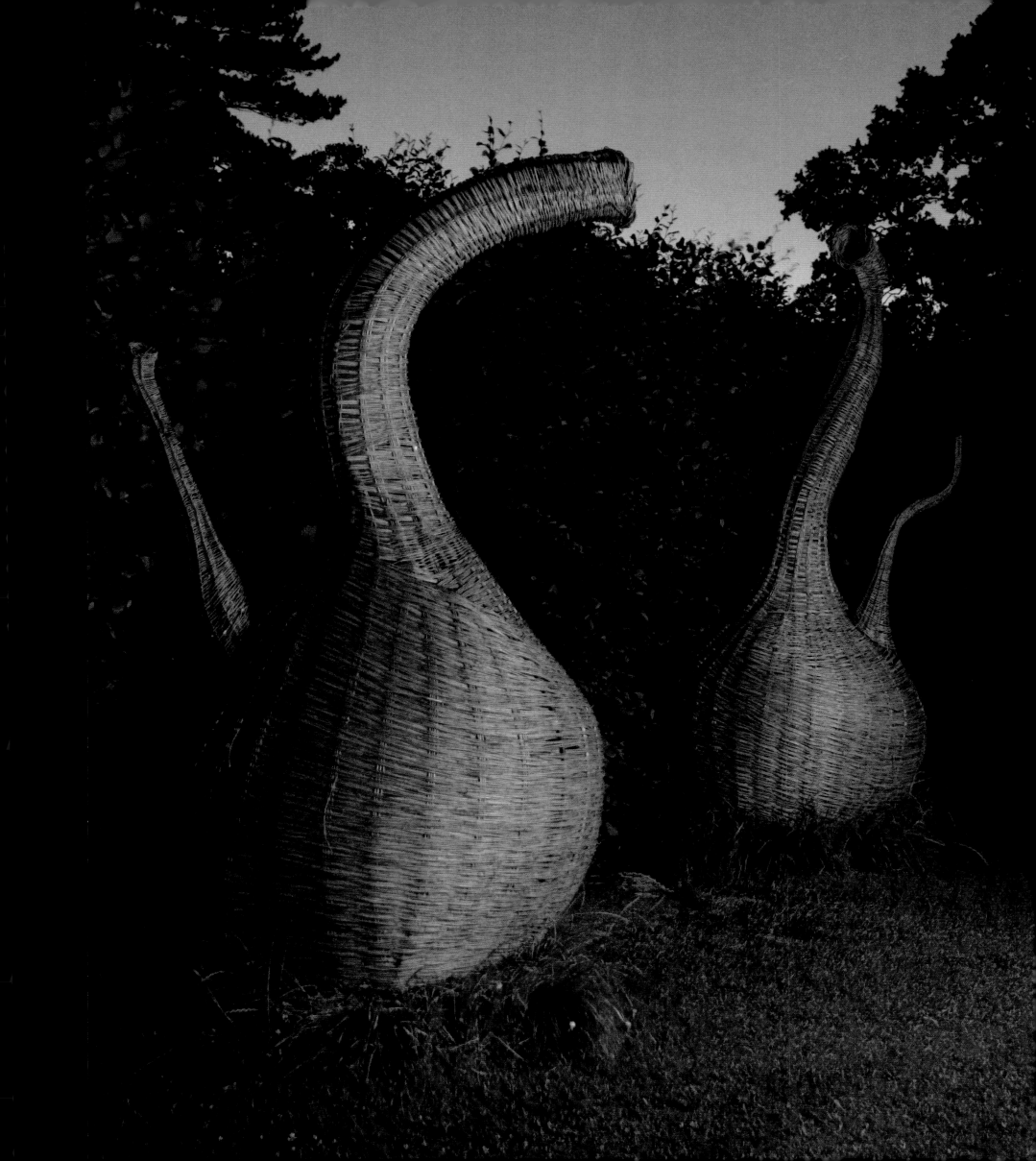

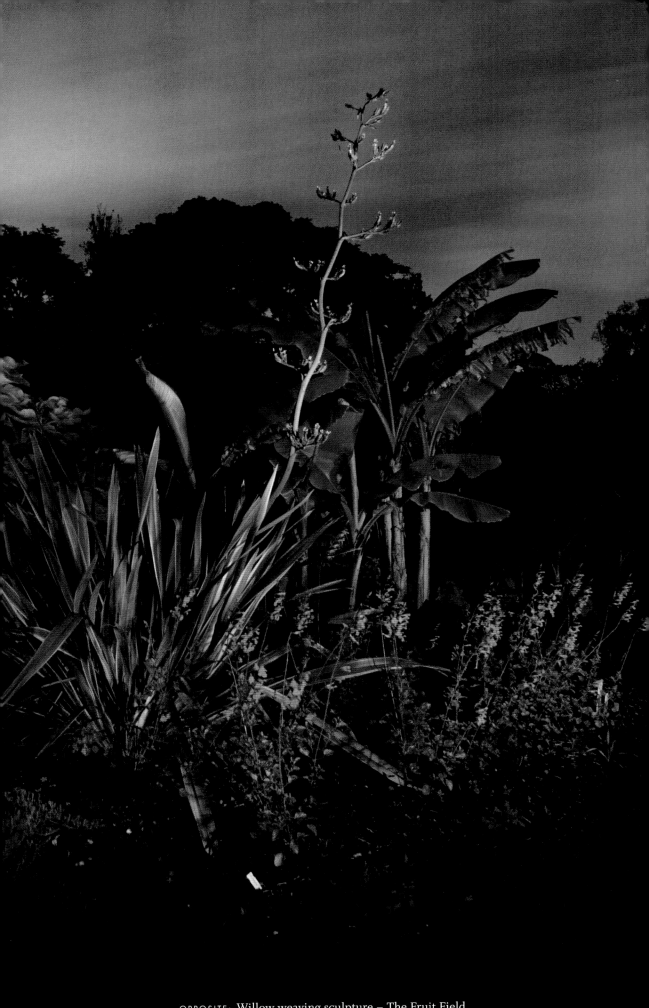

OPPOSITE: Willow weaving sculpture – The Fruit Field

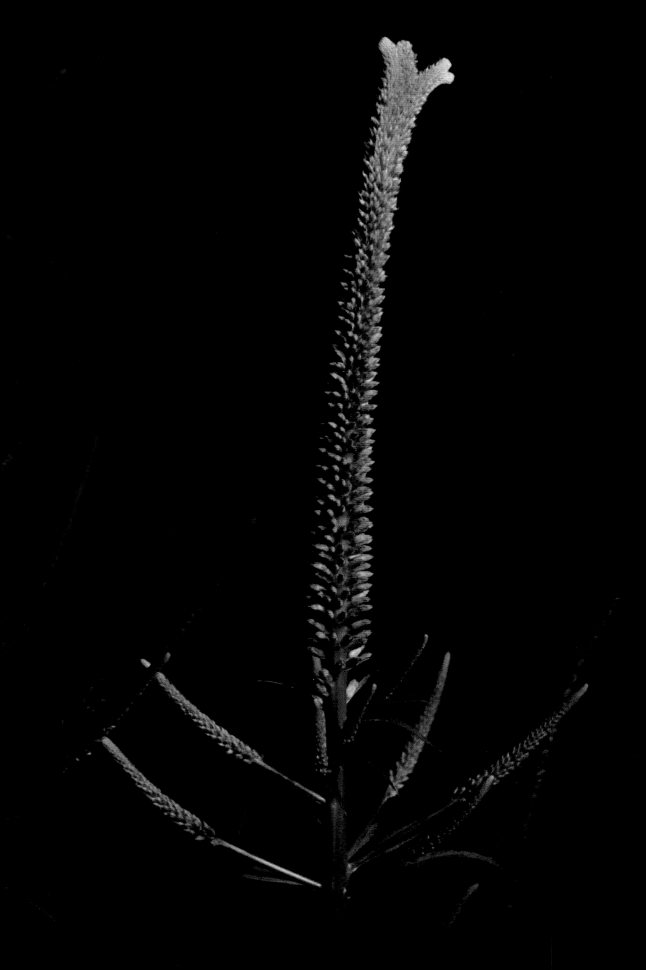

ABOVE: *Veronicastrum virginicum* 'Fascination' Culver's root – The Wild Garden

OPPOSITE: The Alpine Meadow

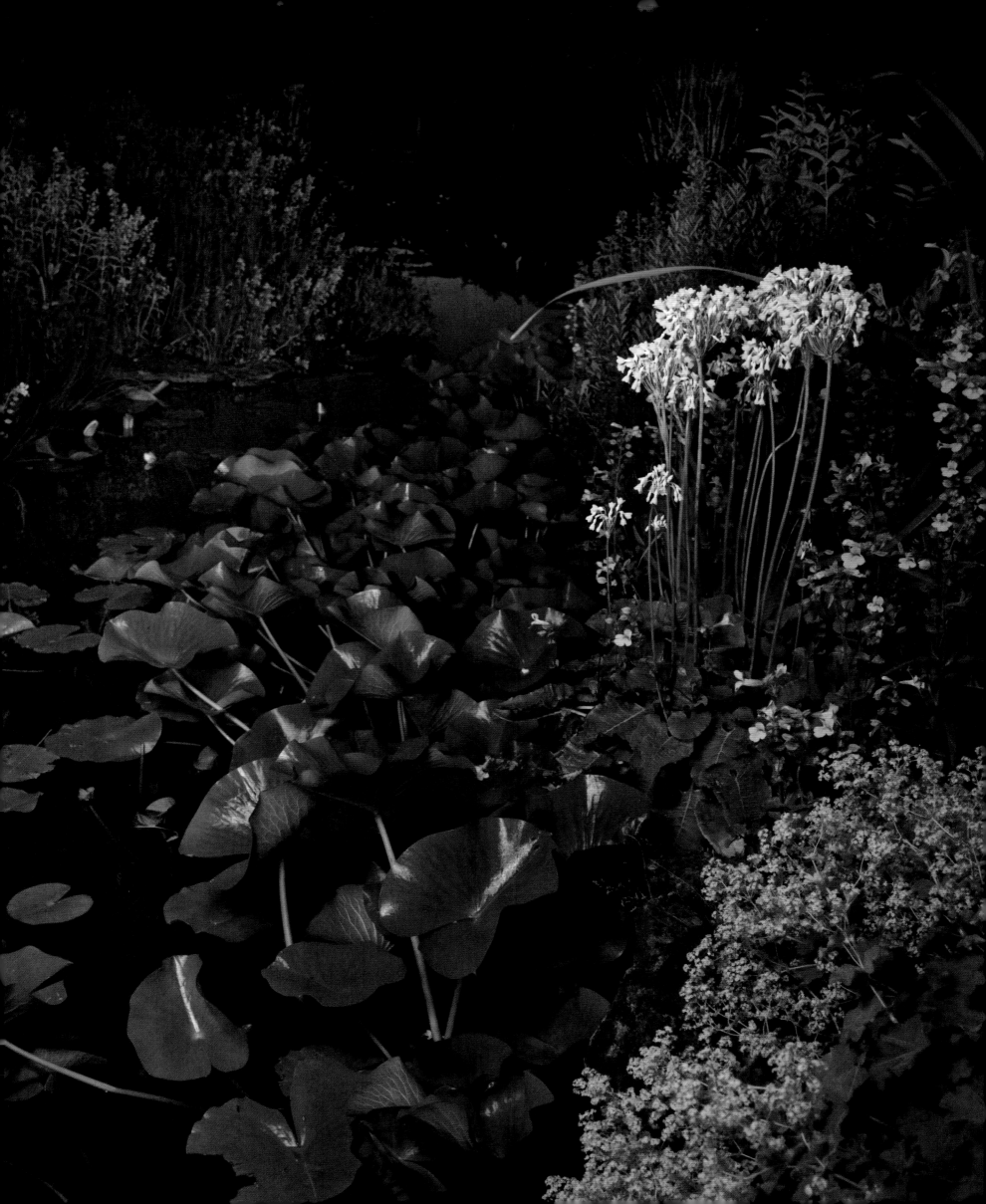

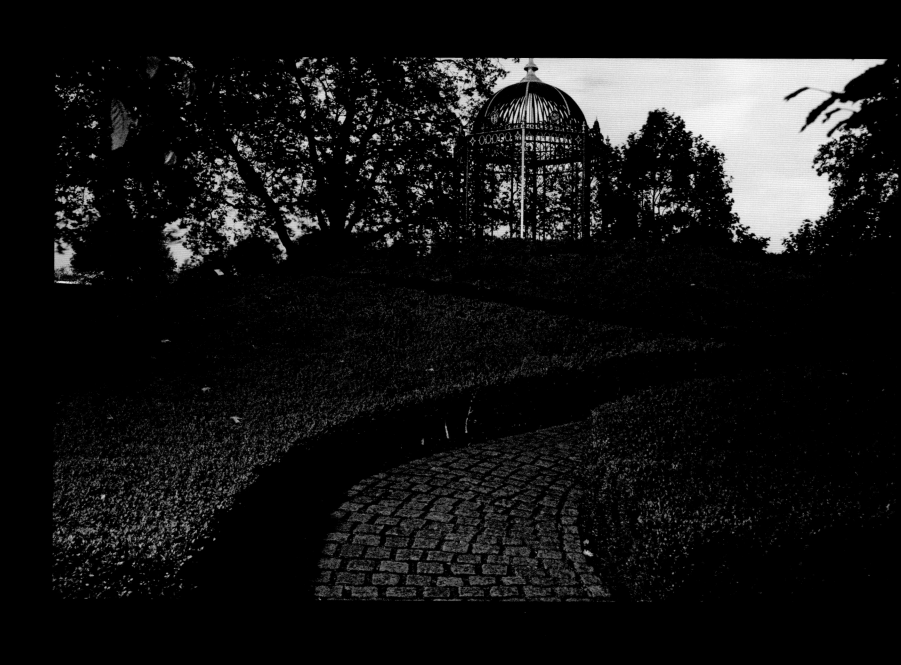

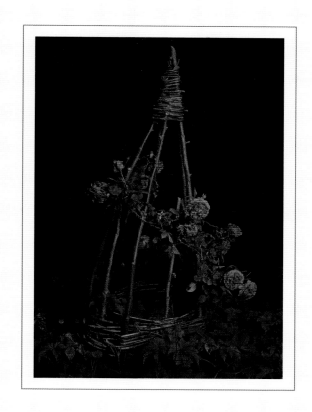

ROYAL BOTANIC GARDENS, KEW
SURREY

CHRISTINA HARRISON

'How sweet and soothing is this hour of calm!' Lord Byron wrote of the 'benign and quiet influence' of the night. Such words seem perfectly to describe the classical landscape of the Royal Botanic Gardens, Kew, at night. Gone are the crowds, ever-present during daylight hours, gone are the busy gardeners, tour guides and shop assistants, and instead a cloak of calm and peace slowly settles over the gardens as the light fades. Now is the time when the gardens can rest; with nothing to prove they can simply be themselves.

Kew is a dark oasis amid the glare of west London. The only lights to guide you here are the eerily illuminated trees, which stand like living candles lighting the main path to the Palm House – Kew's architectural heart. Their strikingly lit shapes make you feel as if you were walking through an enchanted forest, which is a delightful experience at the end of a long day. There is plenty of life here too: wildlife has the run of these 300 acres in the hours of darkness, and being startled by a badger is not an uncommon experience for those seeking the exit on their way home from work. Indeed it's hard to know who is usually the more taken aback, as you stare into their eyes for that all too brief moment and then they turn tail into the gloom, continuing their mission for worms and other delicacies.

One of the most entrancing places in the twilight hours is the Grass Garden, where moonlight silvers the feathery seed heads of a myriad different, delicate grass species. This is a place where you can use all your senses to appreciate plants: the scent of the earth, the constant whisper of leaves, and the velvety feel of freshly mown lawn all call to you more once the light dims. The last dusky shades of sunset are visible through the large panes of the nearby Davies Alpine House, while sentinel-like pines frame the Turneresque sky. It is a joy to discover familiar places anew as secret midnight gardens.

From evening into the deep hours of darkness the landscape seems to breathe a sigh of relief and settle back into itself; it becomes the landscape of royals, plant-hunters, and dreamers again. History is all around you: Victorian glasshouses loom against the sky, fountains can be heard in all their glory, and trees from around the world have the quiet in which to tell you their stories. The great vistas stretch into long dark tunnels of rustling leaves with only glimmers of distant views. The thousands of plants here are no longer the backdrop to a tourist's day out: they stand tall for their original purpose, brought here to be studied in the name of plant conservation as a wonder in themselves. It is a privilege to absorb the genius of this place at such a special hour, when detail disappears and form takes over. Savouring a great national institution on your own can be an inspiring experience, especially when it is the most bio-diverse postcode in Britain!

OPPOSITE: The Queen's Garden
ABOVE: A rose in the Secluded Garden

75

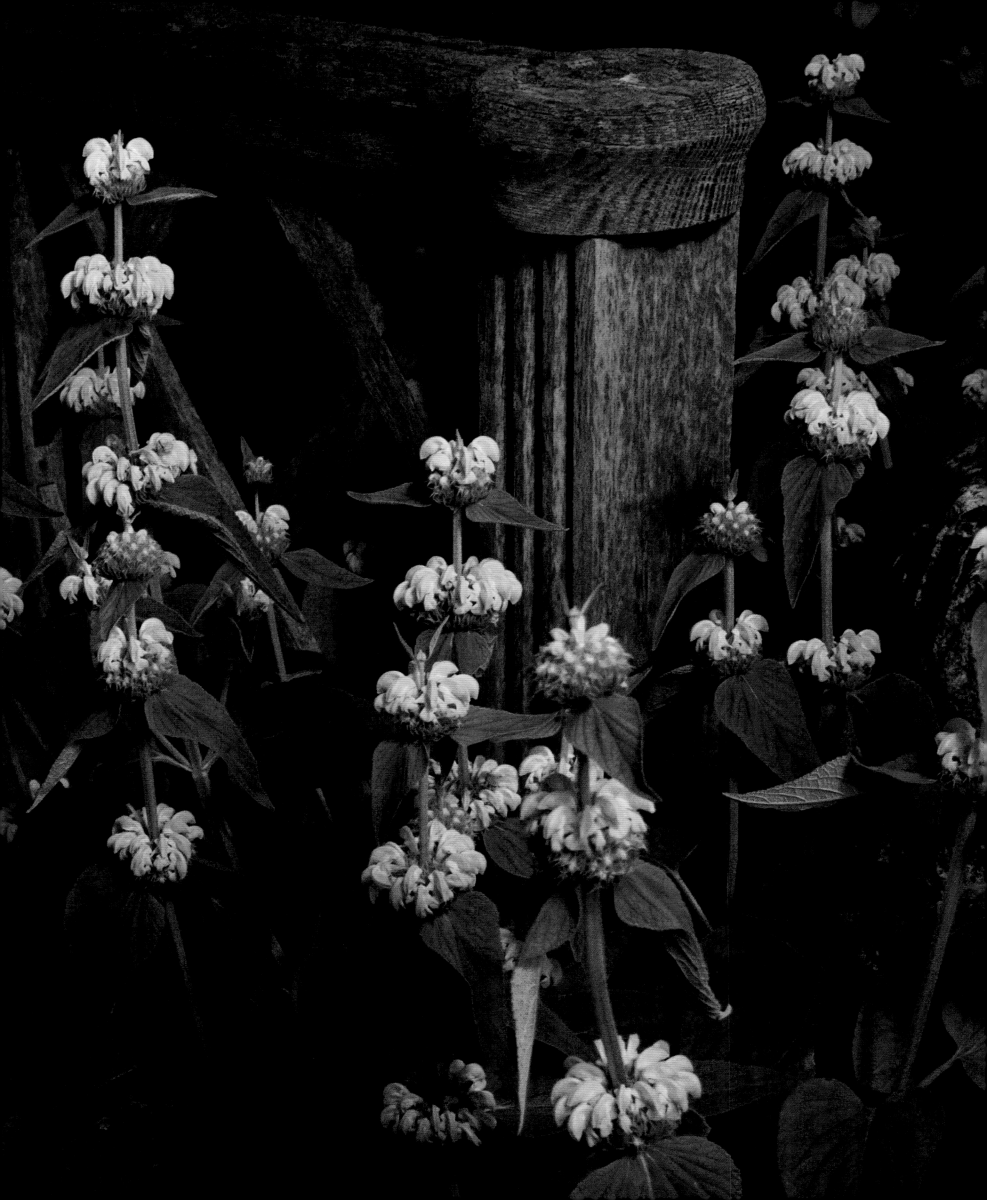

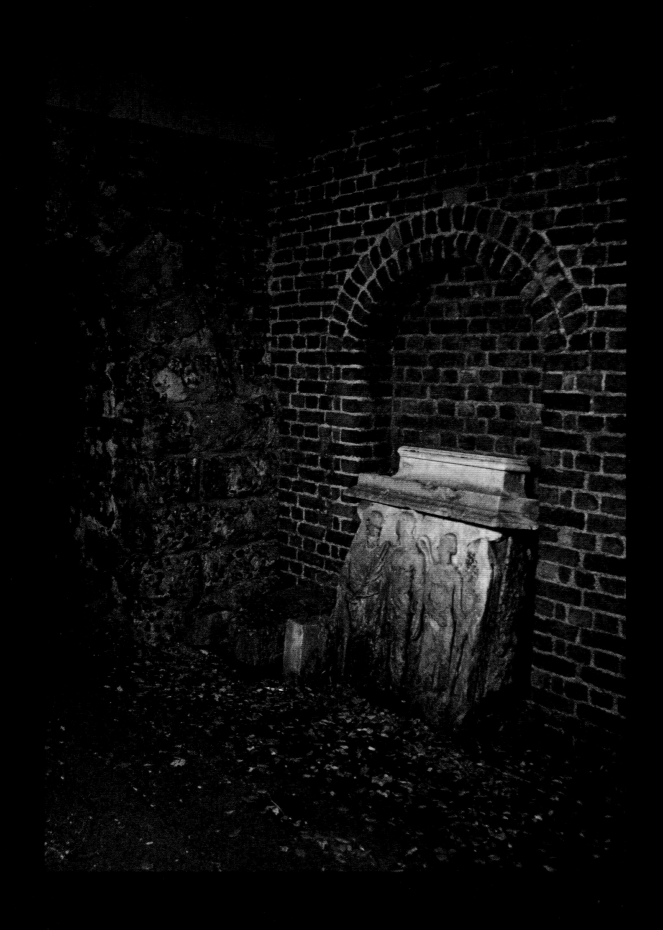

OPPOSITE: *Phlomis leonurus* Lion's-tail phlomis – The Secluded Garden
ABOVE: The Ruined Arch

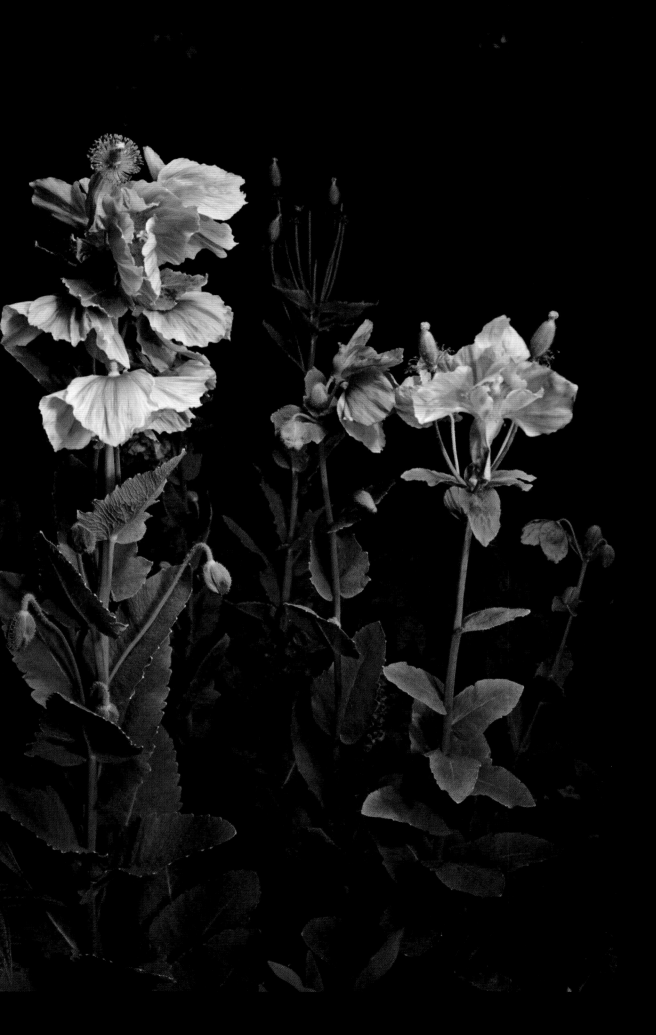

ABOVE: *Meconopsis* Blue poppy – The Woodland Garden
OPPOSITE: Near Victoria Gate

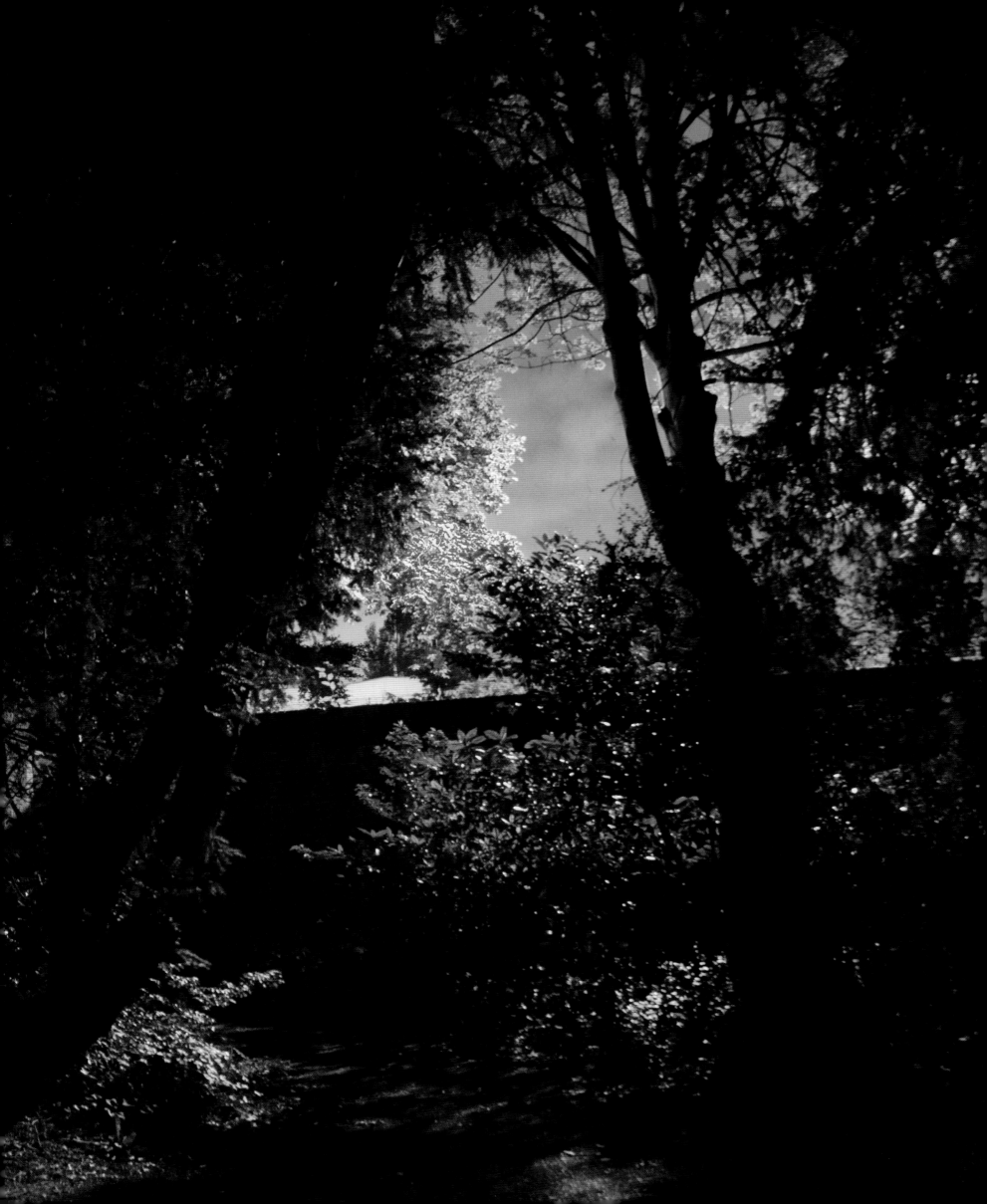

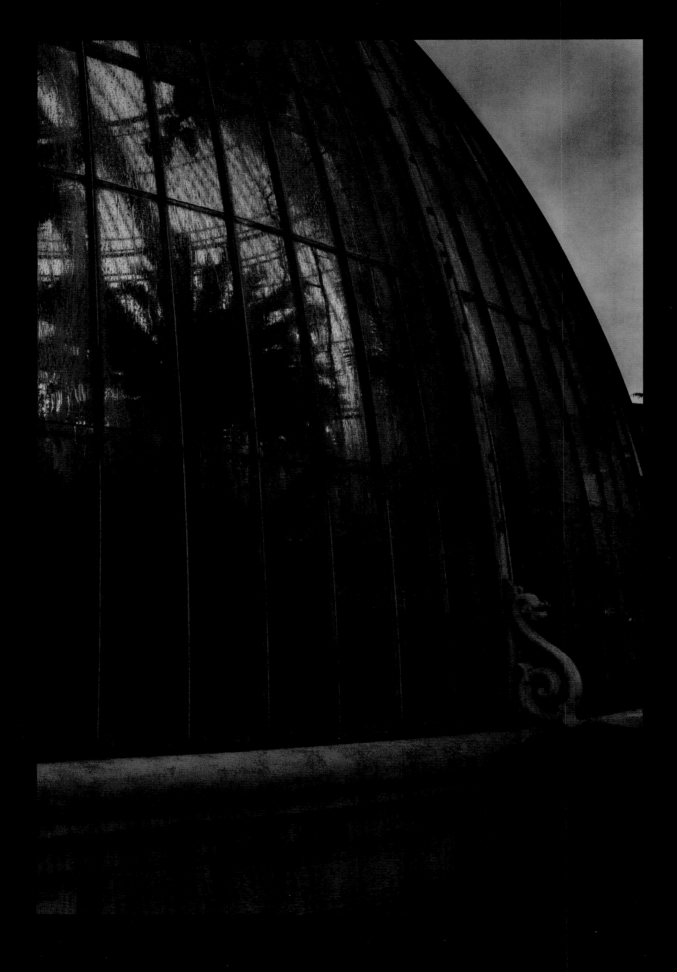

ABOVE: The Palm House
OPPOSITE: Herbarium Gate

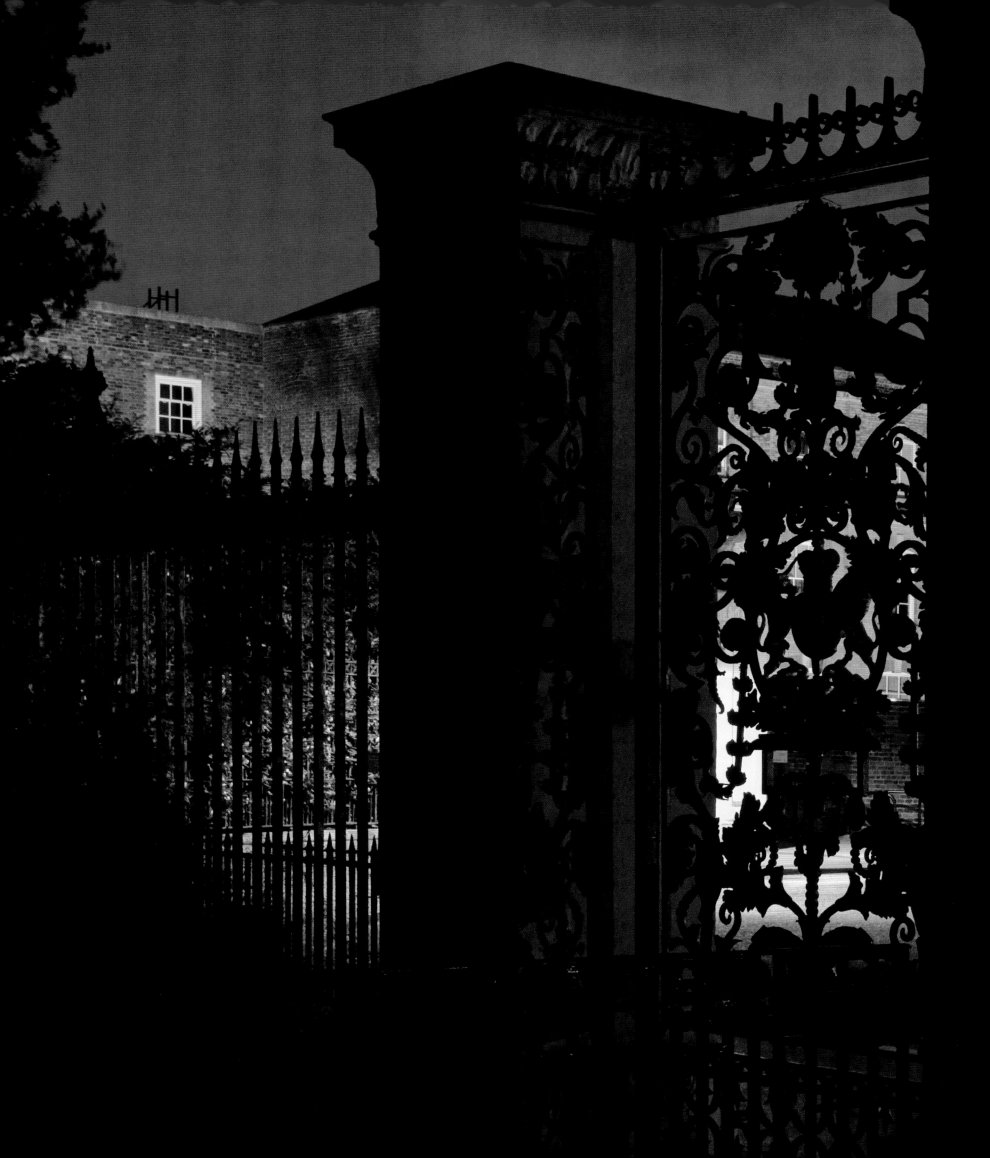

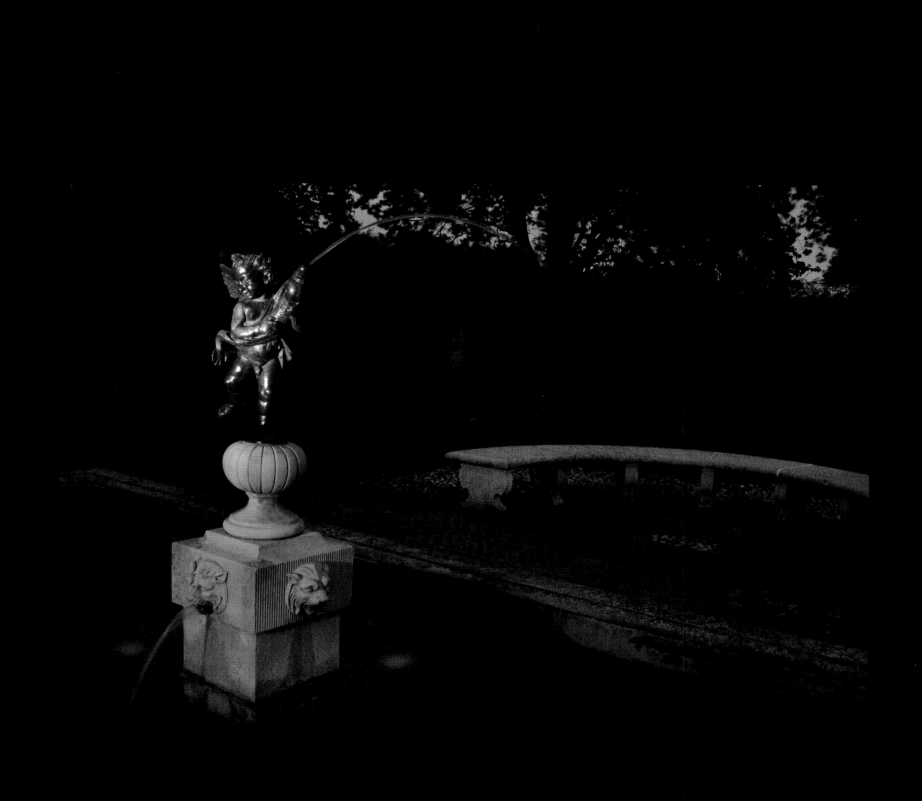

ABOVE AND OPPOSITE: The Queen's Garden

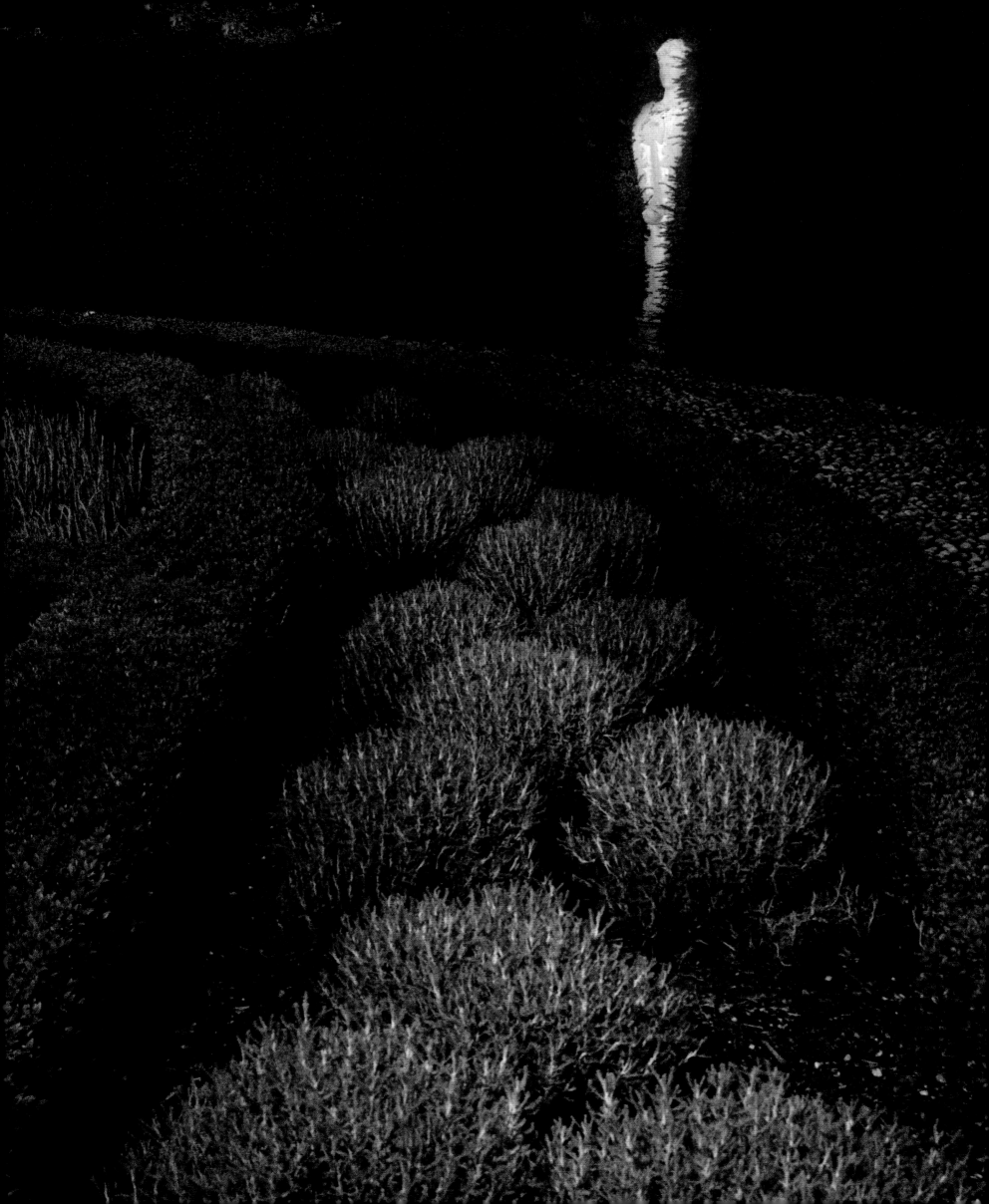

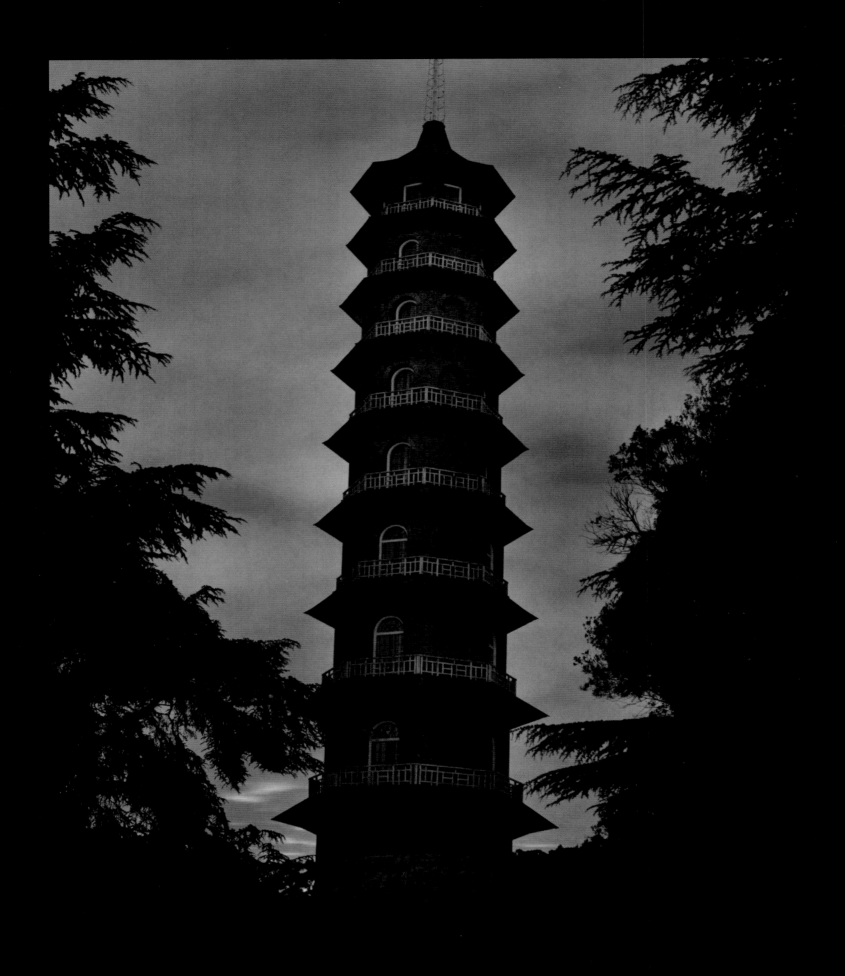

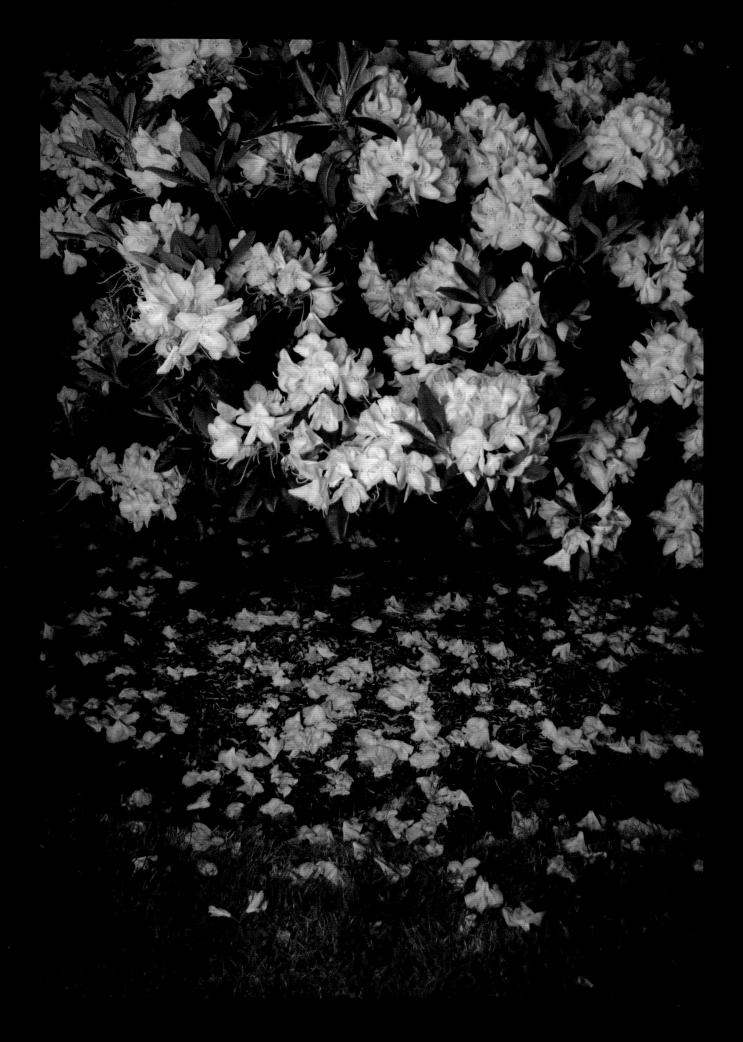

OPPOSITE: The Pagoda
ABOVE: Rhododendron in the Broad Walk

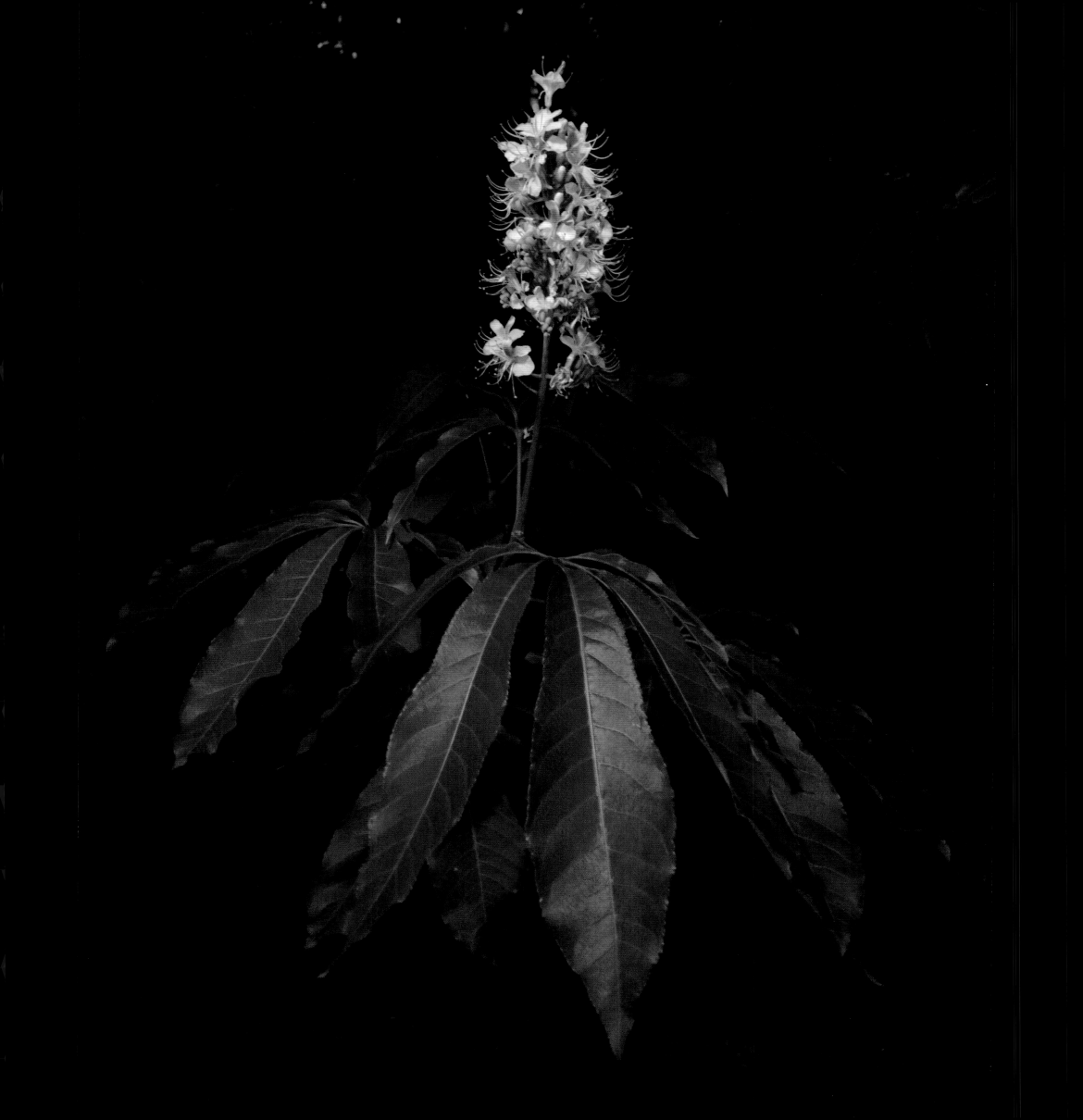

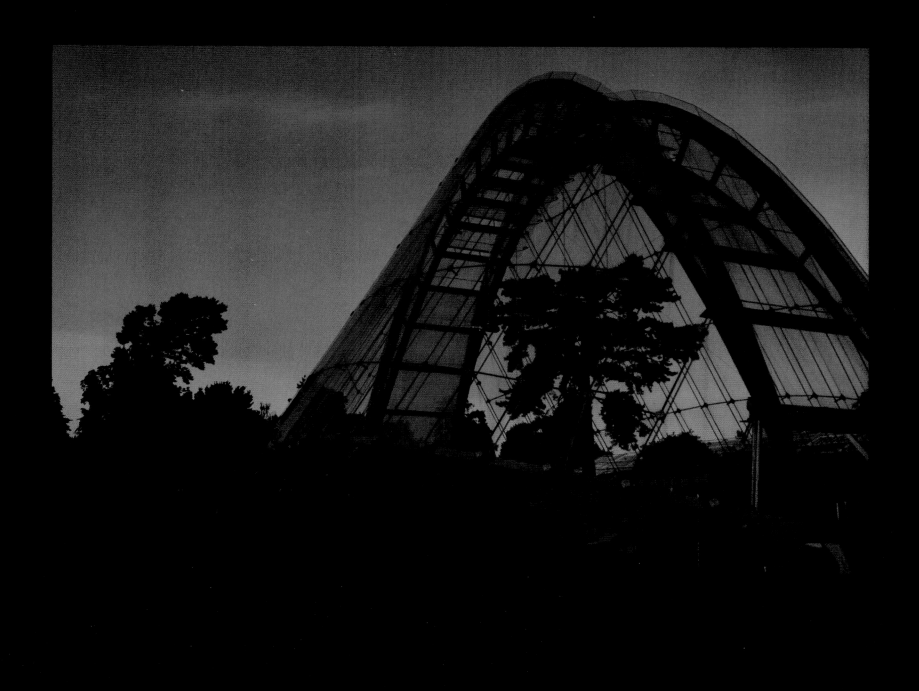

OPPOSITE: *Castanea sativa* Sweet chestnut ABOVE: The Davies Alpine House
OVERLEAF: Avenue of hornbeams in the Queen's Garden

FROM THE OVAL-SHAPED FLOWER-BED THERE ROSE PERHAPS A HUNDRED

STALKS SPREADING INTO HEART-SHAPED OR TONGUE-SHAPED LEAVES HALF WAY

UP AND UNFURLING AT THE TIP RED OR BLUE OR YELLOW PETALS.

VIRGINIA WOOLF (1882–1941)

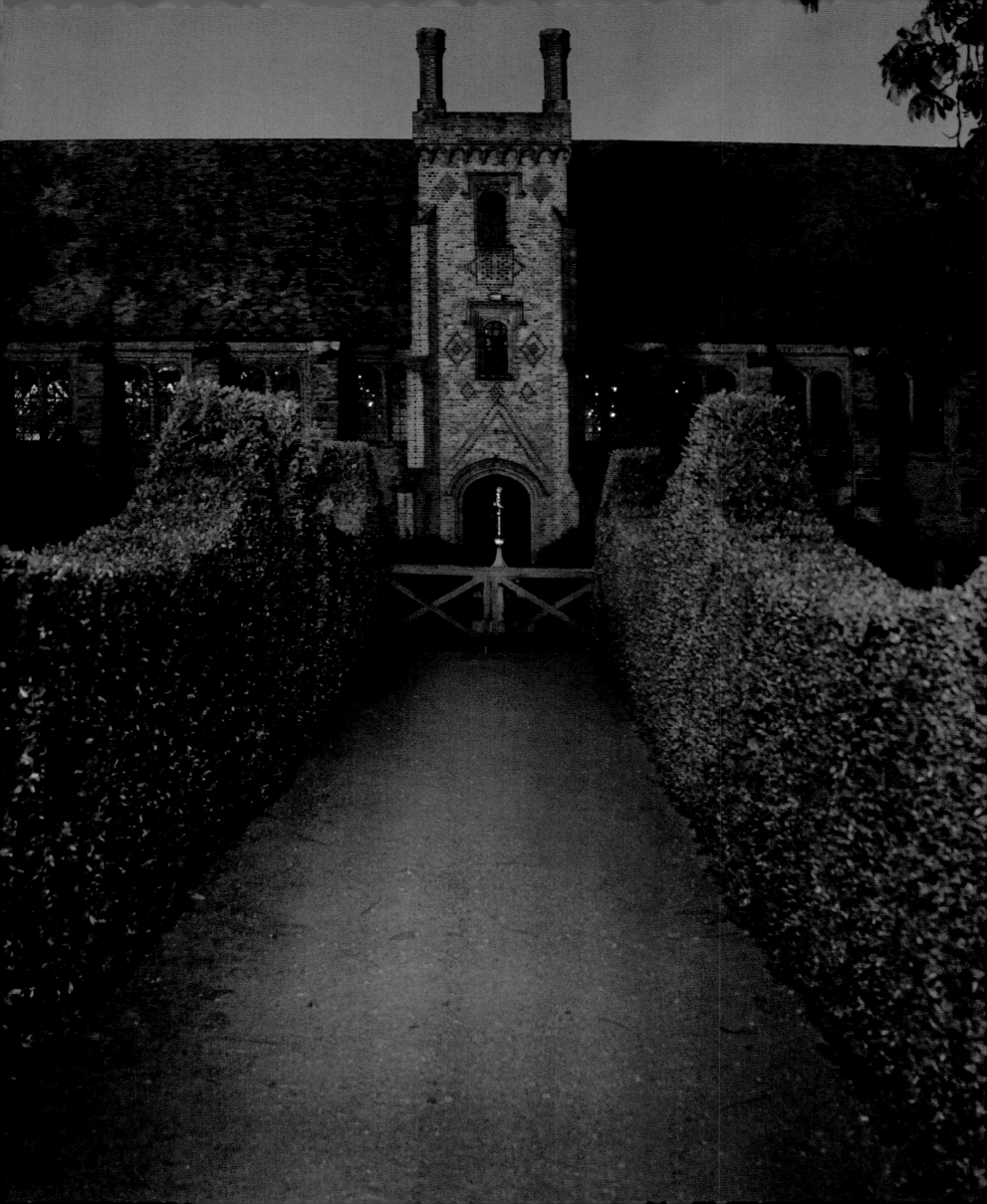

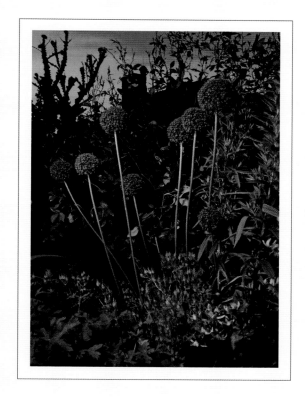

HATFIELD HOUSE
HERTFORDSHIRE

TREA MARTYN

MID-AFTERNOON ON AN UNUSUALLY warm day in late summer, stepping into the coolness of the park at Hatfield is an inviting prospect. Surrounded by its majestic oak trees, the stillness of the place steals over you and opens up the imagination to the legend that Elizabeth was sitting beneath an ancient oak in the grounds when she received the news she was queen.

What chiefly survives of the Old Palace is the Great Hall, where Elizabeth held her first council meeting. The Great Hall is now a magnificent backdrop for the bright Knot Garden planted by the Marchioness of Salisbury on what was once the palace's courtyard. The garden is enclosed by a balustrade walk from which the geometrical patterns can be seen to advantage, giving, as Elizabethan gardener Thomas Hill commented, 'comfort and delight' to the viewer's 'wearied mind'. Hill added that a knot garden should 'give such grace to the garden, that the place will seem like a tapestry of flowers'.

In 1607, James I persuaded his chief minister, Robert Cecil, 1st Earl of Salisbury, to exchange his family's sumptuous palace of Theobalds, also in Hertfordshire, with its internationally famous pleasure grounds, for Hatfield and a number of other royal properties. Cecil responded by building a new house on the site of the old palace and creating architectural gardens inspired by the terraced water gardens of Italy. The scale and diversity of the planting were astonishing. Head gardener John Tradescant the Elder travelled to France and the Netherlands to collect plants, importing hundreds of fruit trees, tens of thousands of vines, forty fritillaries, sixteen Province Roses, and florist's flowers such as the great double anemone and tulip (eight hundred bulbs from Harlem) which are still grown in the gardens.

After the Second World War, the relationship between the house and grounds was lost. This unity has been restored by Lady Salisbury, who has recreated the gardens laid out by Cecil, drawing on sixteenth- and seventeenth-century designs and using Tradescant's lists of plants. Wherever you are in the gardens, the house is always there in the background, rising above the stage scenery of hedges and trees. Seen from the West Parterre, it stands stately and commanding. Viewed from the Wilderness, the south front, with its Italianate arcade, has the benign and gentle presence of a guardian.

These are pleasure grounds of movement and rest. In the Scented Garden, the sound of the splashing fountain in the West Parterre fades as you walk through green arches to a simple Eastern-style jet. Time slows down so that you stop and really see a flower – an old-fashioned rose or ancient pink – and then the perfume draws you in. As you move closer, sights, scents, and sounds are one. Everywhere in the gardens, there are places to rest, look, and listen, in the shape of a semi-circular stone seat from Italy set in a bower, or a bench backed by a Tudor brick wall. Enter the Wilderness and you are in enchanted woodland; the sound of the fountain from the Parterre merges, as evening draws in, with birdsong. At the northern end of the Holly Walk, dappled sunlight falls on a statue of Elizabeth.

Hatfield is a garden of surprises, discoveries, and optical illusions which the Tudors and Stuarts loved as we do today. It is a place of infinite variety, different in every season.

OPPOSITE: The Old Palace
ABOVE: *Allium* × *hollandicum* 'Purple Sensation' Allium 'Purple Sensation' – The West Parterre

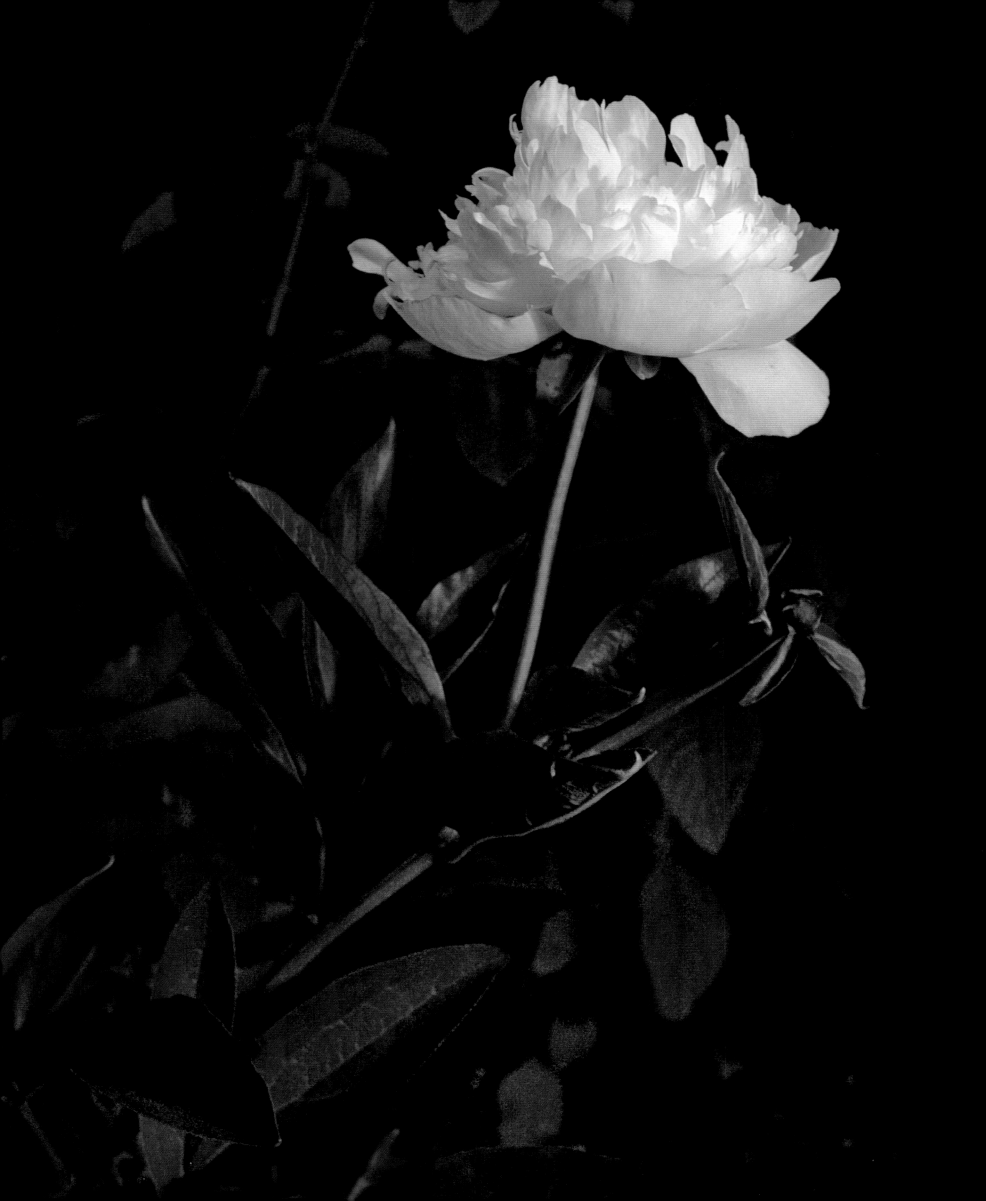

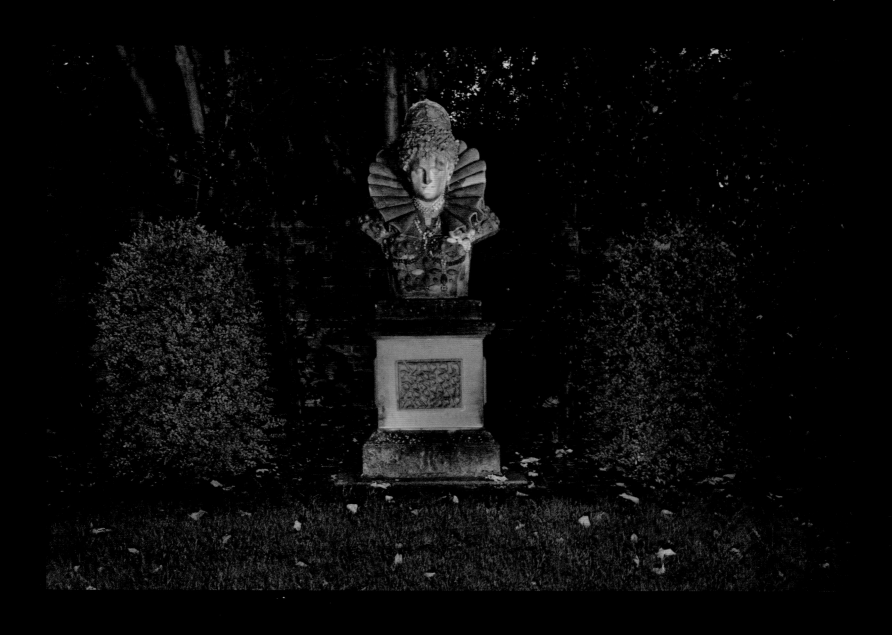

OPPOSITE: *Paeonia* 'White Jade' Peony 'White Jade' – The Scented Garden
ABOVE: Bust of Queen Elizabeth I

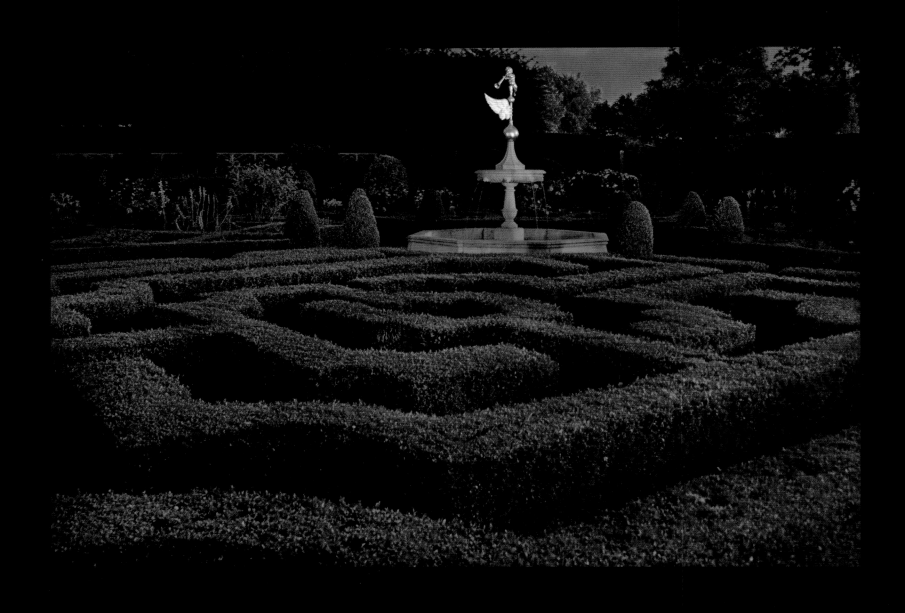

ABOVE: The Knot Garden
OPPOSITE: *Hydrangea quercifolia* Oak-leaved hydrangea – The West Parterre

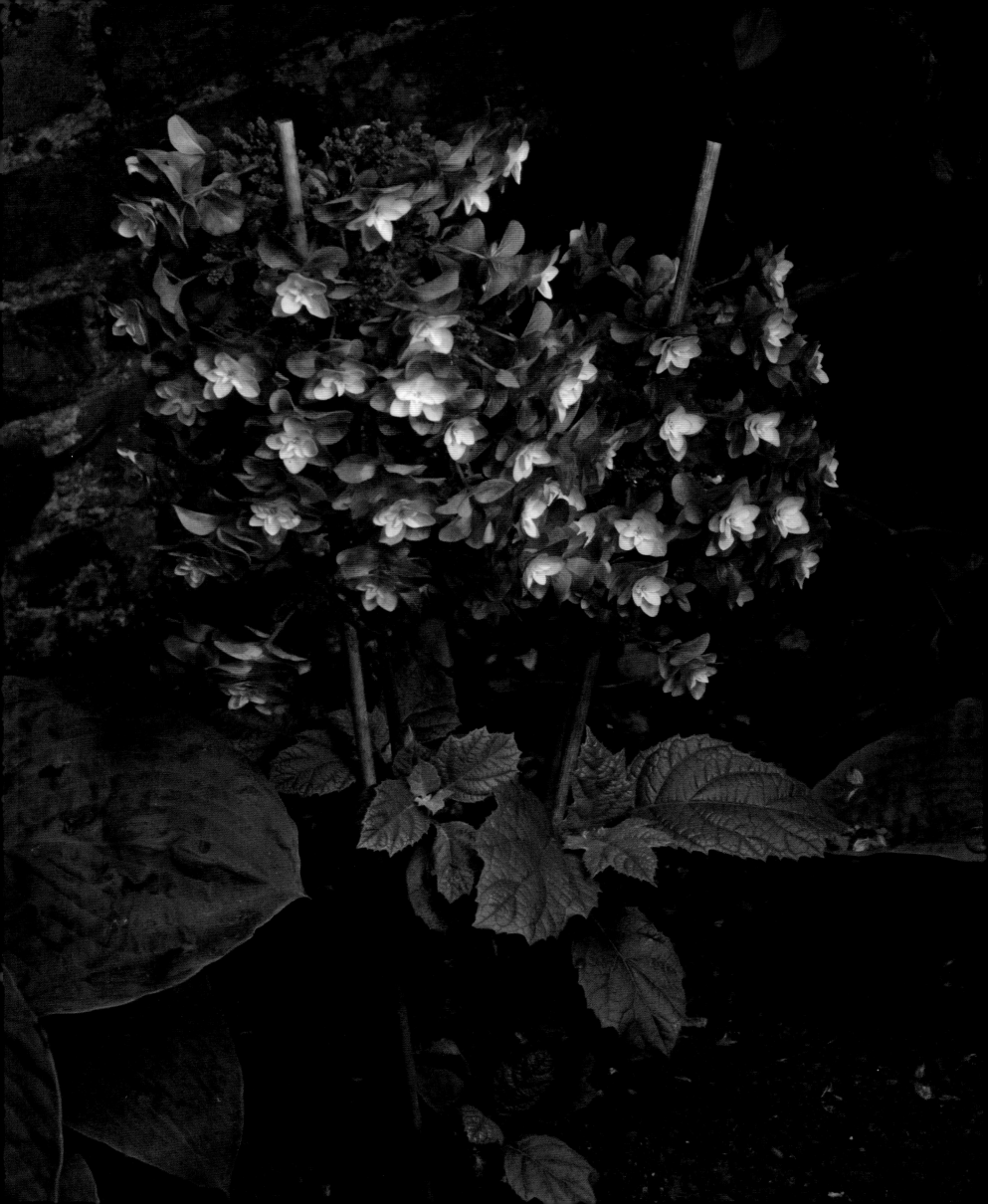

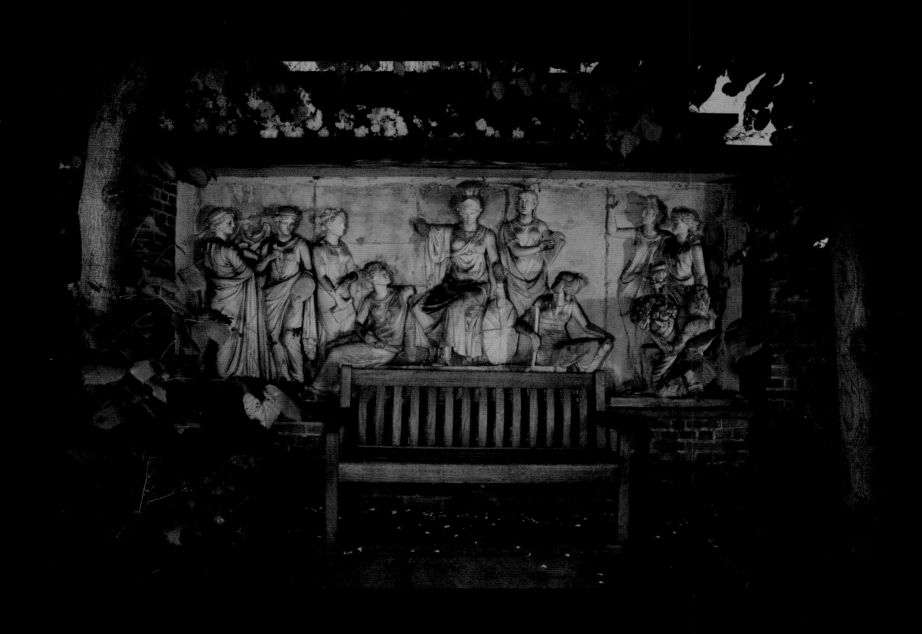

ABOVE: Frieze in the West Parterre

OPPOSITE: West Entrance

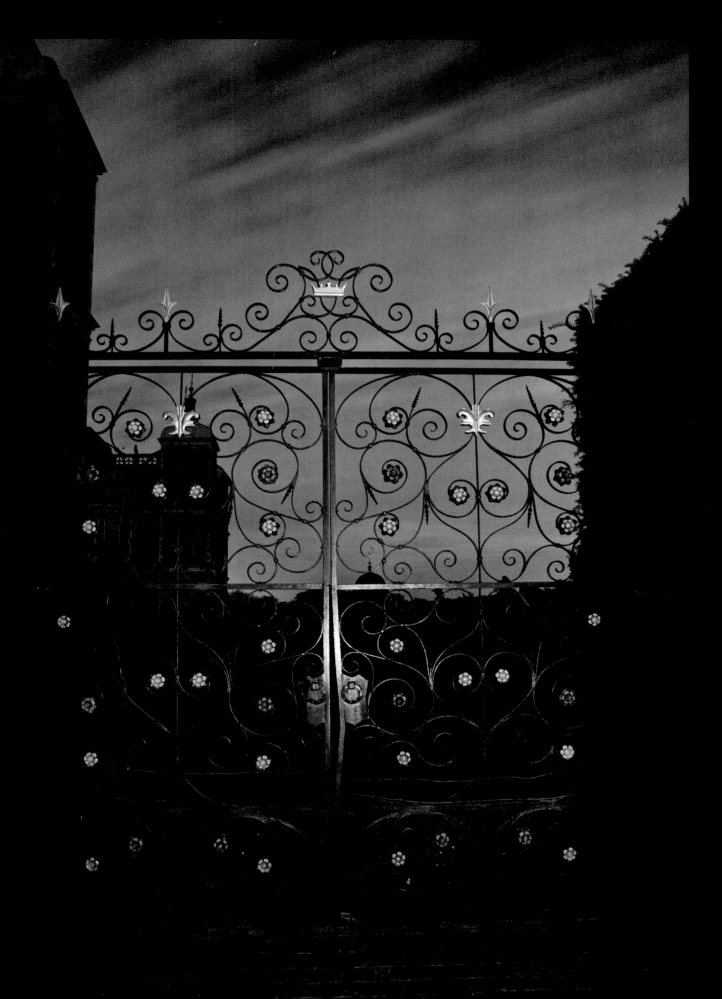

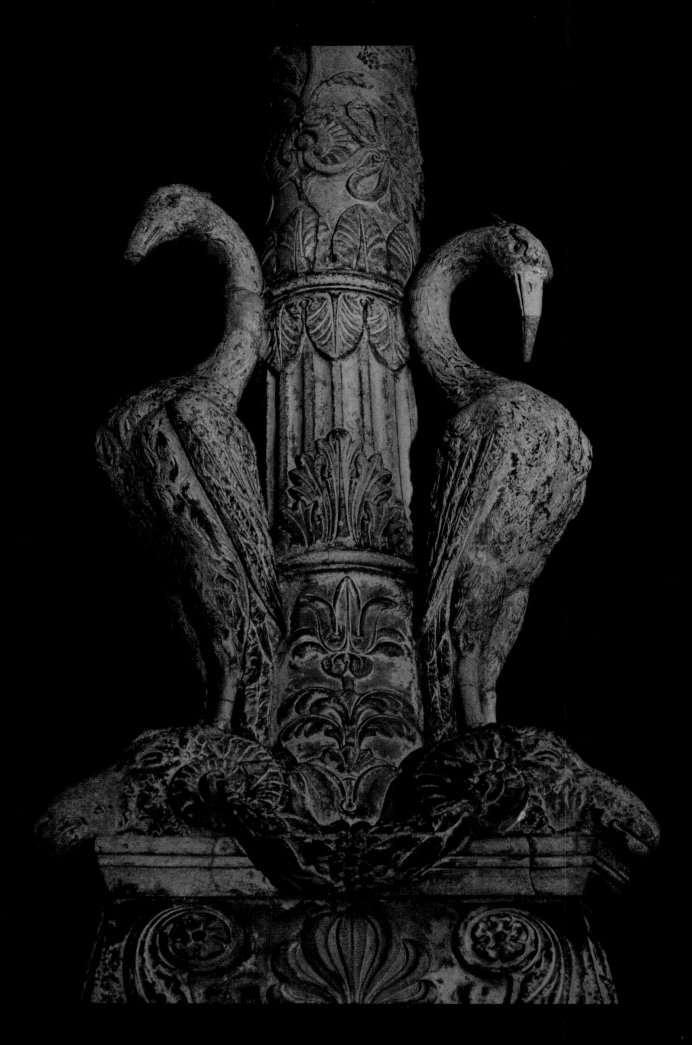

ABOVE: Main Entrance

OPPOSITE: Main Door

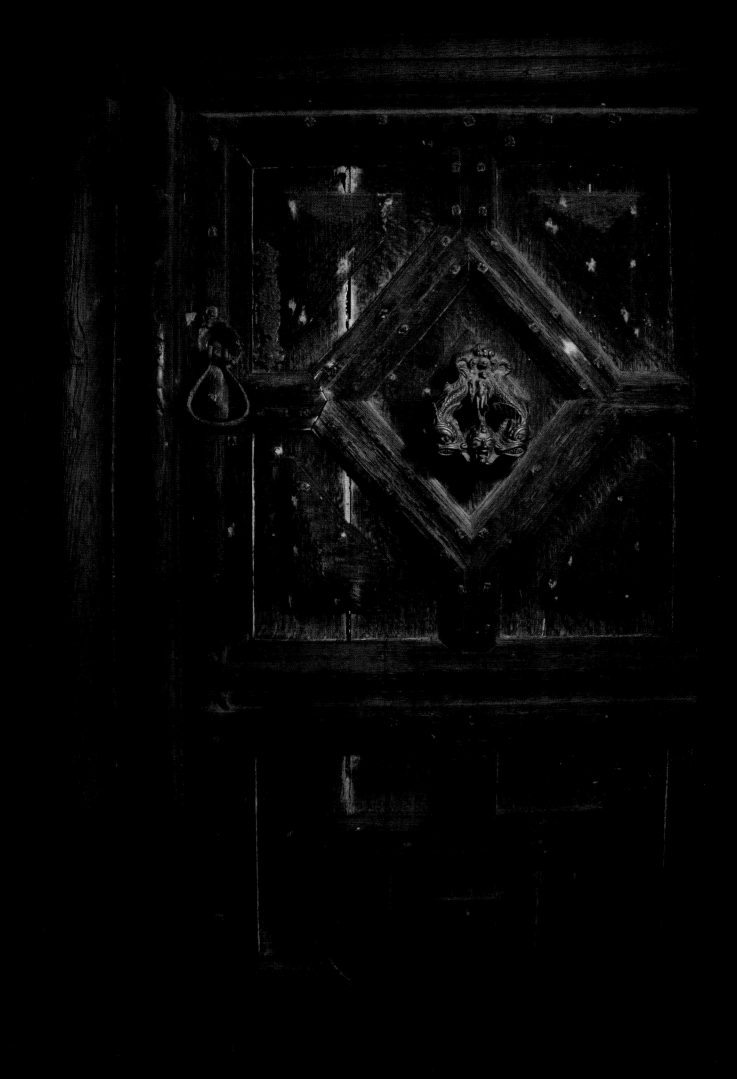

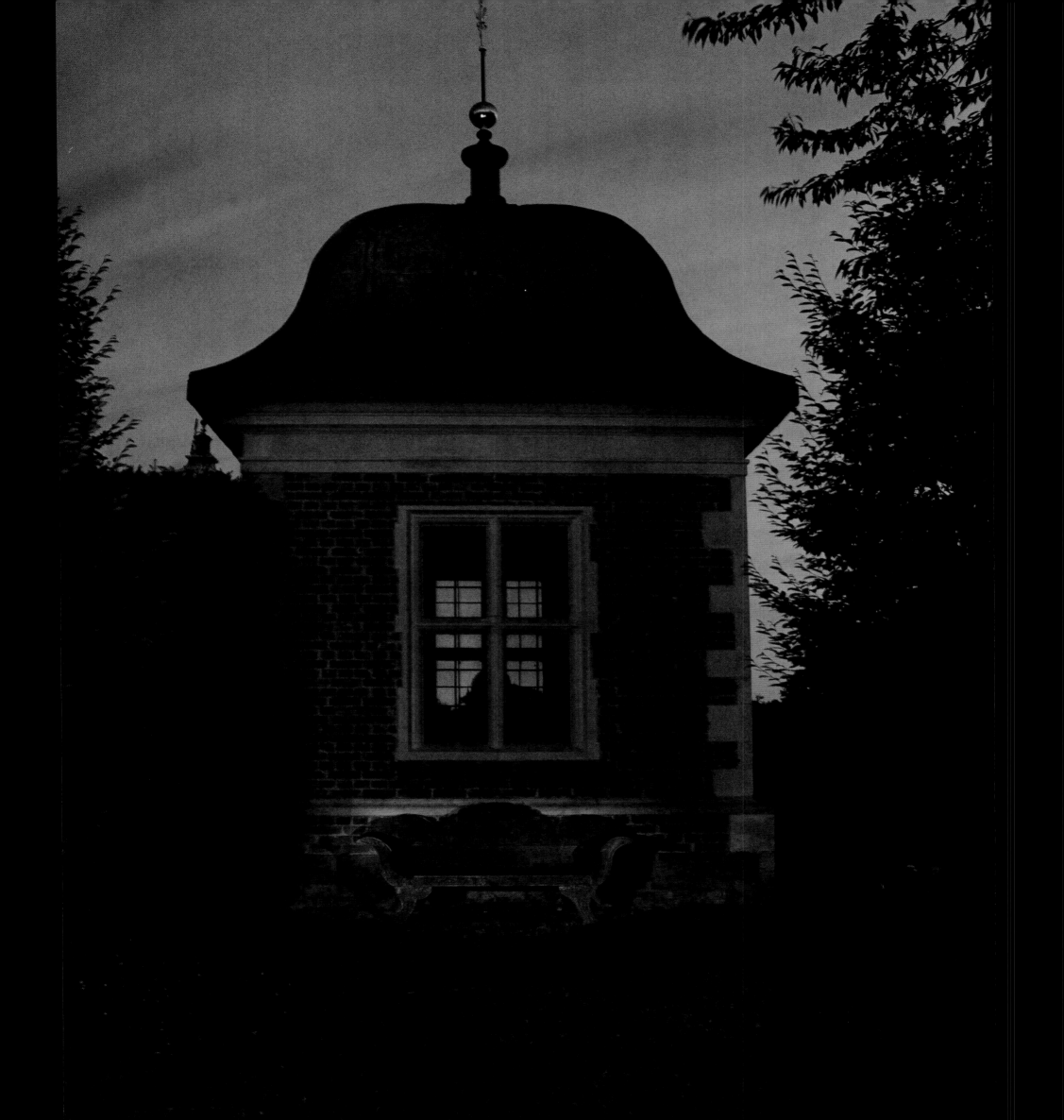

OPPOSITE: South front garden house

ABOVE: *Hedera helix* 'Variegata' Variegated English ivy – The Knot Garden

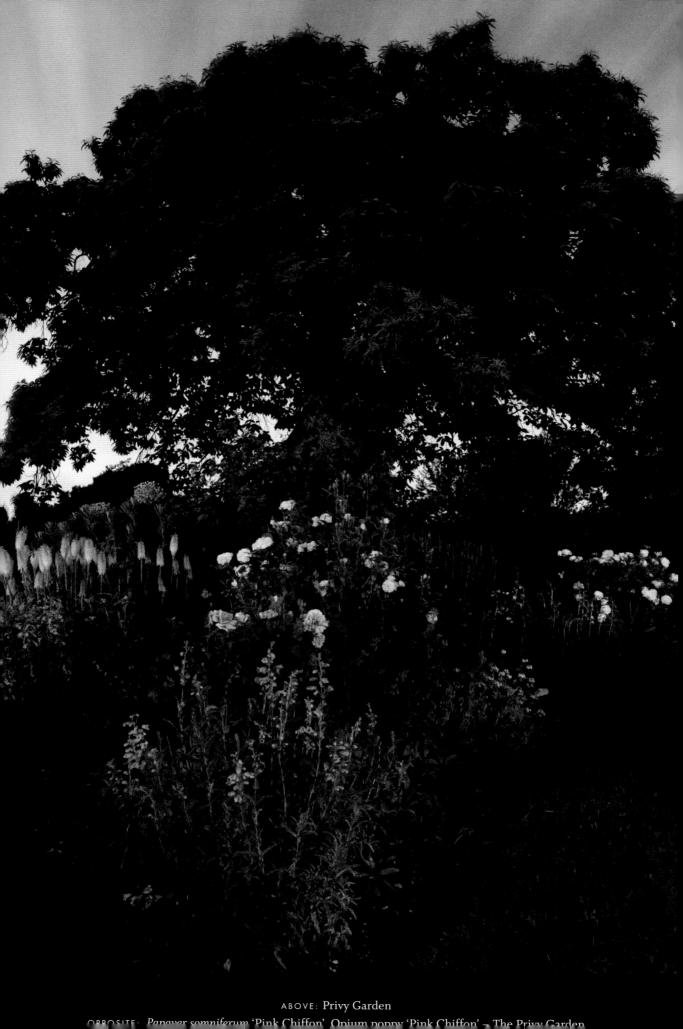

ABOVE: Privy Garden

OPPOSITE: *Papaver somniferum* 'Pink Chiffon'. Opium poppy 'Pink Chiffon' – The Privy Garden

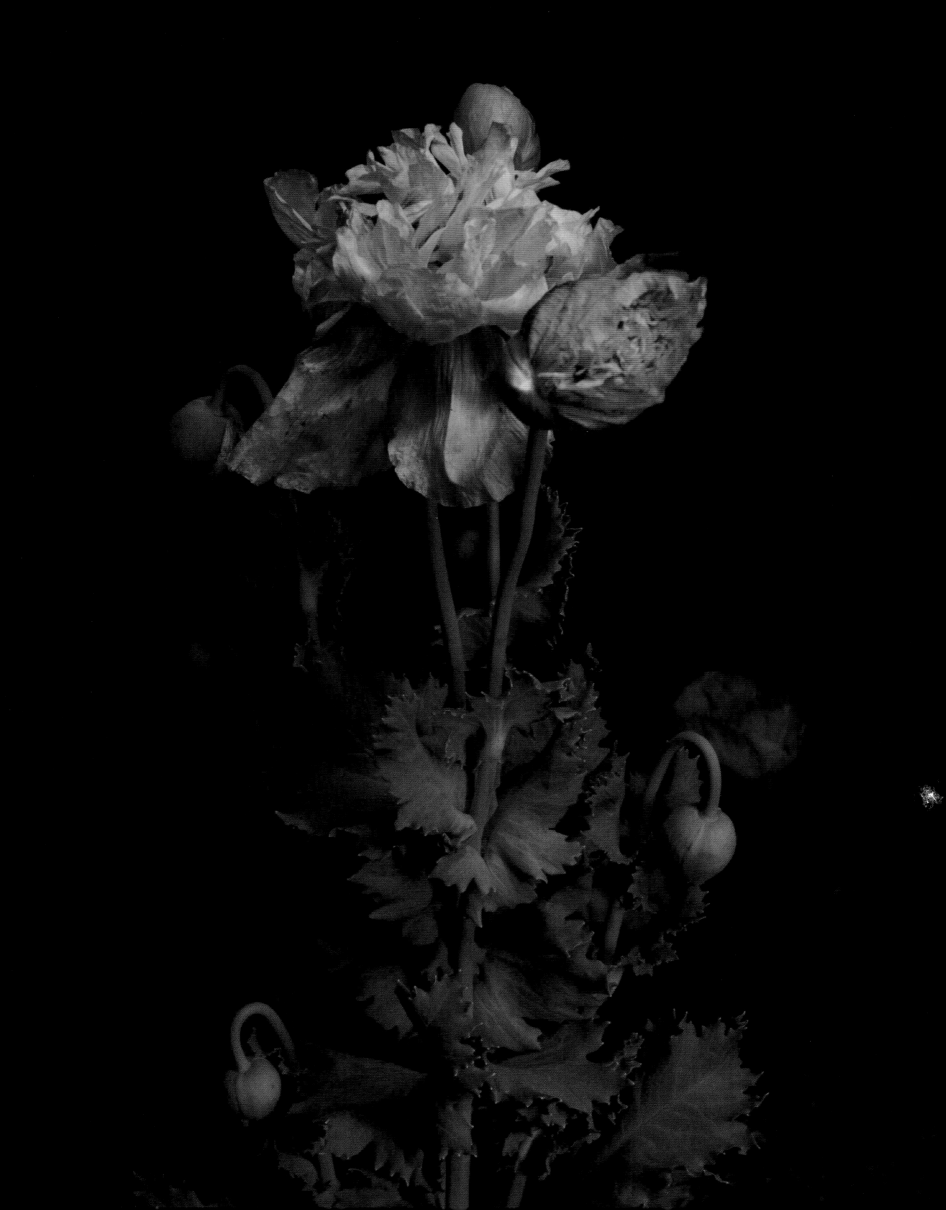

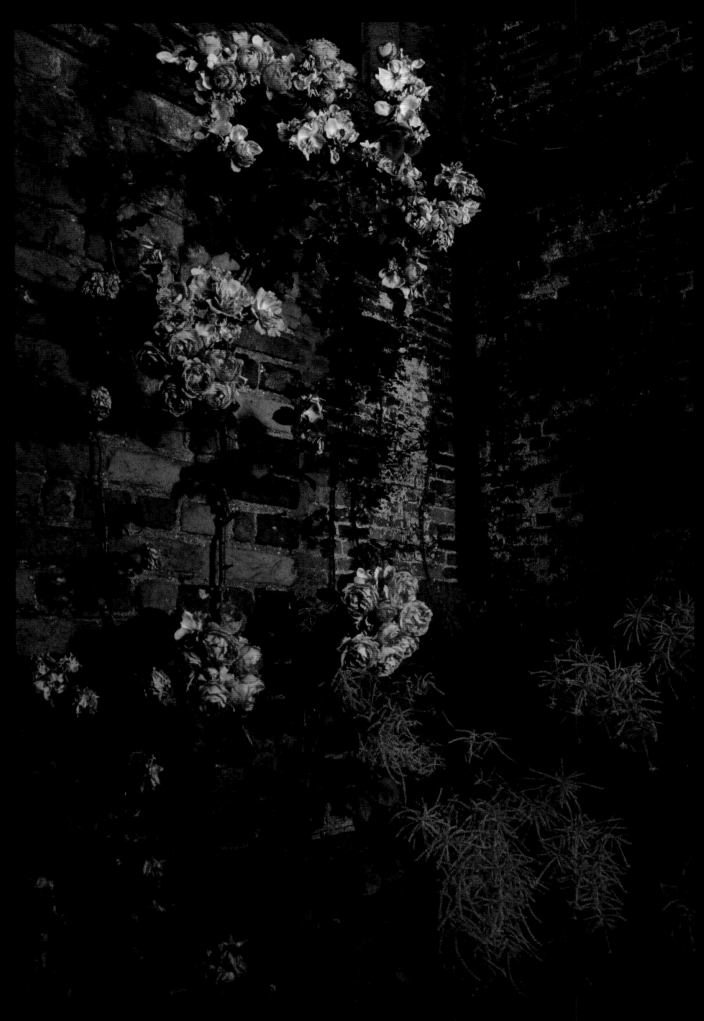

ABOVE: Roses in the Knot Garden
OPPOSITE: South front garden house beyond a hedge

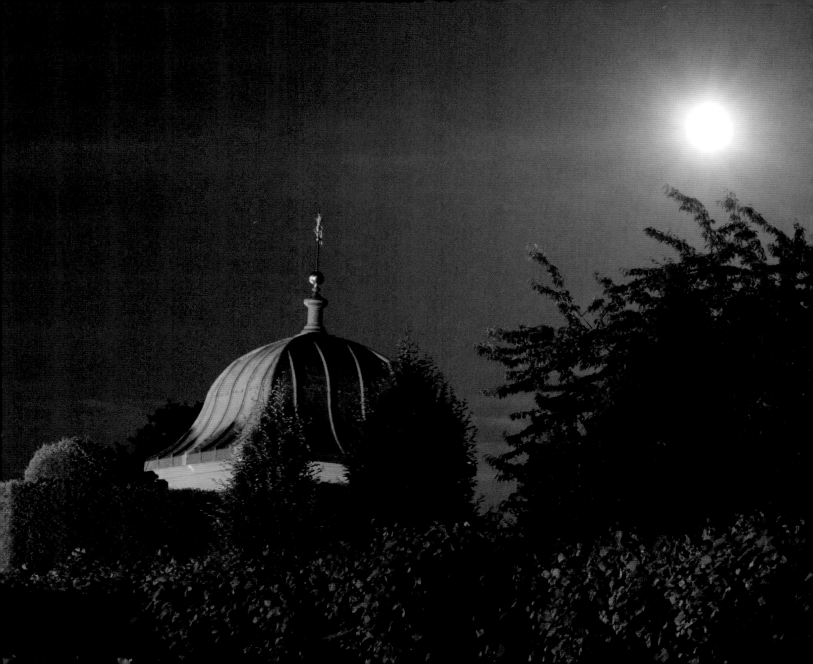

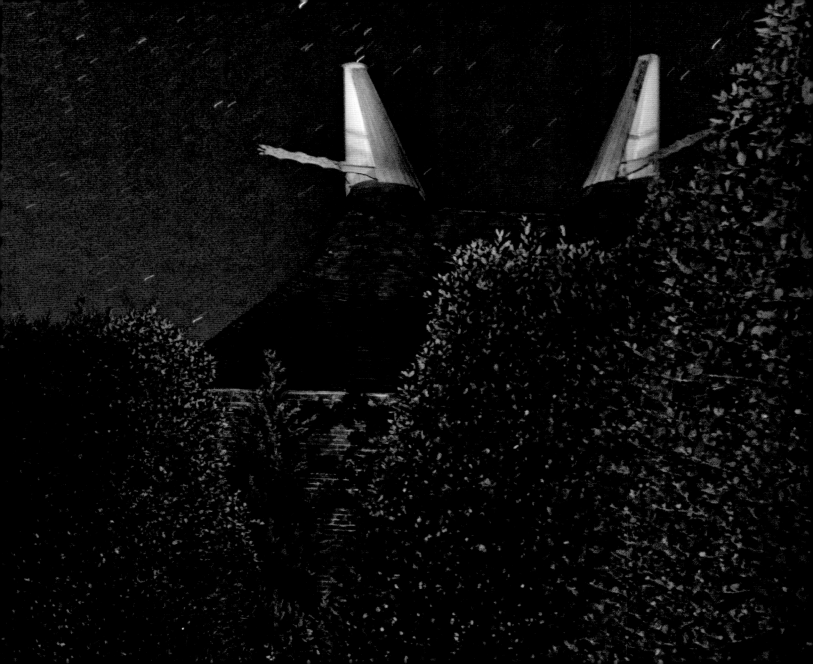

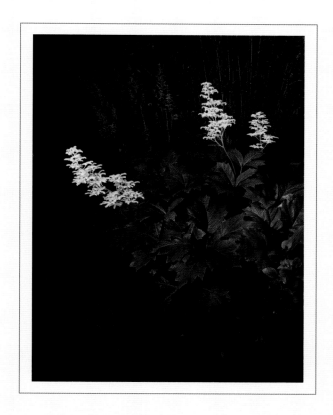

GREAT DIXTER HOUSE AND GARDENS
EAST SUSSEX

FERGUS GARRETT

GOOD GARDENS HAVE ATMOSPHERE. They are awash with breath-taking combinations that show a touch of genius. From corner to corner they are adorned with exciting plants enjoying life, rubbing shoulders sensually with chosen partners. Good gardens have an inbuilt element of surprise, which gives them a hypnotic quality. They have soul and sympathy touched by the hand of skilled and dedicated people who love, respect, and live the dream. These places can have history, amazing architecture, the intimacy of an inward-facing design, or the freedom of a beautiful borrowed landscape. They can be old and distinguished, settled in their past, or contemporary and thought-provoking, innovative, and exciting. Great Dixter has many of these qualities and much more. It is an exceptionally individual place that draws visitors from all corners of the world. From the moment you step in through its weathered oak front gate and walk the lichen-covered uneven York stone path down to the front door, you sense the unique character present. This short journey takes you through ancient meadows rich in wildlife into a dreamy, exciting, exuberant world of past and present.

The six-acre gardens sit in the middle of a sixty-acre estate. Ancient oak trees line the approach road, and a semi-natural horse pond shimmers in the light as you catch your first glimpse of the extraordinary building positioned majestically in the distance. Framed by vegetation and silhouetted against the sky, this was the home of one of our finest gardeners and garden writers of all time, Christopher Lloyd. He was born here and Dixter became his life's work.

The garden at home was his notebook to write from and even after his death remains a mecca for gardeners all around the world.

The original part of the house dates back to the 1460s, and was bought by Christopher's parents, Nathaniel and Daisy Lloyd, in 1910. The mediaeval hall was in desperate need of renovation and restoration, and the Lloyds commissioned the famous architect Edwin Lutyens to carry out the repairs. He also laid out the gardens from what was essentially a farm yard. He compartmentalized the site, dividing it into a series of rooms around the main house and proving himself to be as masterful in the landscape as he was in the house. Lutyens put down a strong but comfortable structure, laid down in such a way that there is a seamless flow from one compartment to another with the existing farm buildings cleverly incorporated into the garden scene. There is intimacy and enclosure, but also inviting glimpses into the next compartment. Each space has its own set of plants and its own atmosphere. You go from one to the other with an element of surprise, not quite knowing what the next archway or the next doorway is going to lead to. The pace may change from exhaustive, dynamic, colourful displays to restful and relaxed self-sowers. Undulating yew hedges, brick walls, and buildings form the framework within which all this happens.

The place has its sense of history, an attachment to its land, a sense of being, and a sense of purpose, but also it has remarkable freedom where creativity is the master. This is where Christopher Lloyd's spirit lives on and this is where we continue to garden in the same breath.

OPPOSITE: Oast house
ABOVE: *Aruncus dioicus* Goat's beard – The Walled Garden

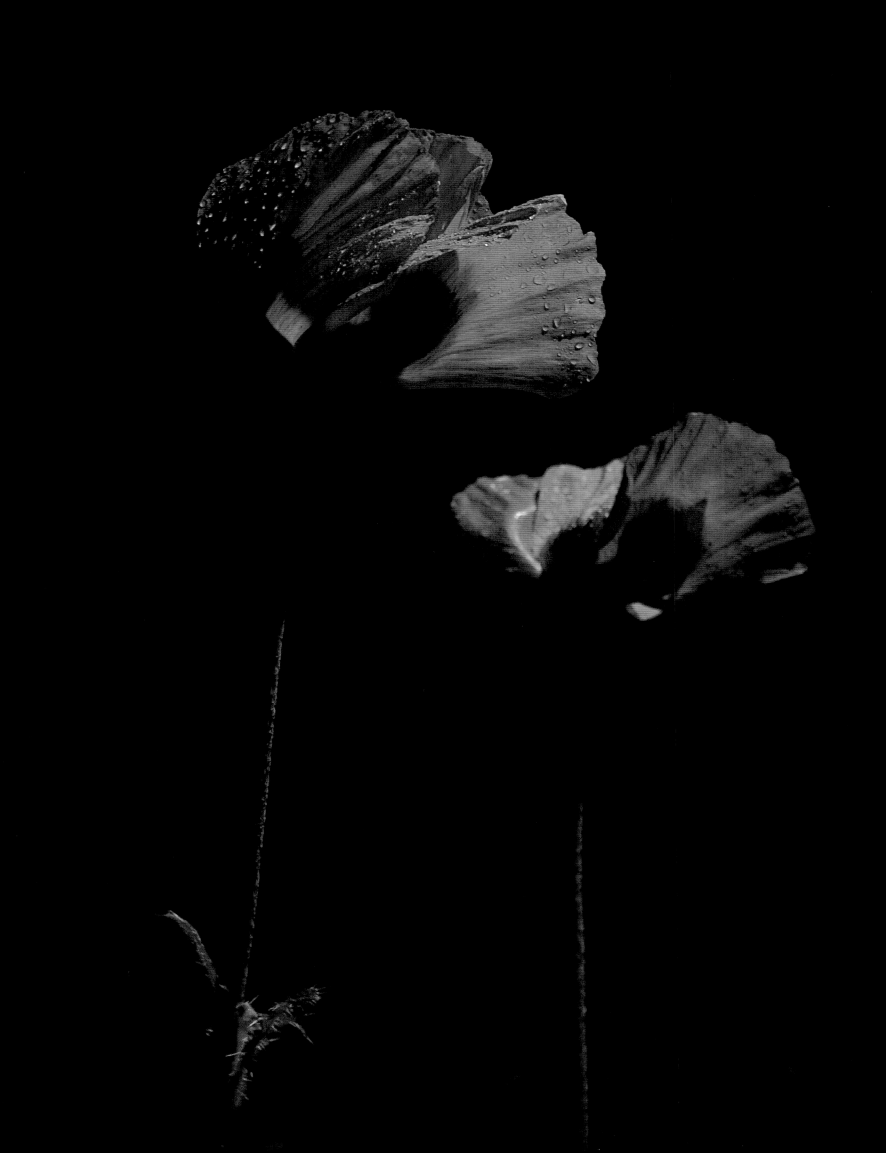

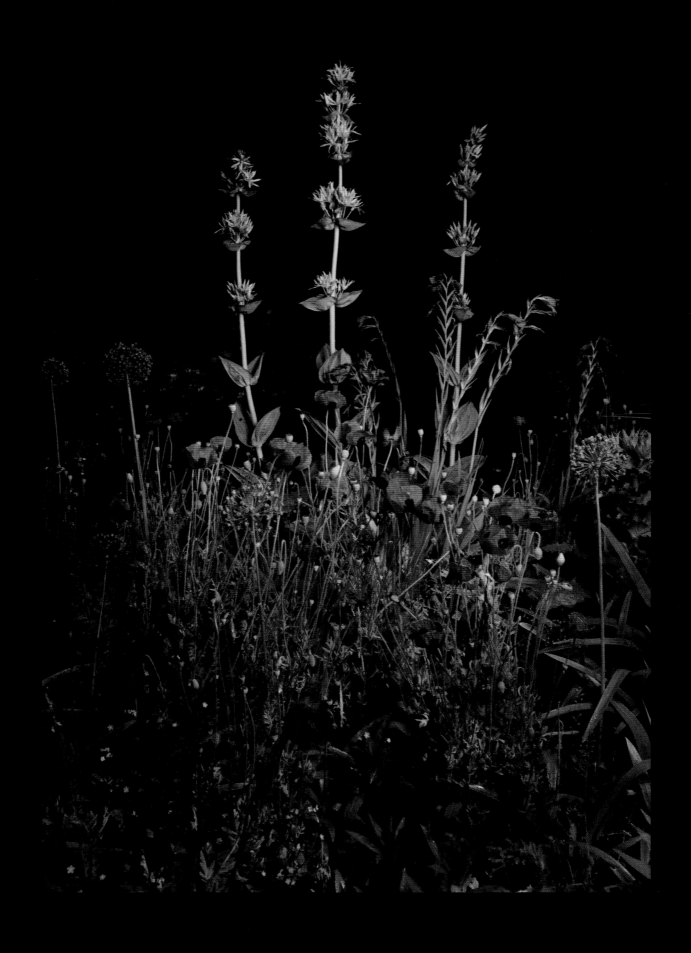

OPPOSITE: *Papaver orientale* Oriental poppy – The Sunken Garden
ABOVE: *Gentiana lutea* Great yellow gentian • *Gladiolus communis byzantinus* Byzantine gladiolus

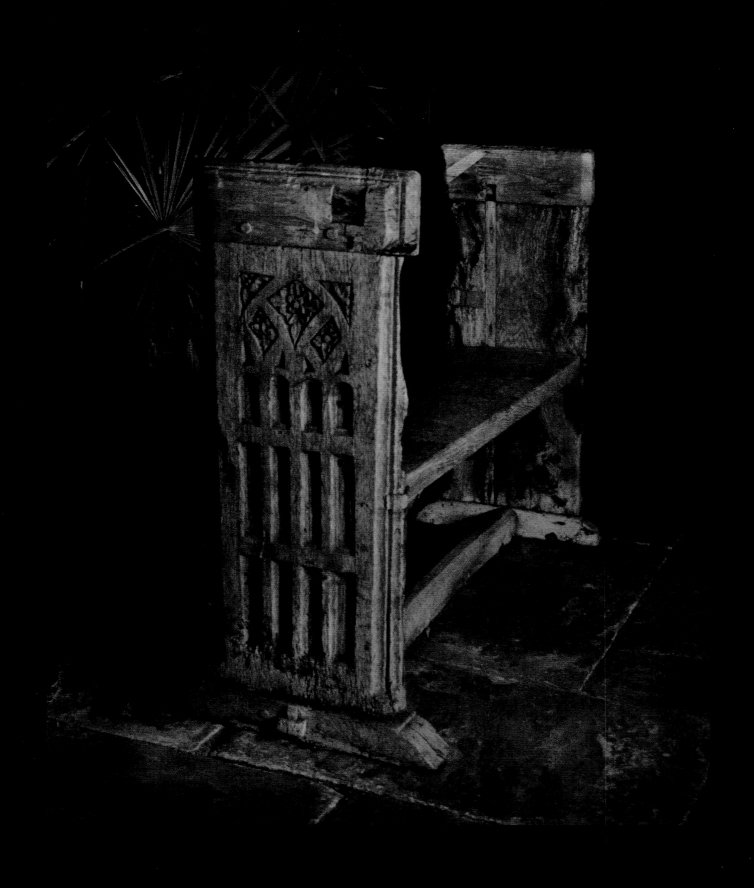

ABOVE: The Exotic Garden
OPPOSITE: Circular steps and arch from the Walled Garden into the Blue Garden

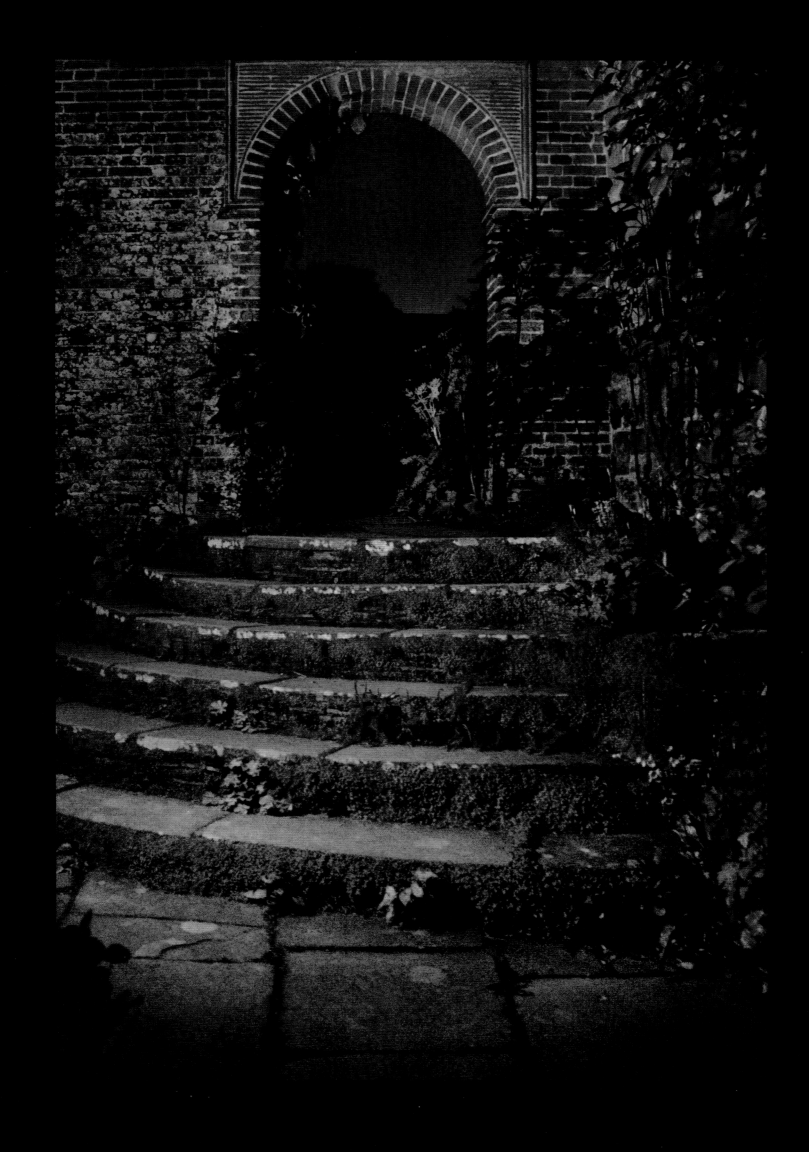

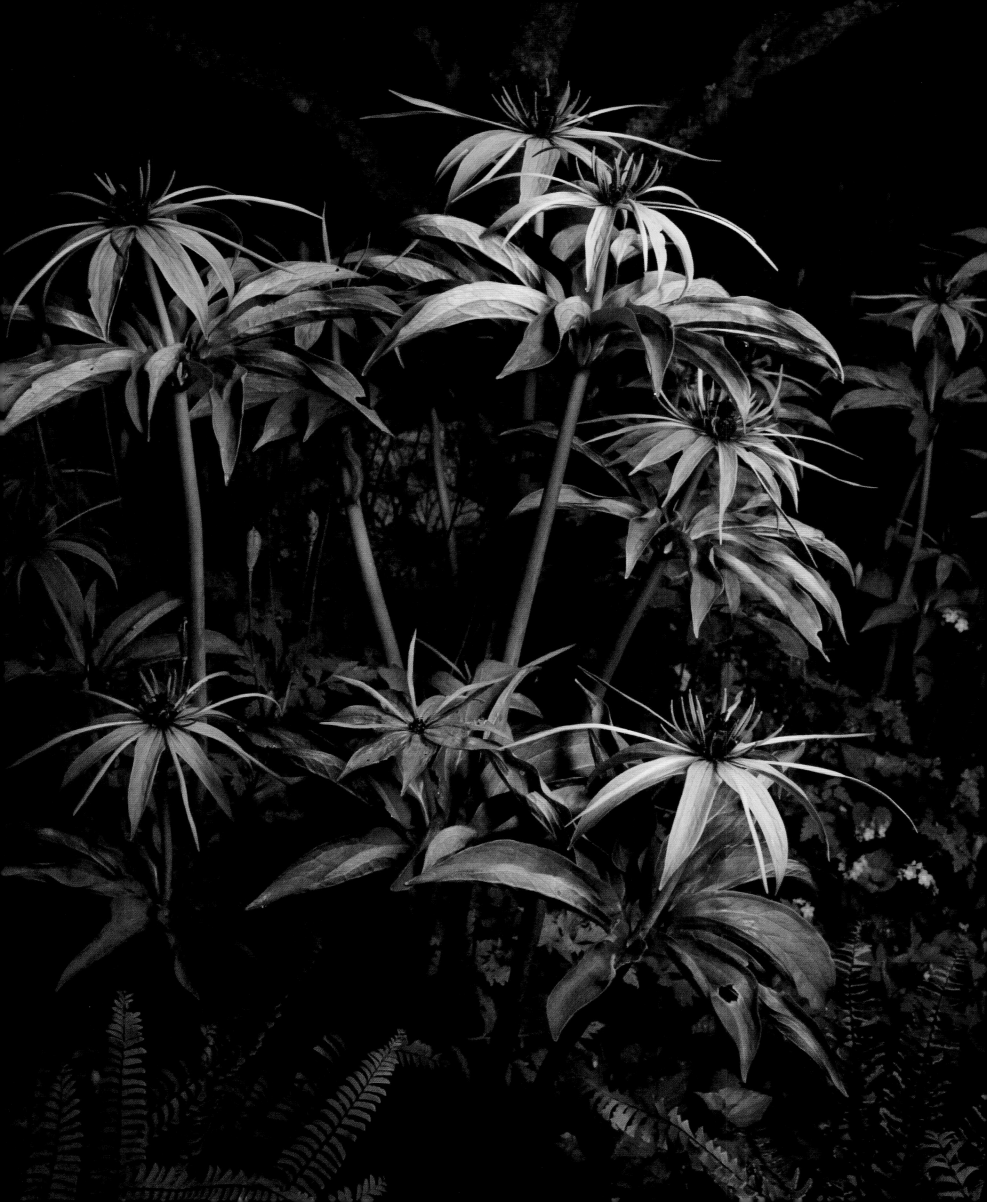

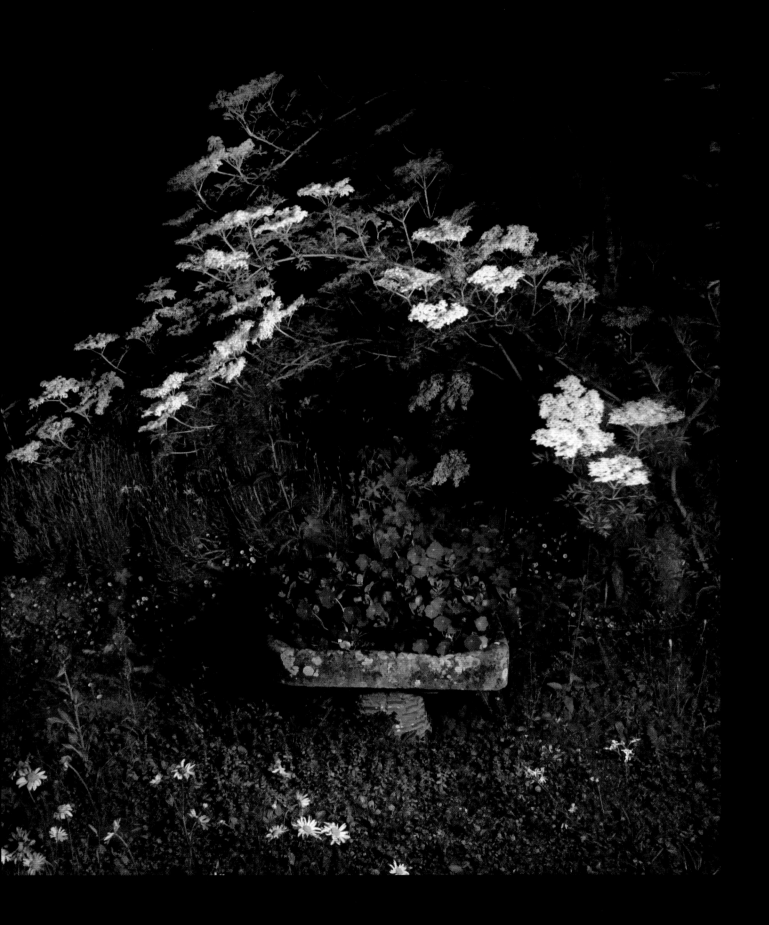

OPPOSITE: *Paris polyphylla* Herb paris – The Barn Garden
ABOVE: *Sambucus nigra* 'Laciniata' European cut-leaf elderberry

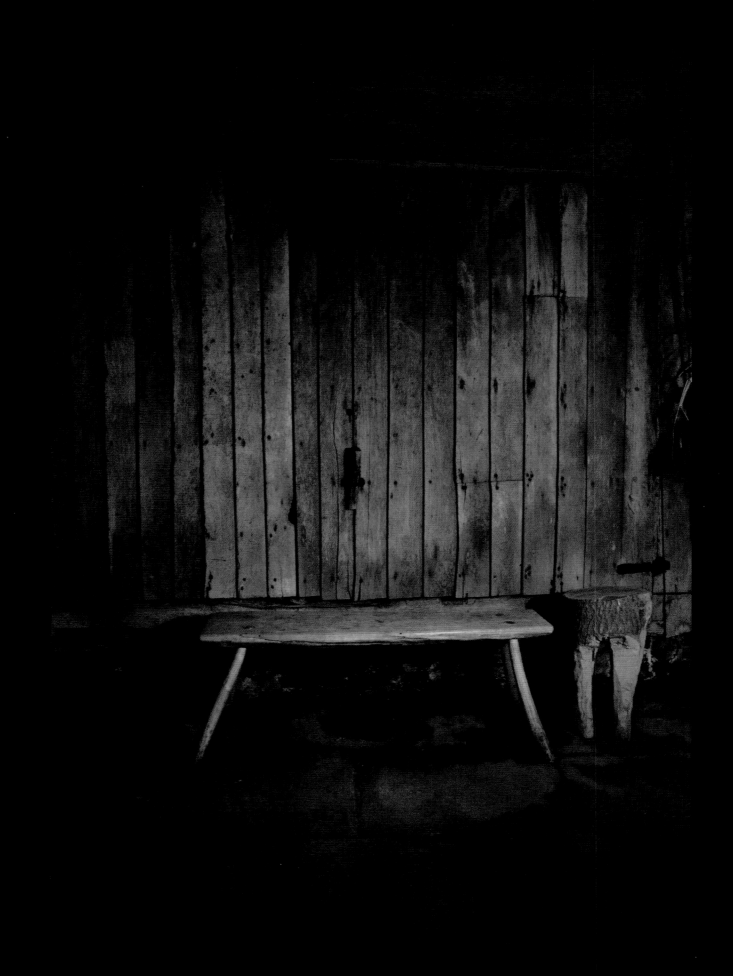

ABOVE: **The Barn**
OPPOSITE: *Digitalis purpurea* 'Glittering Prizes' Foxglove 'Glittering Prizes' – The Solar Garden

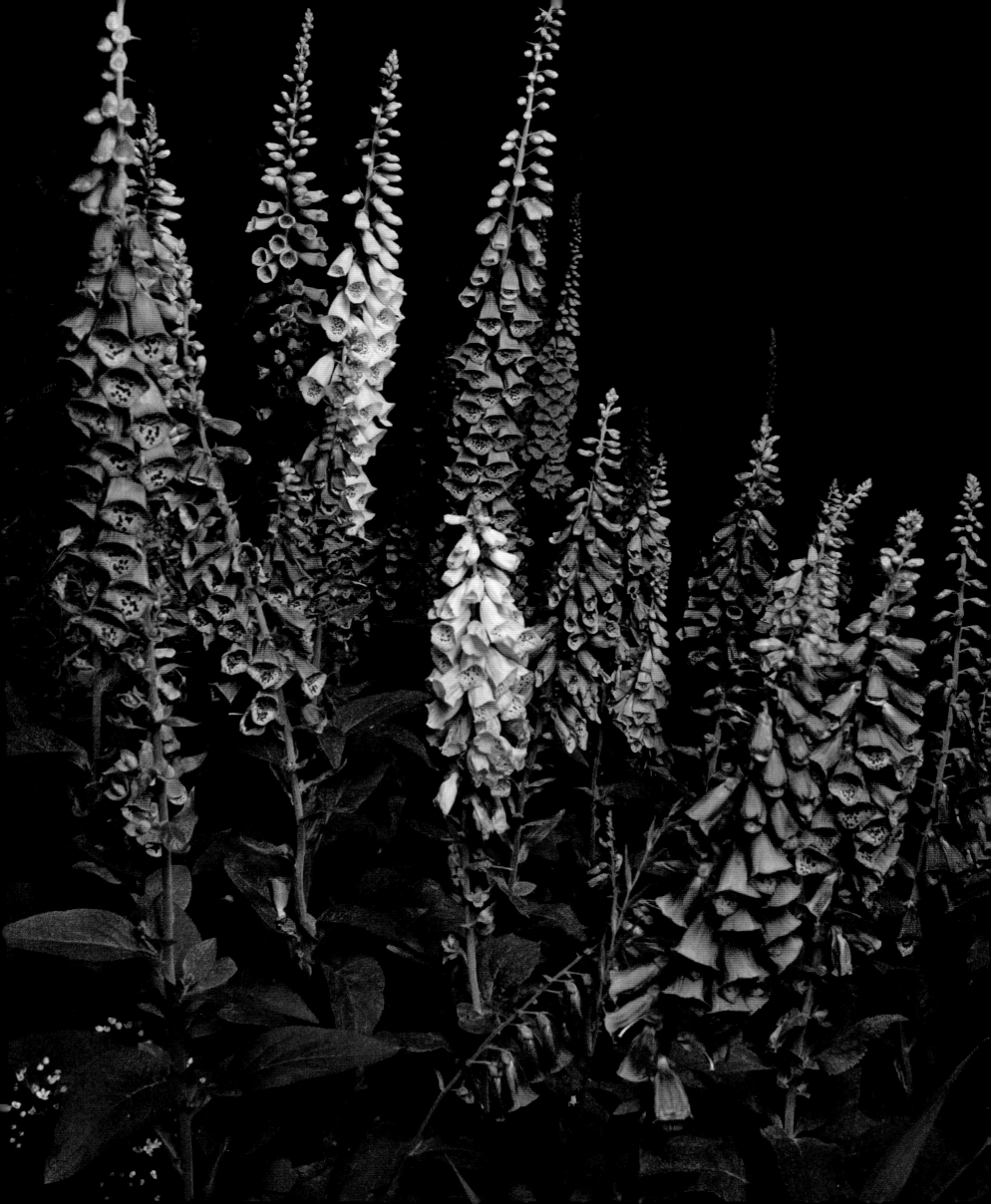

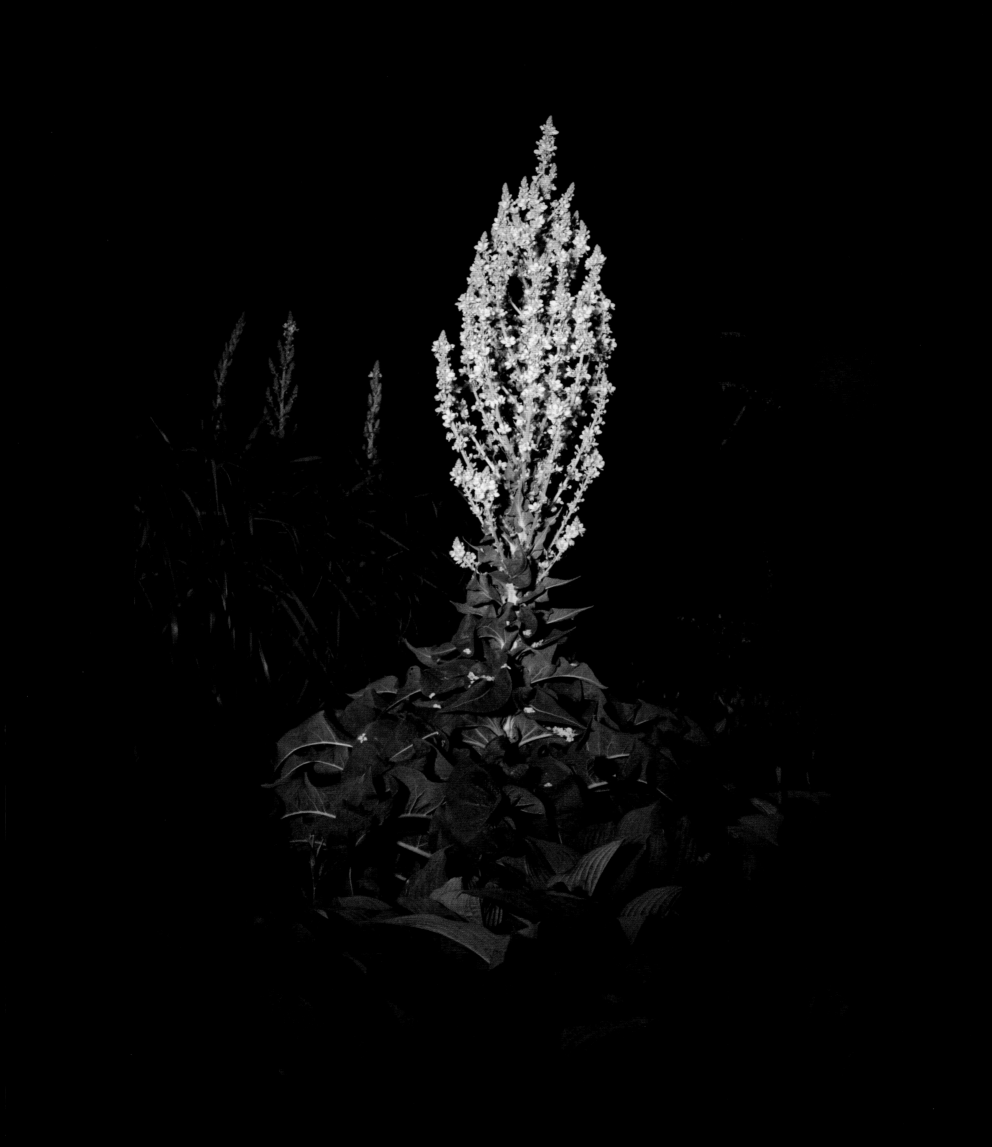

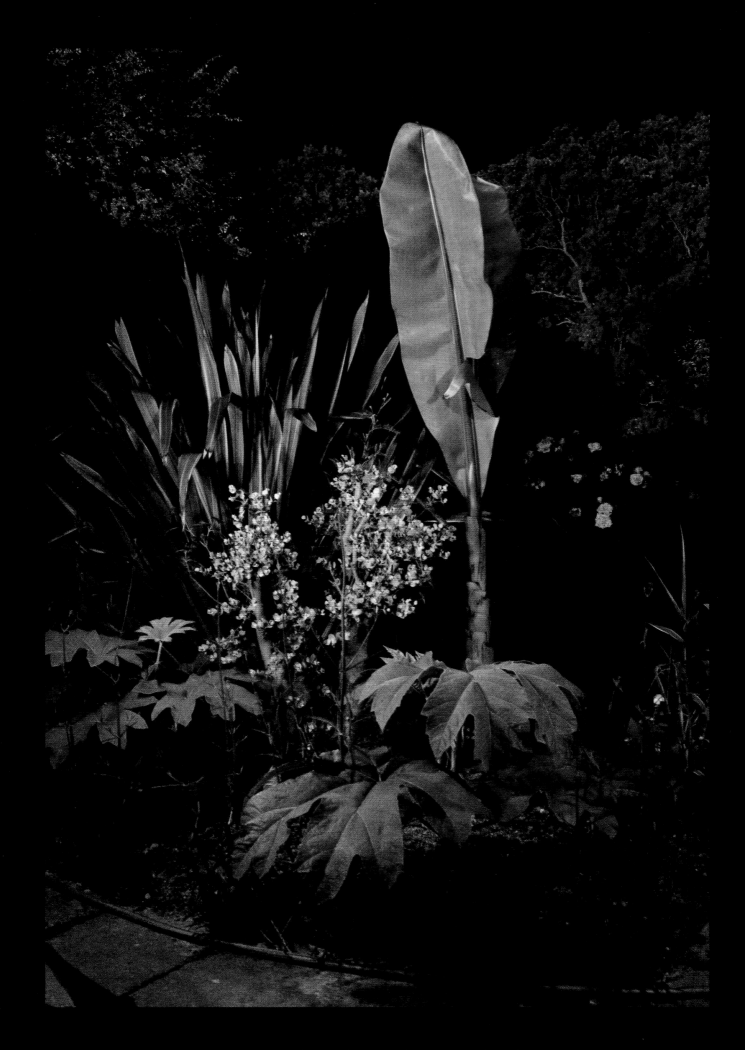

OPPOSITE: *Verbascum thapsus* Mullein – The High Garden
ABOVE: *Musa ensete* Banana • *Tetrapananx papyrifer* Rice-paper plant – The Exotic Garden

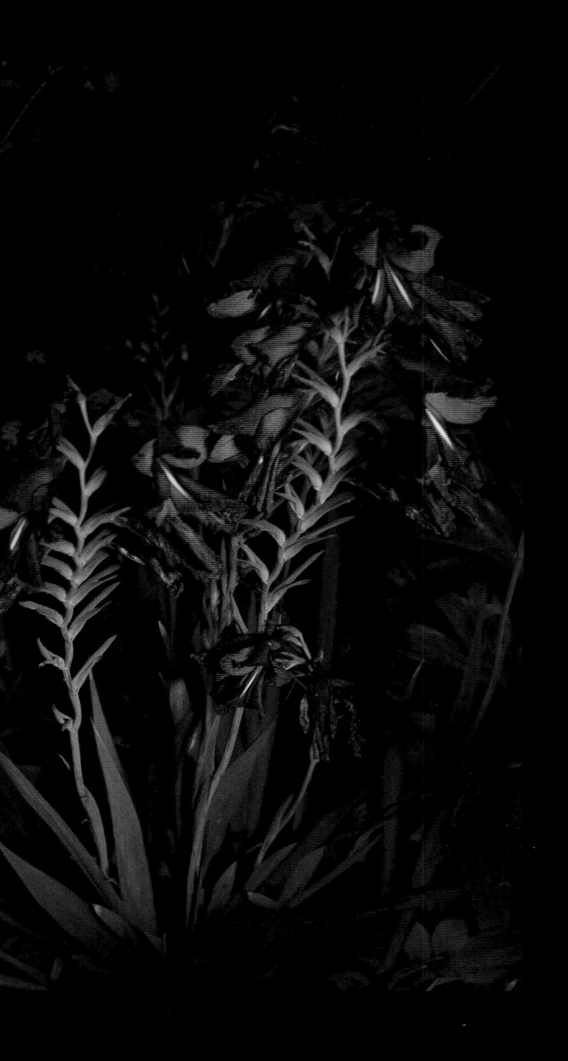

ABOVE: *Gladiolus communis byzantinus* Byzantine gladiolus – The Solar Garden
OPPOSITE: Peacock topiary

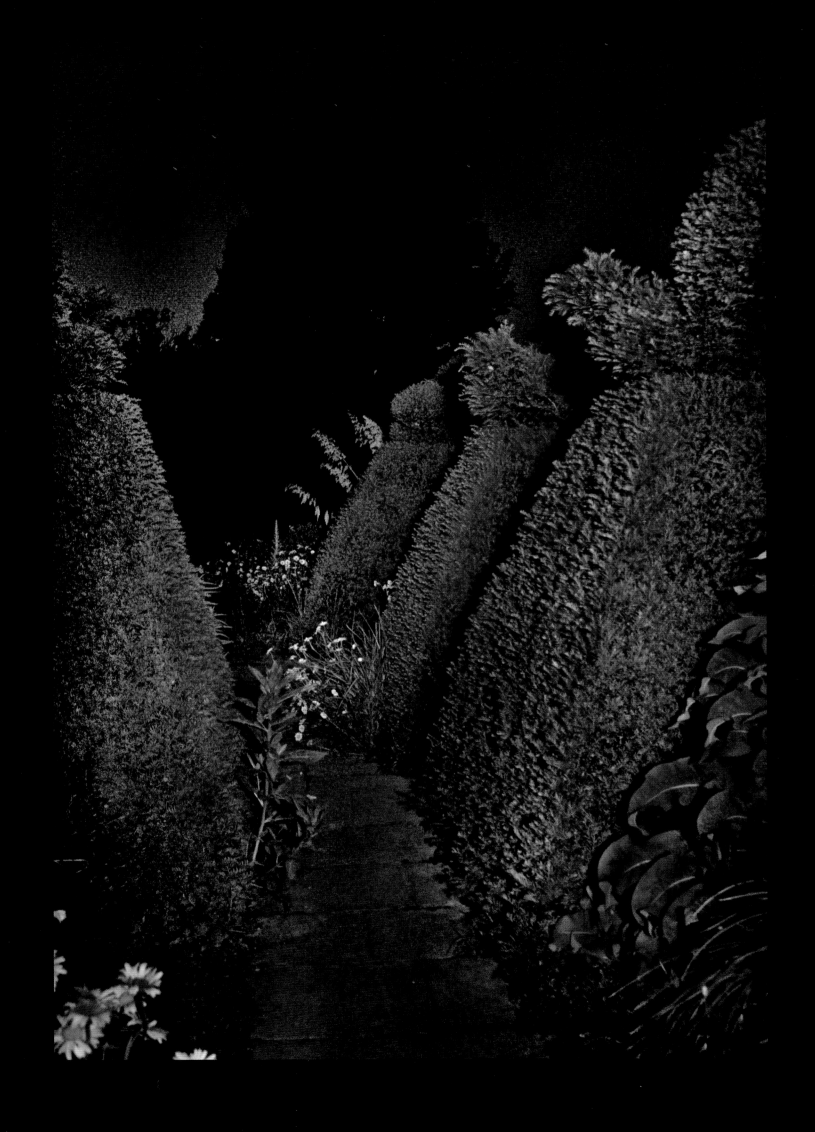

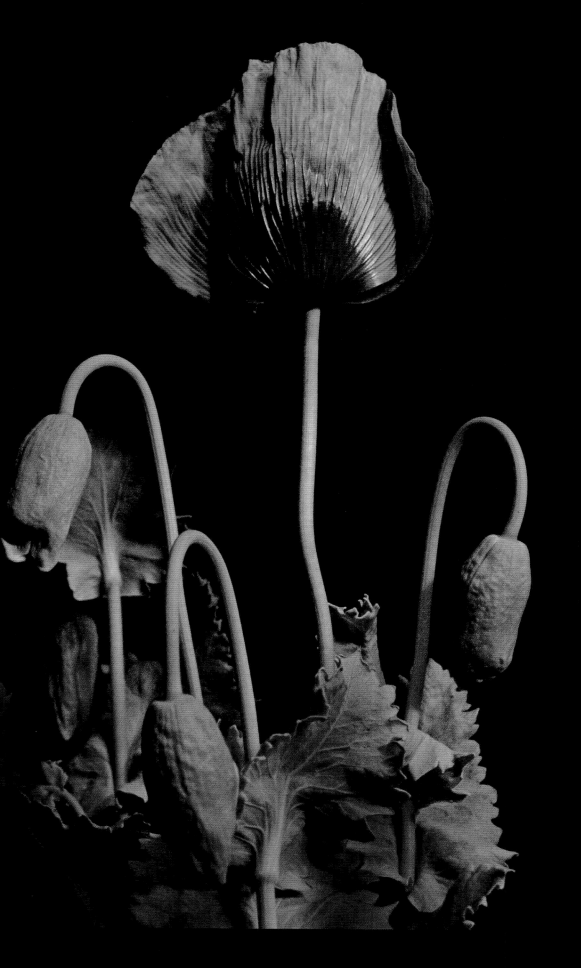

ABOVE: *Papaver somniferum* Opium poppy

OPPOSITE: The main house OVERLEAF: *Lupinus* Gallery Series Lupin Gallery Series – The Long Border

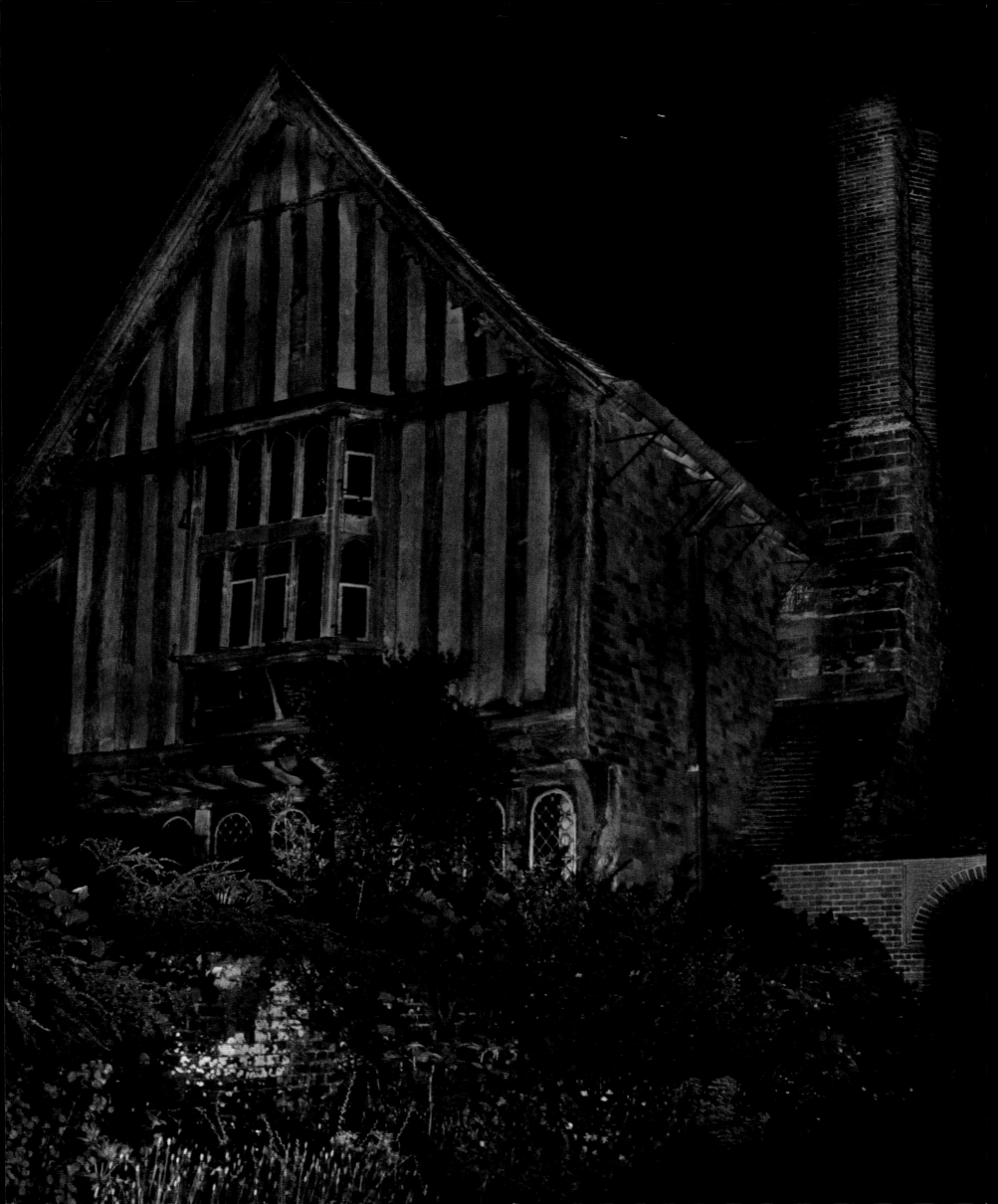

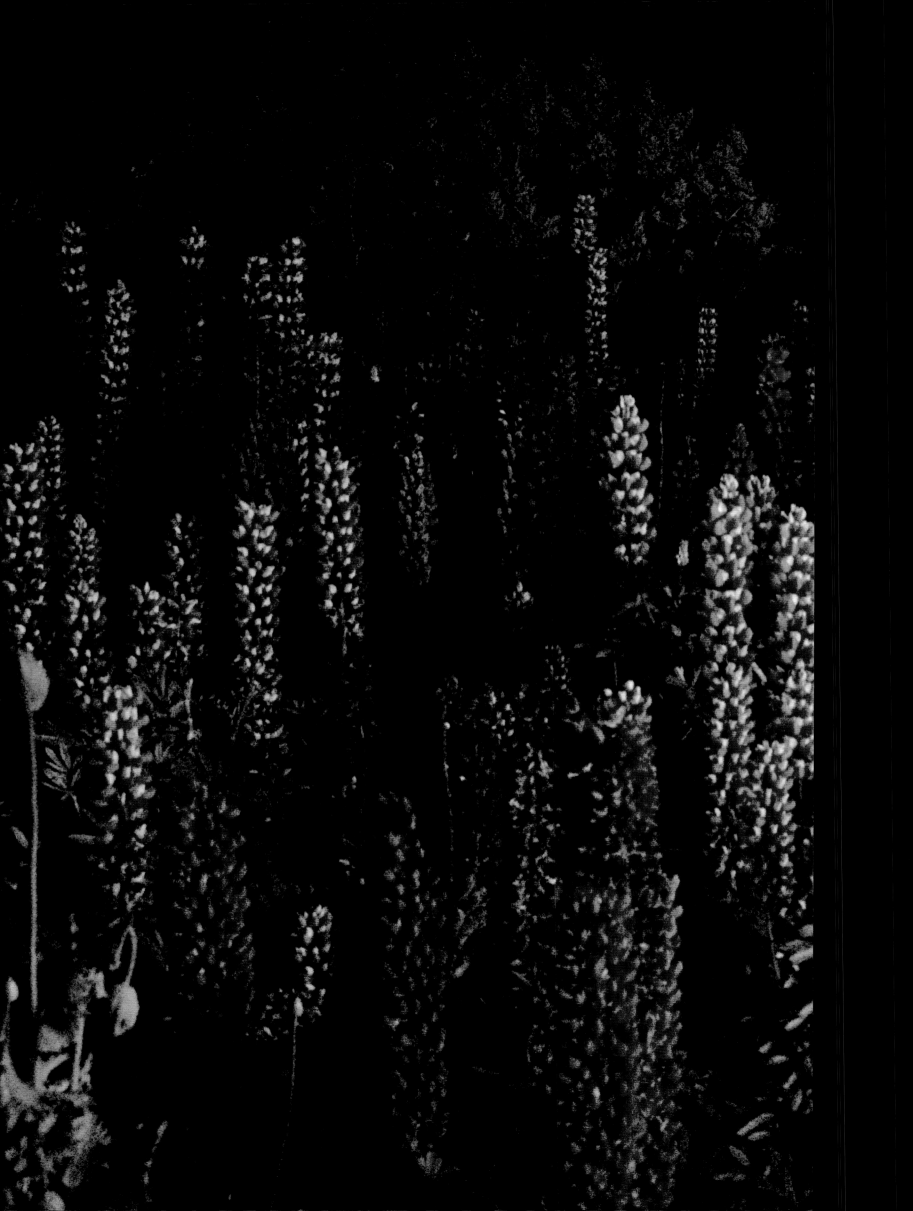

THOU SHALT, AT ONE GLANCE, BEHOLD

THE DAISY AND THE MARIGOLD;

WHITE-PLUM'D LILIES, AND THE FIRST

HEDGE-GROWN PRIMROSE THAT HATH BURST;

SHADED HYACINTH, ALWAY

SAPPHIRE QUEEN OF THE MID-MAY;

AND EVERY LEAF, AND EVERY FLOWER

PEARLED WITH THE SELF-SAME SHOWER.

JOHN KEATS (1795–1821)

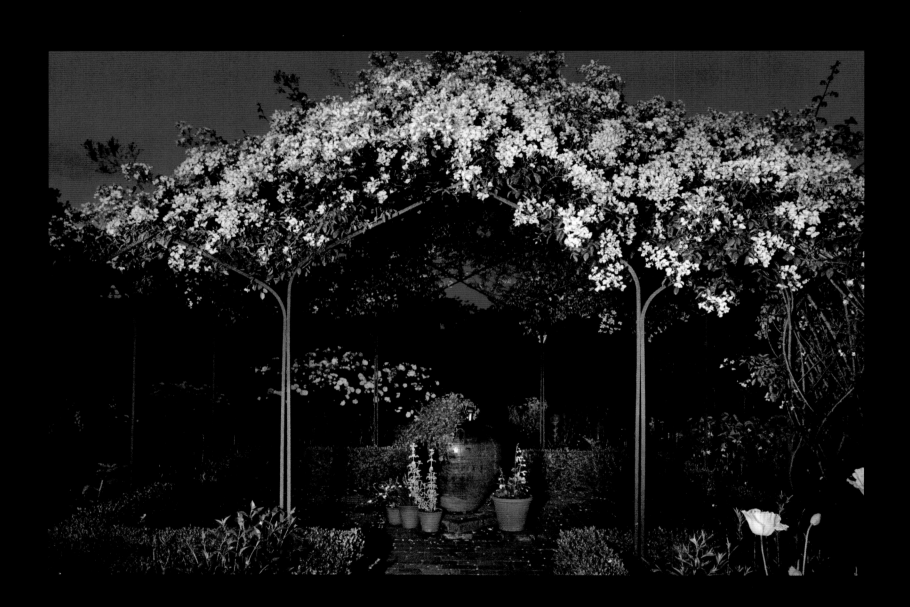

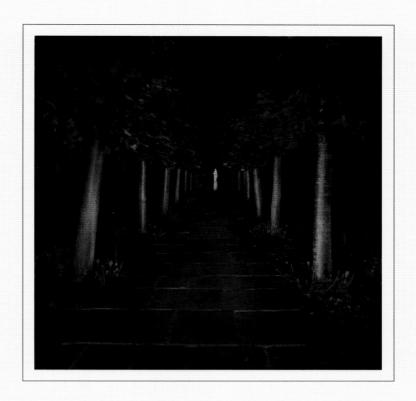

SISSINGHURST CASTLE GARDEN
KENT

ADAM NICOLSON

I HAVE SOMETIMES, on the way back from London, late at night in summer, having seen the full moon coming and going between the buildings on the road, turned aside, at one or two in the morning, with Kent asleep, and taken the lane down to Sissinghurst. At the top of the hill, I turn the lights off, wait for a few seconds while my eyes adjust. If the moon is bright, I can see and feel my way down the strip of tarmac, dropping to the stream between the hedges on either side. I slip the car between the Park and Birches, the oaks as dark as cattle, past the bulk of the farmhouse, along by the garages and the greenhouses. It is slightly downhill here and the car can coast in silence past the entrance arch, towards the barn and the gate into Delos and the White Garden.

You can't do this any more because burglars tried it a few years ago and now lights and alarms would pick up your movements. The whole place would be roused. But then, in the brightness of the summer moon, with the air still warm, and shadows in pools at your feet, you could slip into the White Garden in the very conditions Vita Sackville-West first imagined it.

The pale flowers glow in the night. The froth of the *Crambe maritima* is as cool as sea spray, its white spots caught in mid-air. Beside it, the lead virgin stands in the grey-green shadows. The falls of the irises float above their unseen stems. Moonlight makes everything immaterial, while above this full, glowing, flowered dance floor, in which the dancers are still, and the mood is as slow and unworldly as a nightclub in the early hours, there is the dark presence of the tower. The moon shines in its windows, white and flaring like phosphorus. This is Sissinghurst transformed, the unseen quiet of a hidden garden, a place set apart from the world. All of Vita's long love affair with Knole and Elizabethan glamour; all the forgotten glory of Elizabethan Sissinghurst itself; all her fierce, young belief that mediocrity was not enough; all the surrounding, orbiting rings of the farm, Kent and England: all of that in this white-flowered silence becomes overwhelmingly real.

It is the moment when the art of a garden reaches its most poetic condition. In a famous paragraph in *The Defense of Poesie* (i.e. Poetry), written by Sir Philip Sidney in the very years that the great Elizabethan house at Sissinghurst was built, he makes the claim that only in art is perfection to be found. Nature must always come second to it, regarding the perfection of art's forms with envy: 'Nature never set forth the earth in so rich Tapestry as divers Poets have done, neither with so pleasant rivers, fruitful trees, sweet-smelling flowers, nor whatsoever else may make the too much loved earth more lovely: her world is brazen, the Poets only deliver a golden.'

Perhaps that is true, but this garden, at night, seems to deny it. For once, nature has delivered a more perfect world than the poet ever could, not golden but silver, floating, disconnected from the real, and more perfect because of it.

OPPOSITE: *Rosa mulliganii* Mulligan climbing rose – The White Garden
ABOVE: *Tilia platyphyllos* 'Rubra' Red-twigged lime – The Lime Walk

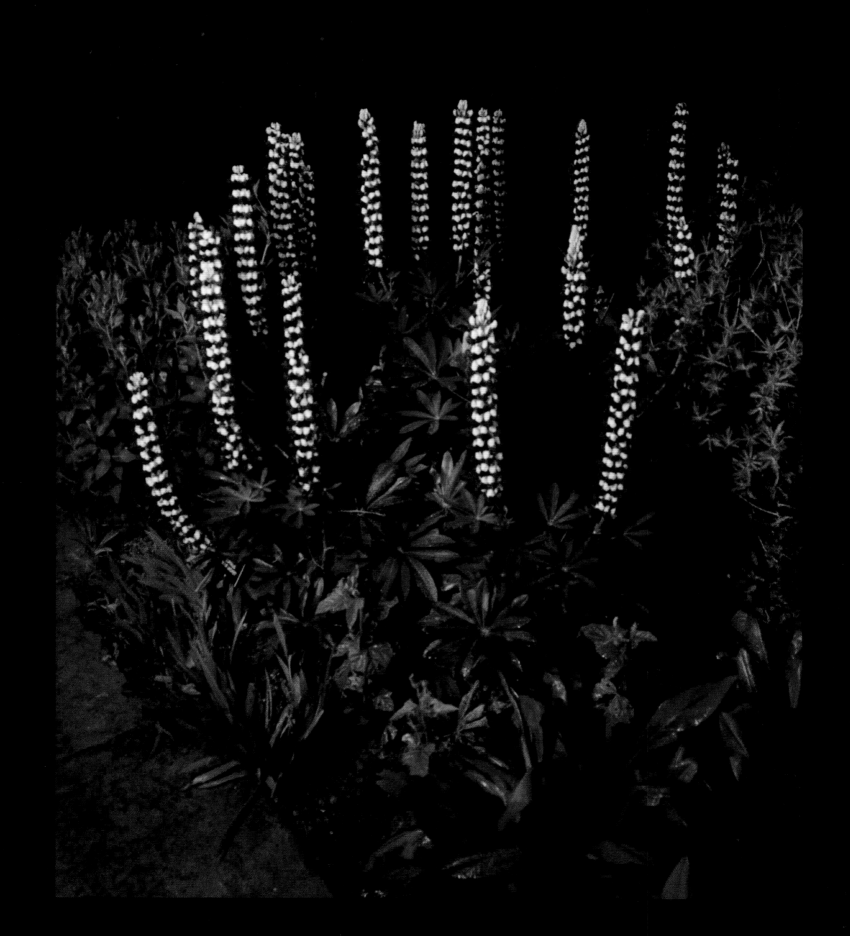

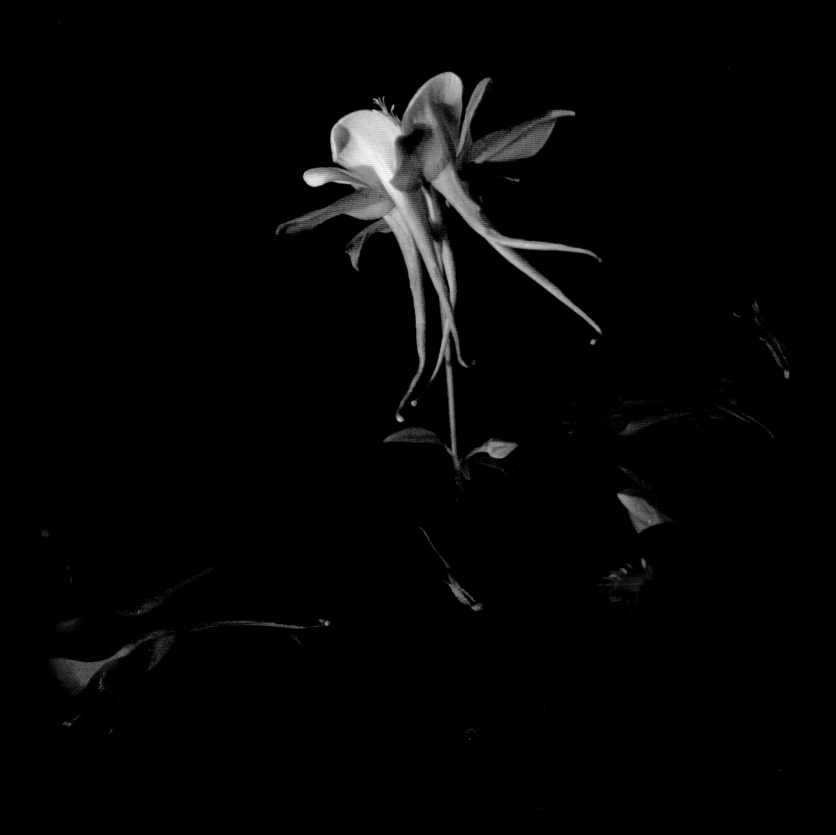

OPPOSITE: *Lupinus* 'Blue Jacket' Lupin 'Blue Jacket' – The Purple Border
ABOVE: *Aquilegia* Long-spurred hybrid Long-spurred hybrid columbine – The Top Courtyard

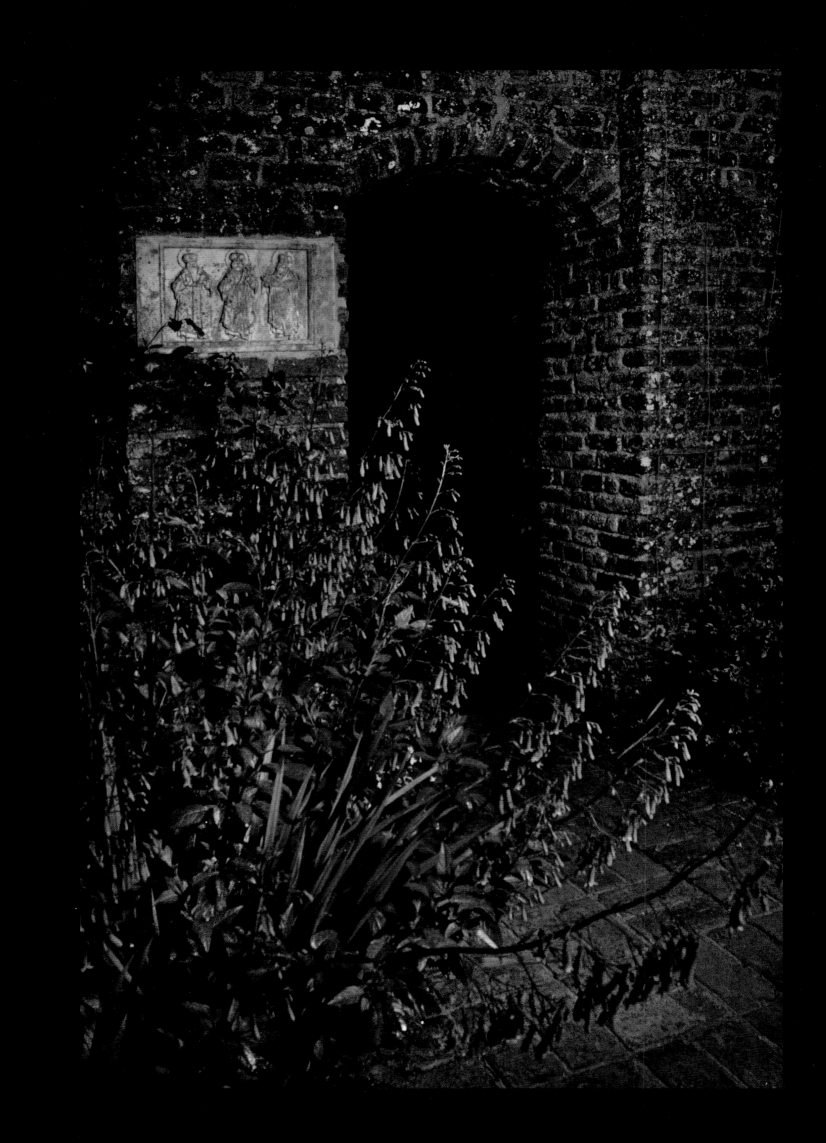

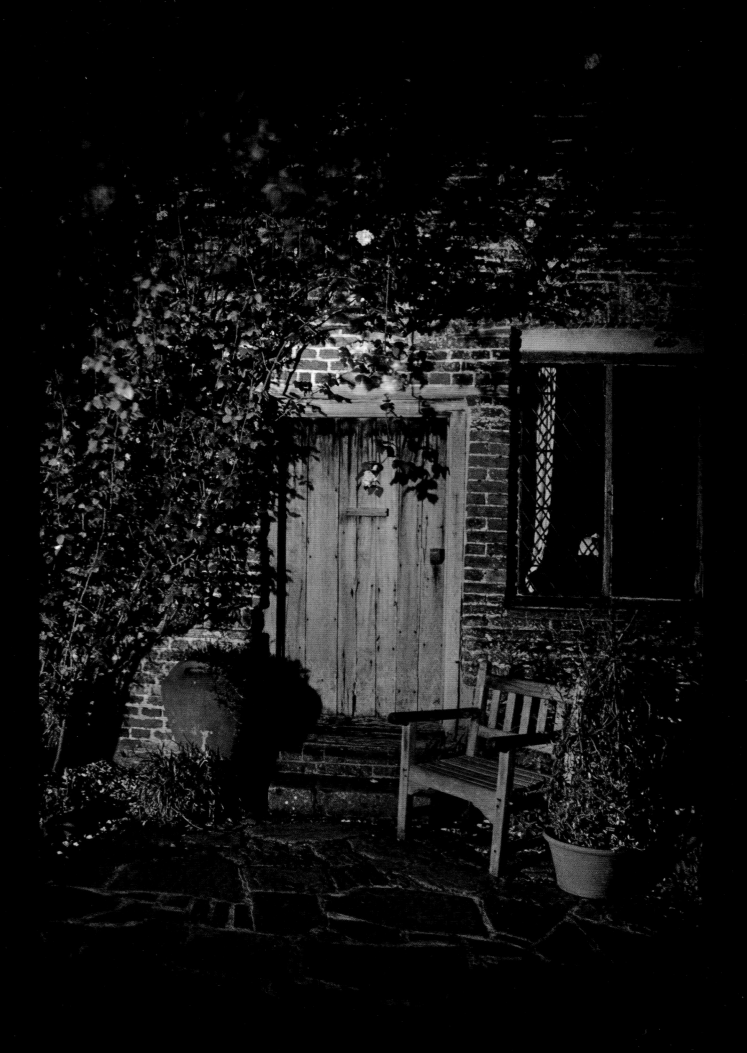

OPPOSITE: *Phygelius aequalis* 'Yellow Trumpet' Cape fuchsia – The Lower Courtyard
ABOVE: *Rosa* 'Madame Alfred Carrière' – The Cottage Garden

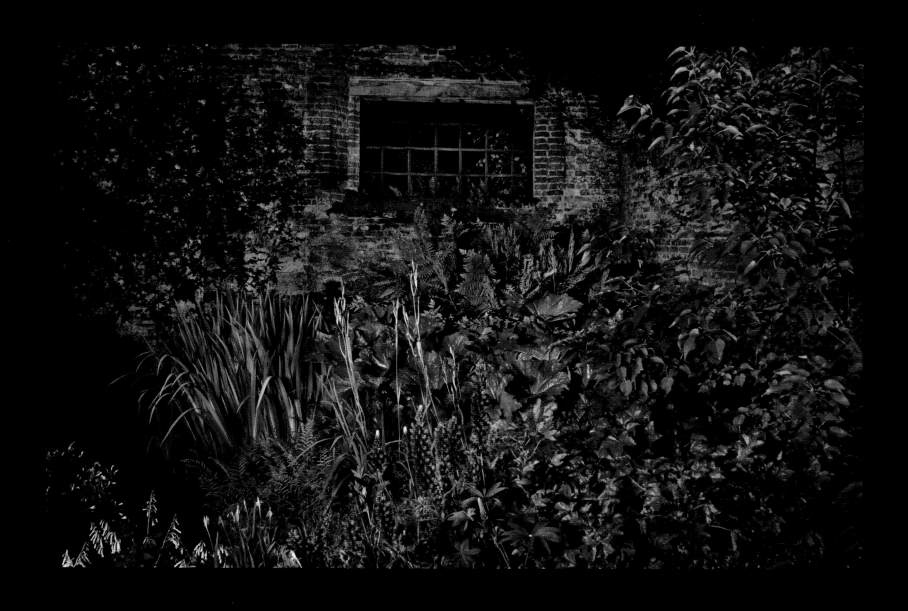

OPPOSITE: *Magnolia liliiflora* 'Nigra' Lily-flowered magnolia – The Lower Courtyard
ABOVE: The Sunken Garden

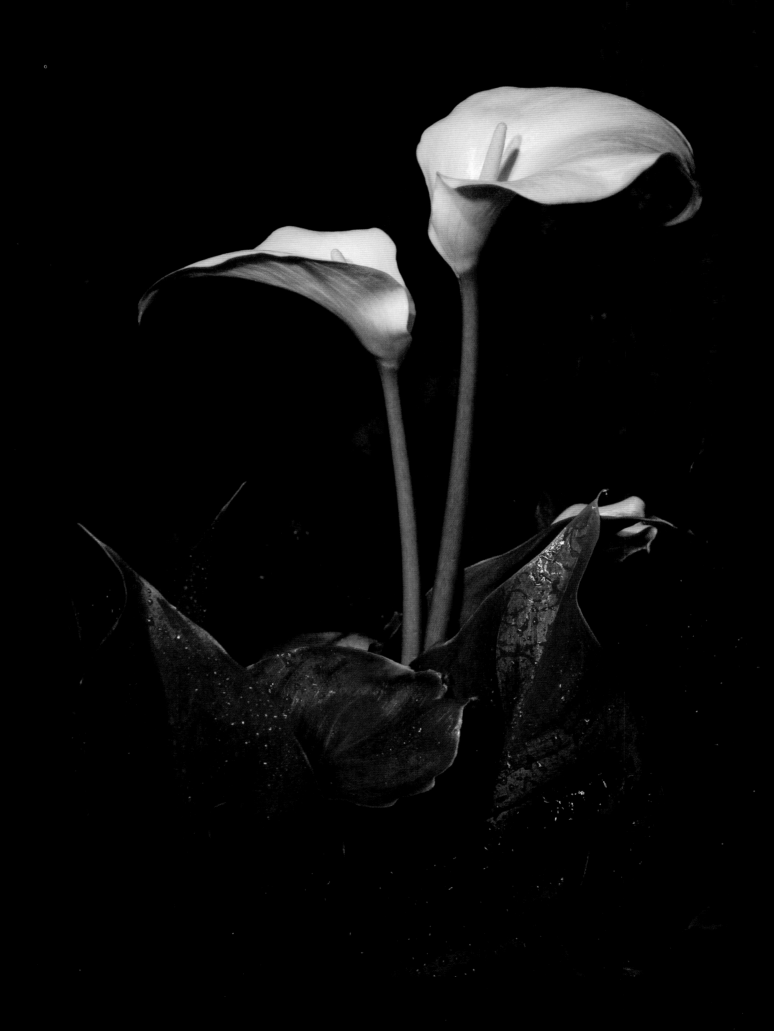

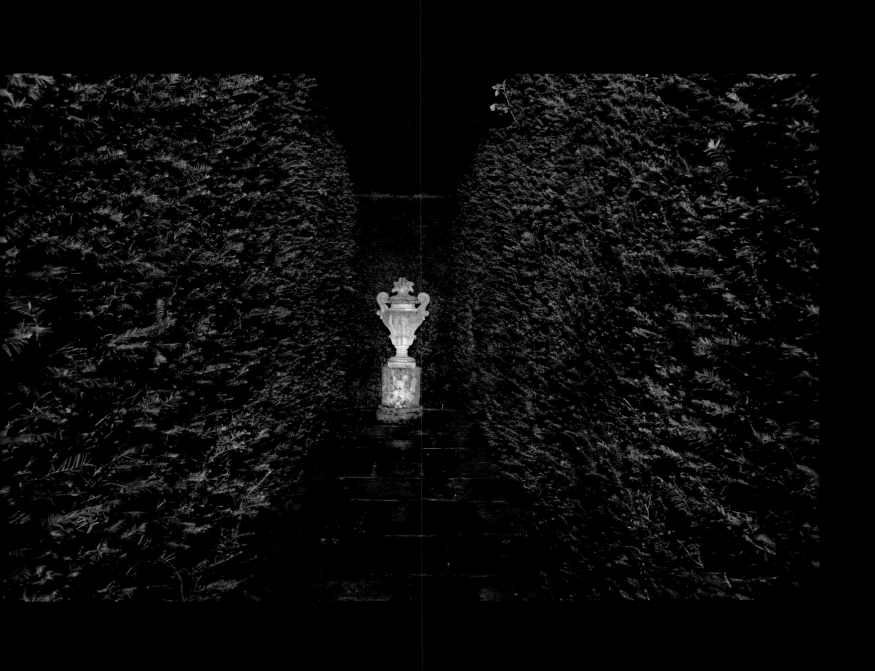

OPPOSITE: *Zantedeschia* Calla lily – The Lower Courtyard
ABOVE: Beech Hedge

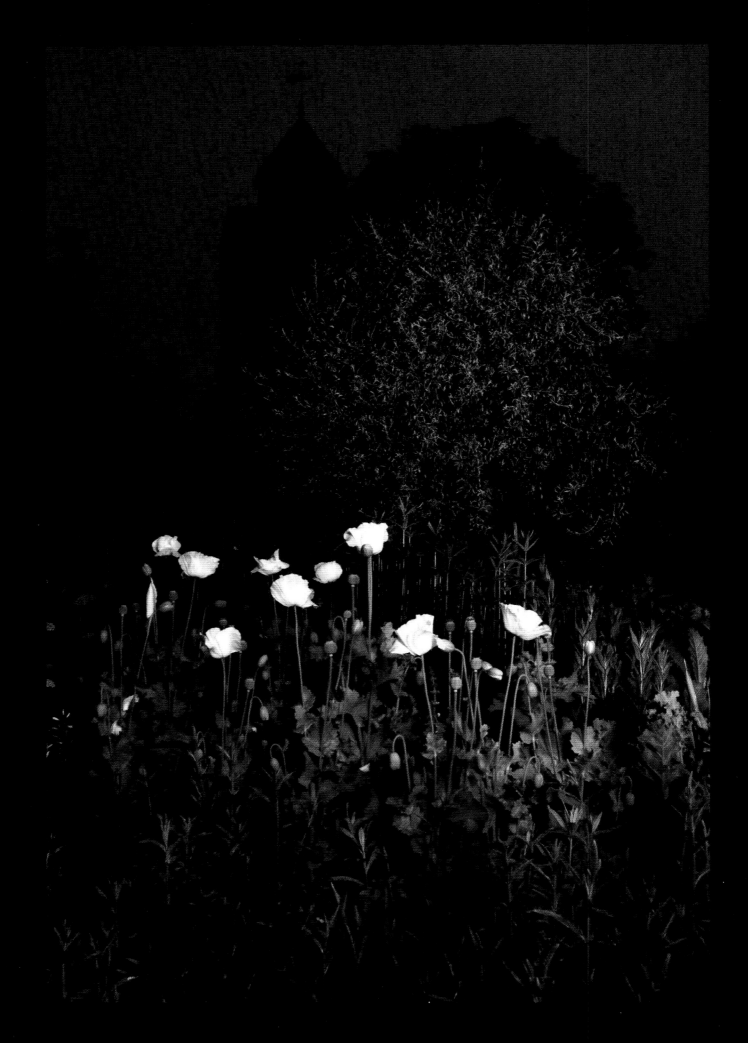

ABOVE: *Papaver somniferum* Semi-double white opium poppy – The White Garden
OPPOSITE: *Eryngium alpinum* Sea holly – The Rose Garden

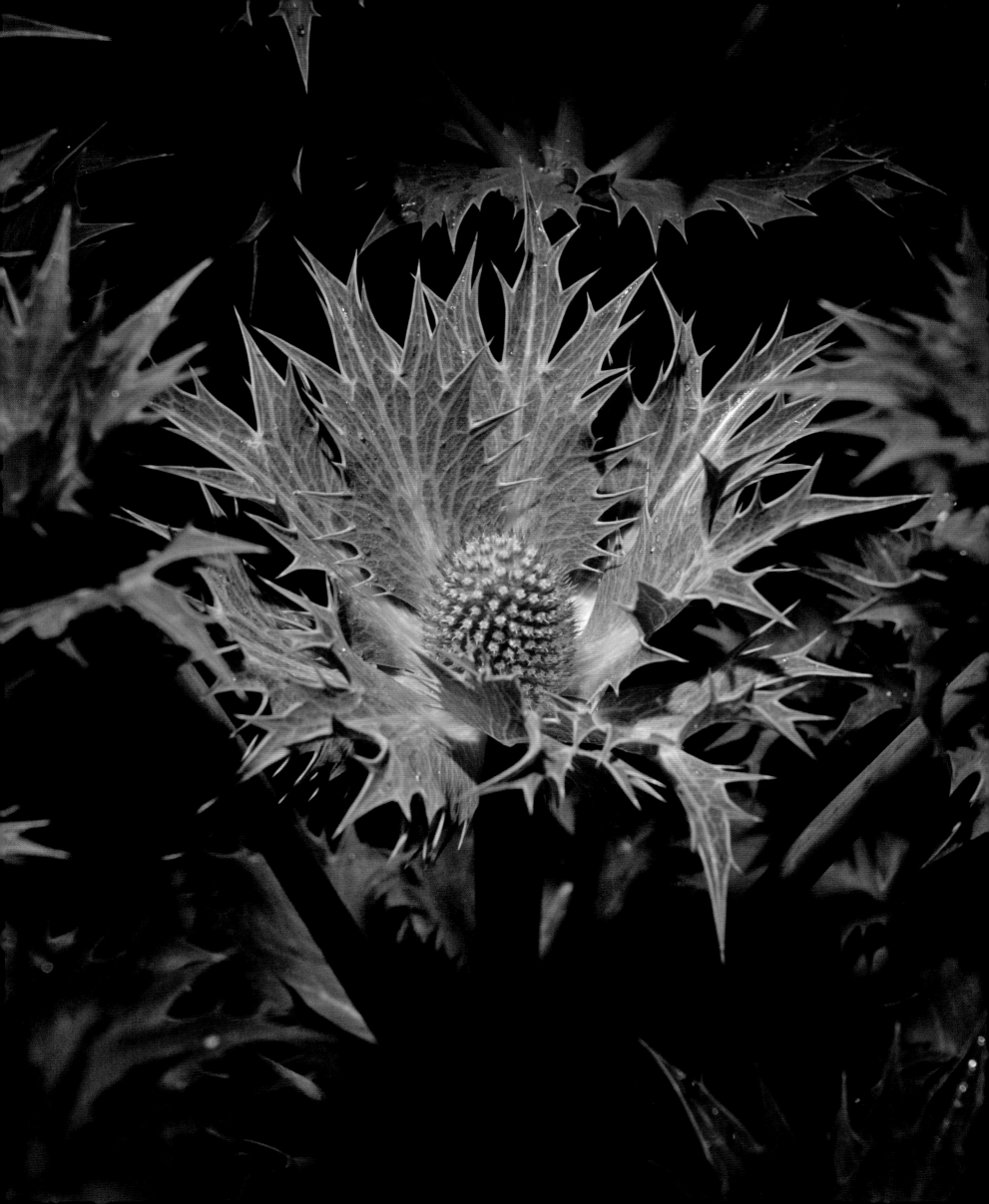

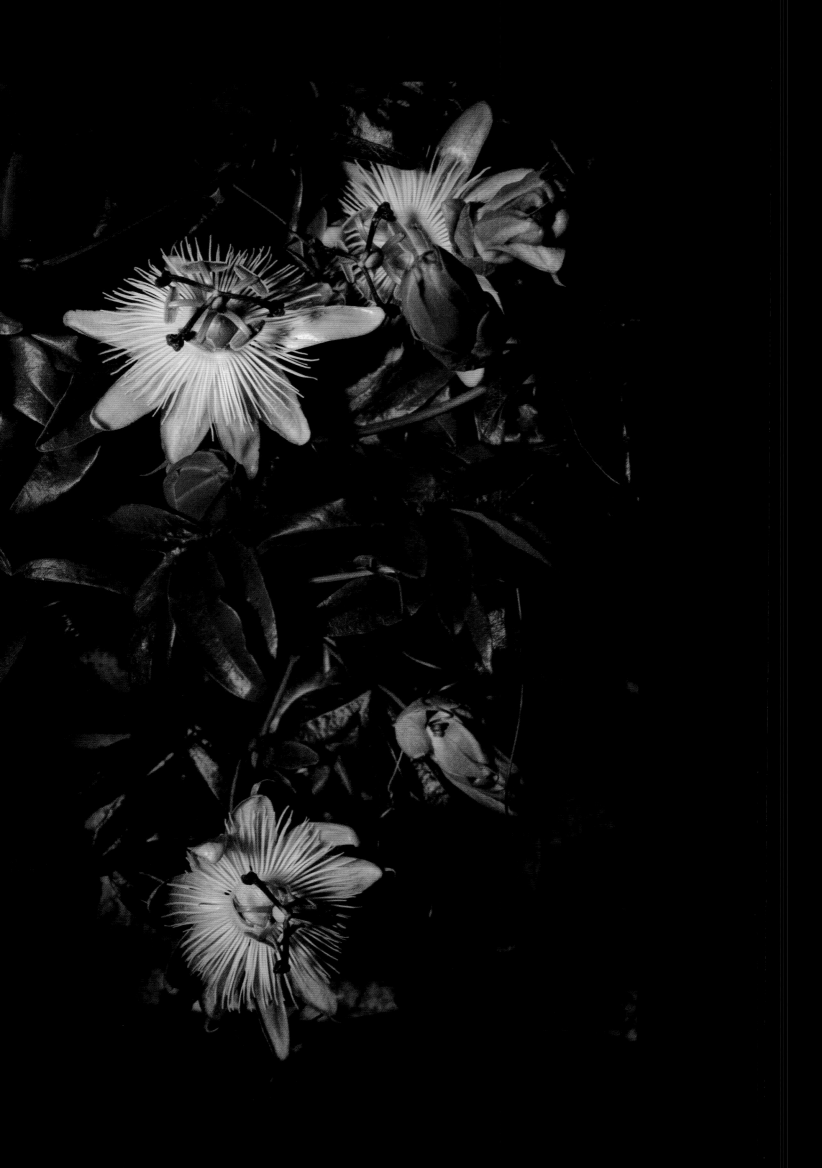

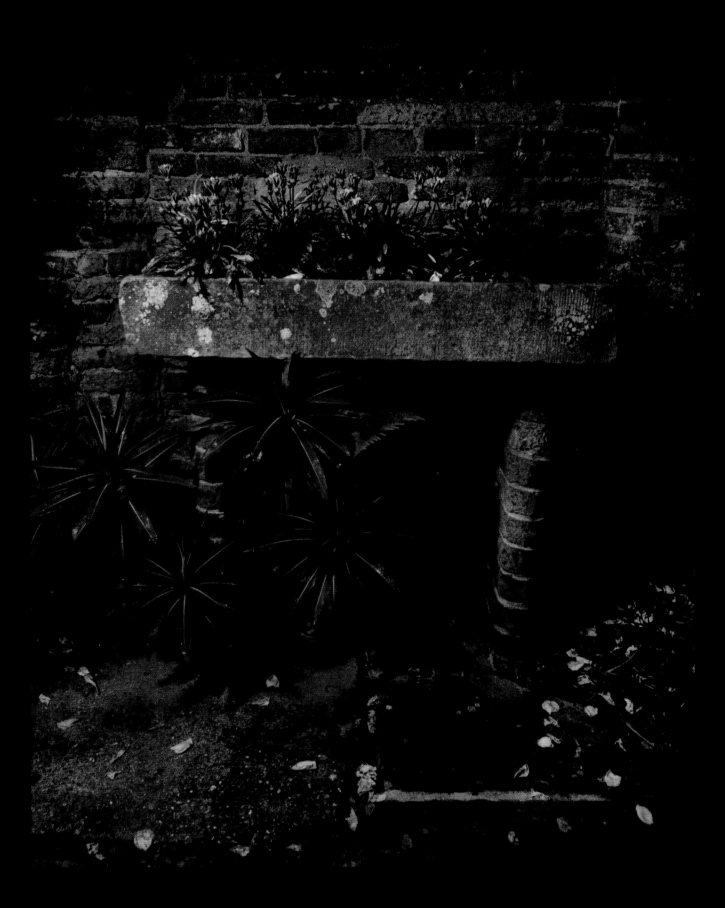

OPPOSITE: *Passiflora caeruela* 'Constance Elliot' Passion flower 'Constance Elliot' – The Courtyard Garden
ABOVE: *Gazania rigens* 'Freddie' Treasure flower 'Freddie' – The Courtyard Garden

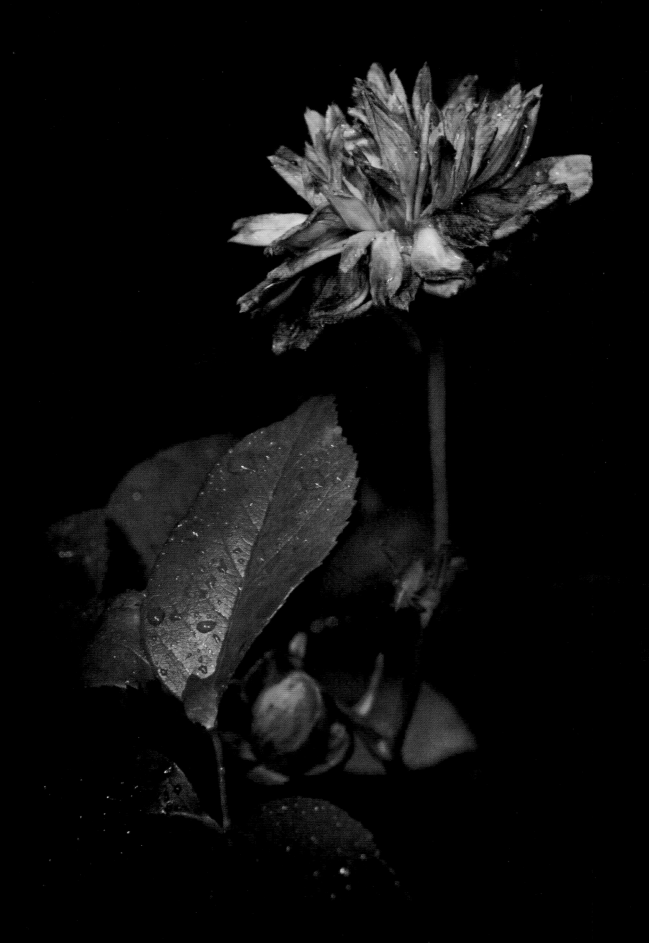

ABOVE: *Rosa chinensis* 'Viridiflora' Green rose – The Flower Garden

OPPOSITE: The Tower OVERLEAF: The Courtyard

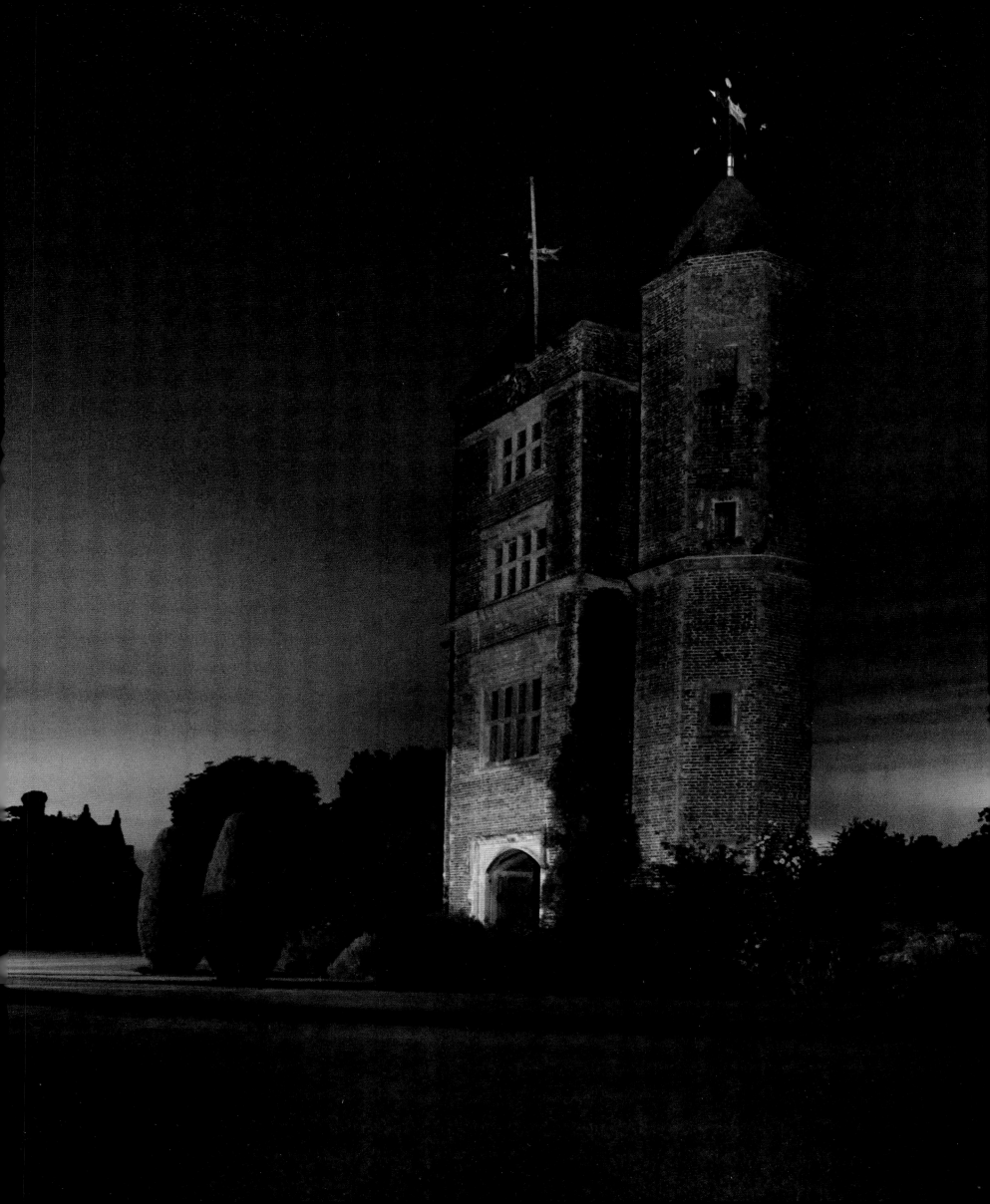

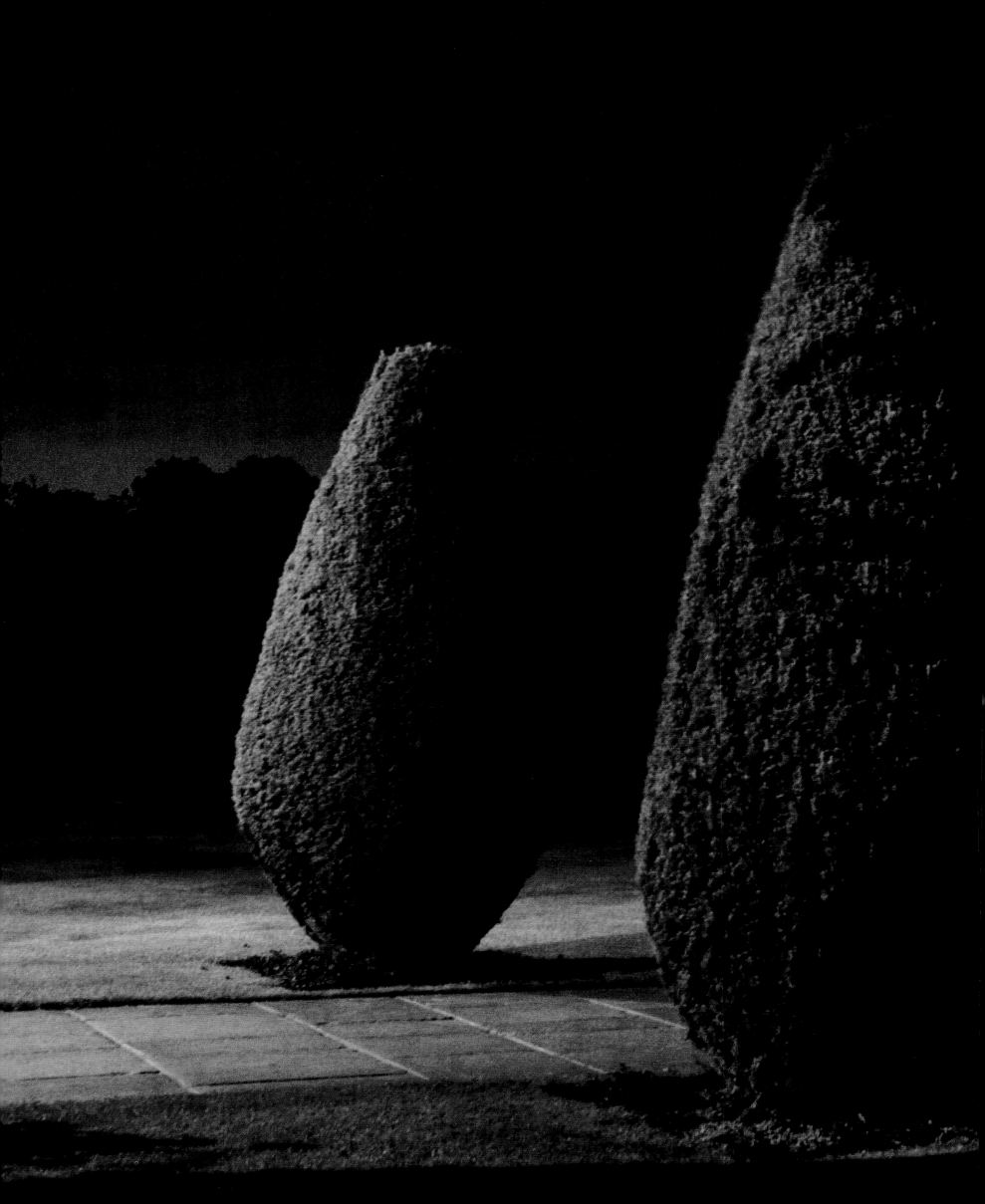

THROUGH PRIMROSE TUFTS, IN THAT GREEN BOWER,

THE PERIWINKLE TRAILED ITS WREATHS;

AND 'TIS MY FAITH THAT EVERY FLOWER

ENJOYS THE AIR IT BREATHES.

WILLIAM WORDSWORTH (1770–1850)

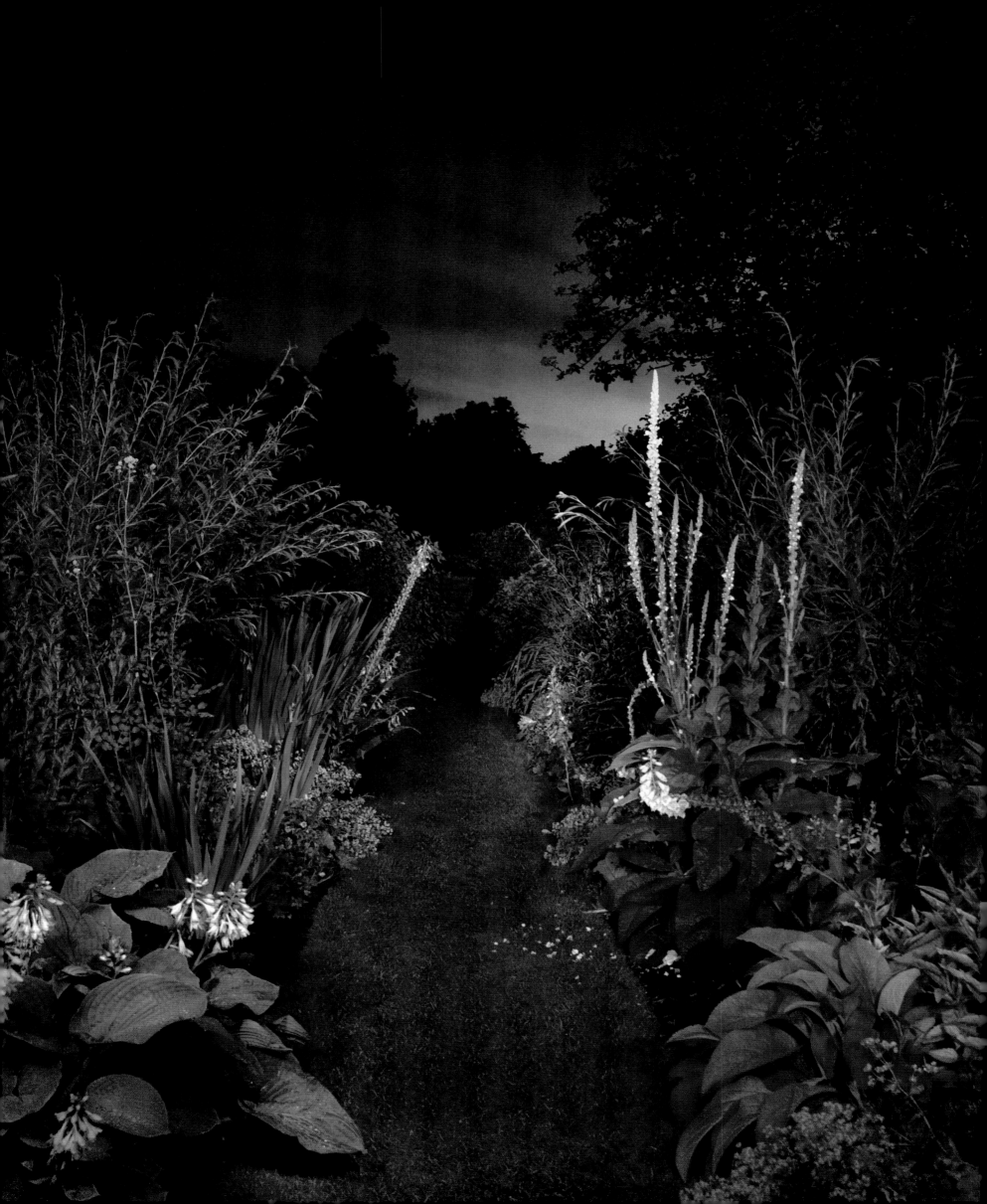

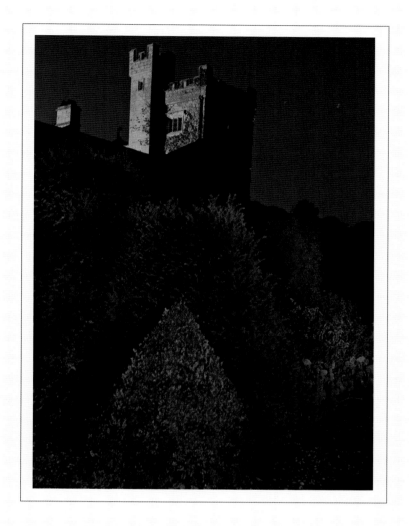

LEVENS HALL AND GARDENS
CUMBRIA

SUSAN BAGOT

THE MAGIC OF THE TOPIARY GARDEN at night was first introduced to me by my mother-in-law, who used to insist that everyone must see the garden by the light of the full moon. She would lead all comers outside and we would stand in wonder as the moonlight outlined the variety of shapes and cast eerie shadows into the depths. Whilst very beautiful it was also rather edgy and frightening. We were undoubtedly intruding on the quiet solitude of these old yews – it was their secret world, their memories, their silences. Ghosts wander with ease here, uninterrupted and respected.

The yews have seen so many changes and yet have survived. Even the sudden descent of a massive cedar tree in a January gale only damaged two or three yews, and they will revive to show off to the public once more. In our own time the night sky has been lit by fireworks and the yew trees garlanded with fairy lights at family celebrations, happy, jolly occasions enabling them to be a worthy backdrop – part of the family.

Four hundred years of change and growth, of patient care and skilled clipping, have formed this garden. Ten head gardeners have supervised the upkeep of the yews, taught others to trim their haircuts and shape their destinies. Elegant ladies and gentlemen have strolled in their midst and children have run free through the tunnels and secret dwellings at their bases. They have gazed out over abundant Victorian bedding, neat rows of colour and standard plants, and now vibrant blocks of colour brush their roots in spring and summer. In the winter they stand alone with nothing to detract from their stately presence until the frost and snow creep up on them in the night. Moonlight on snow – magic!

All the owners of Levens have loved the garden, relishing its moods and atmosphere and sharing its uniqueness with visitors. The beauty will live on when we are long gone, as the great age of the yews serves to remind us that we are just a passing beat in the heart of time. The garden at night will keep its secrets and the old yews will live on in quiet solitude, even melancholy, safe in their own world.

OPPOSITE: Herbaceous border
ABOVE: The Hall

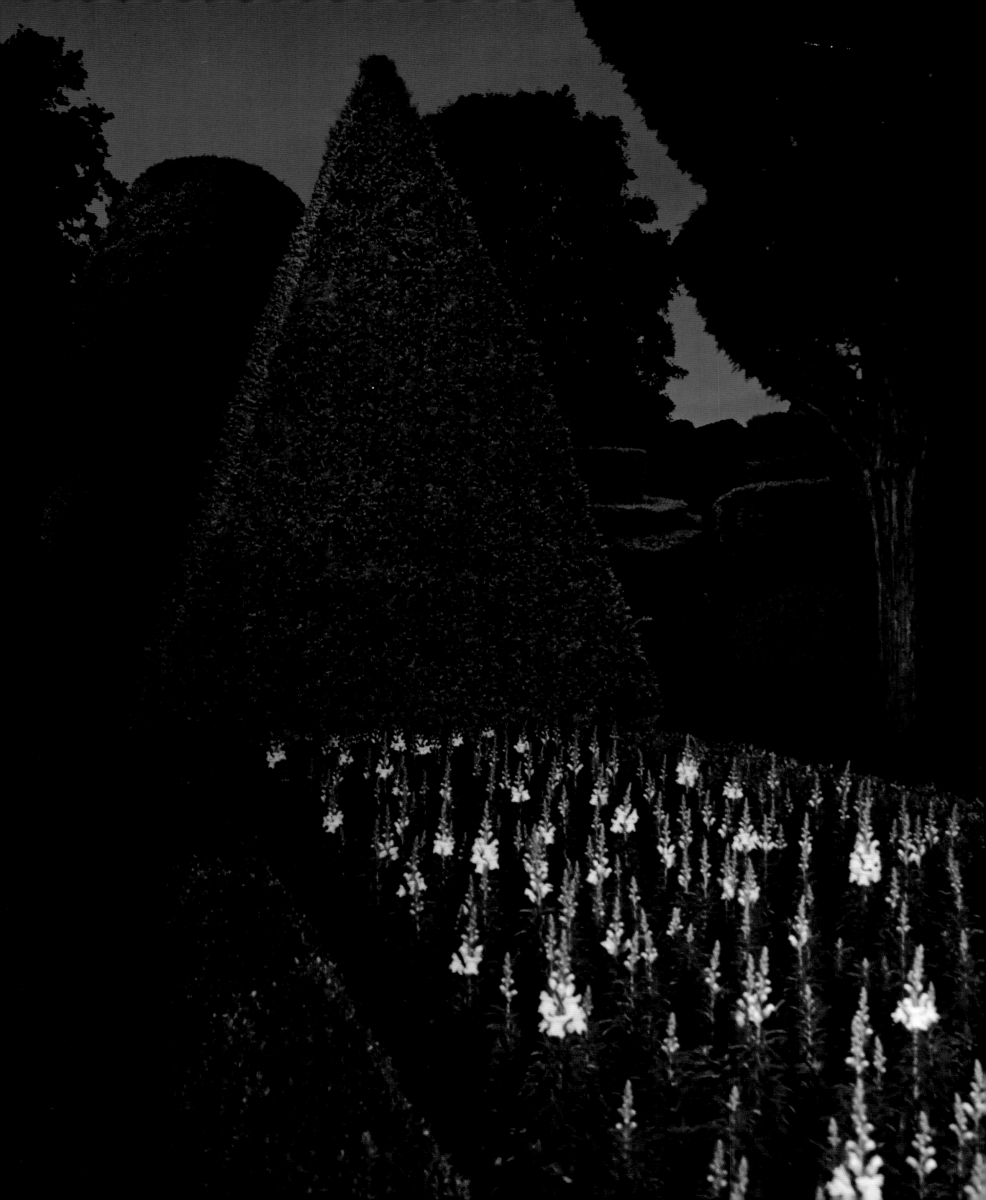

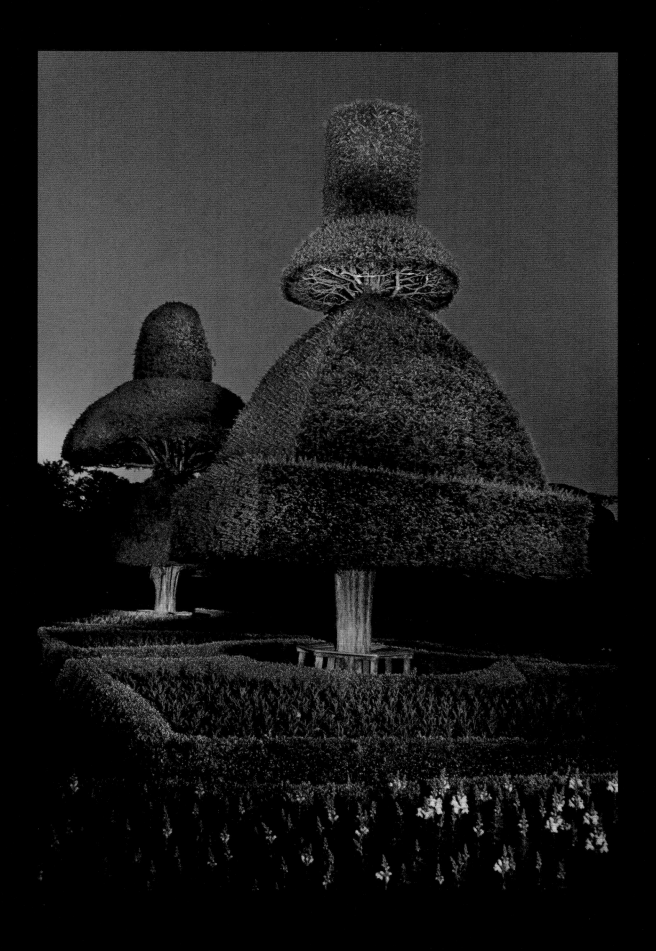

OPPOSITE: *Antirrhinum* Coronette Series Lemon yellow snapdragon – The Topiary Garden
ABOVE: The Great Umbrellas

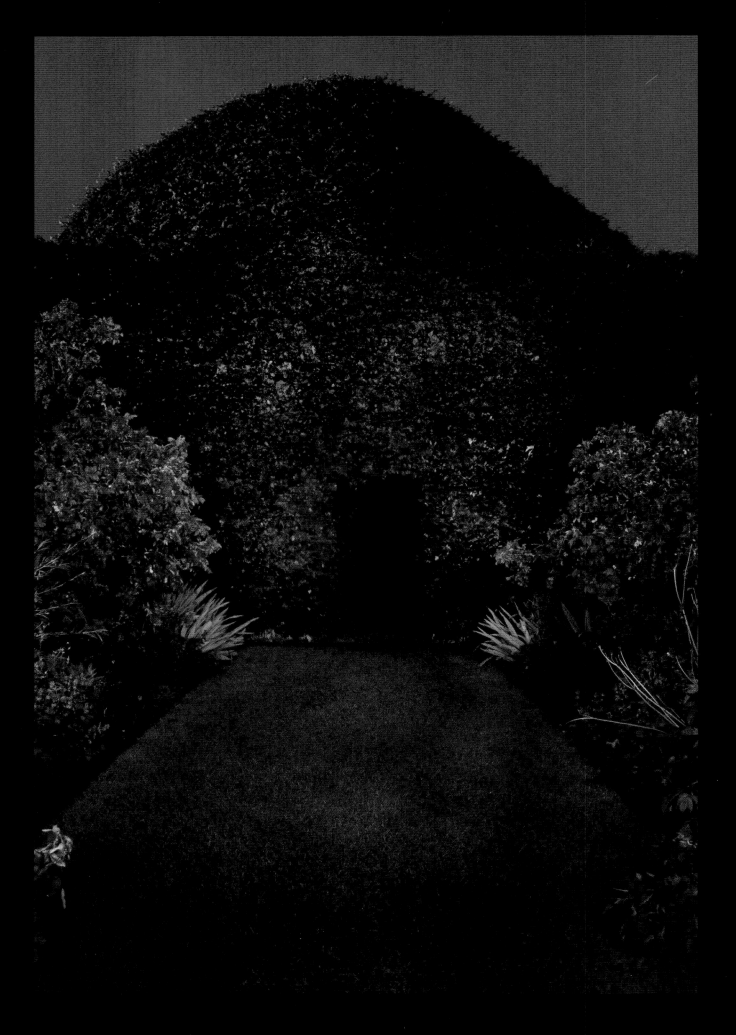

ABOVE: The Beech Hedge

OPPOSITE: *Clematis* 'Niobe'

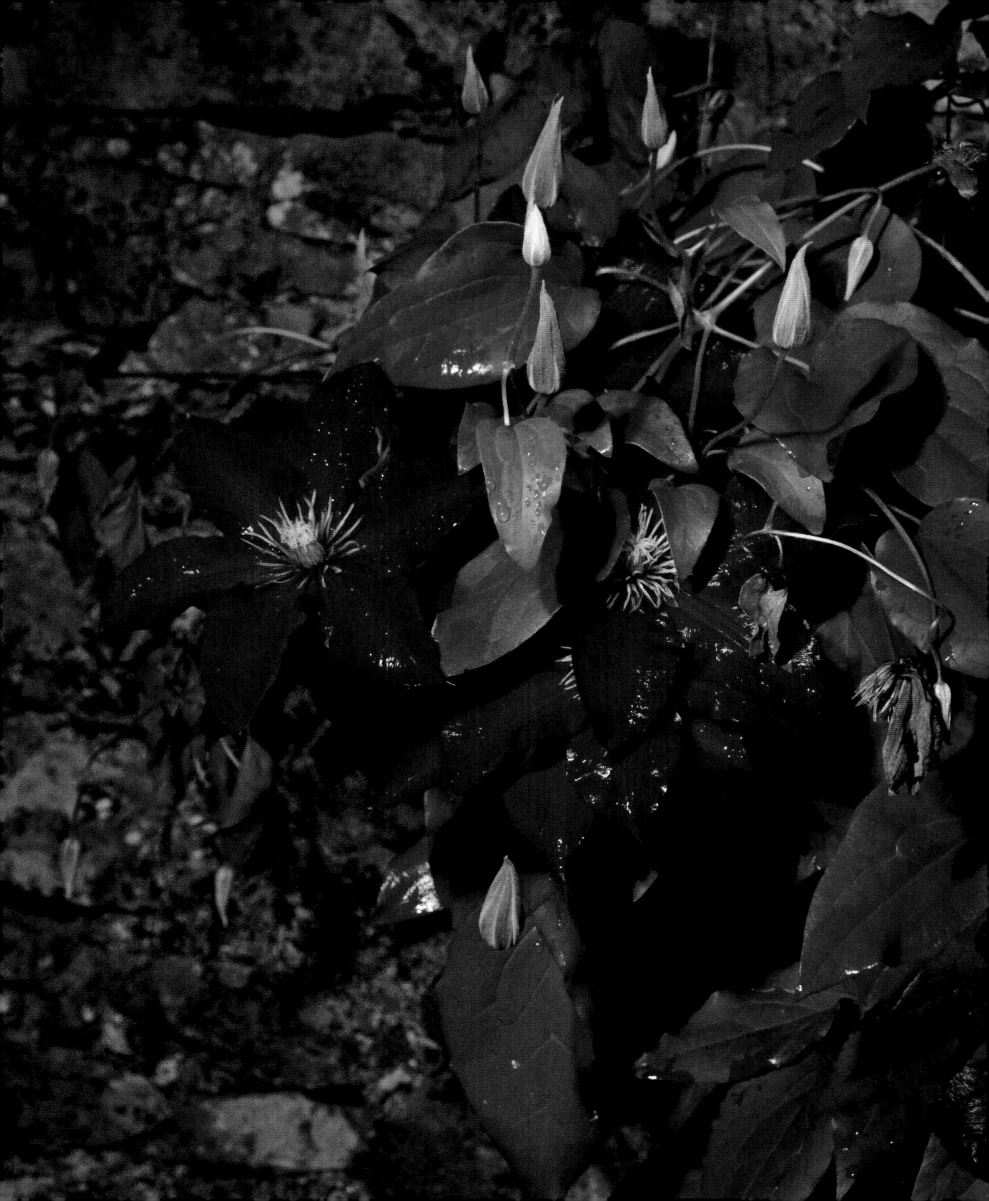

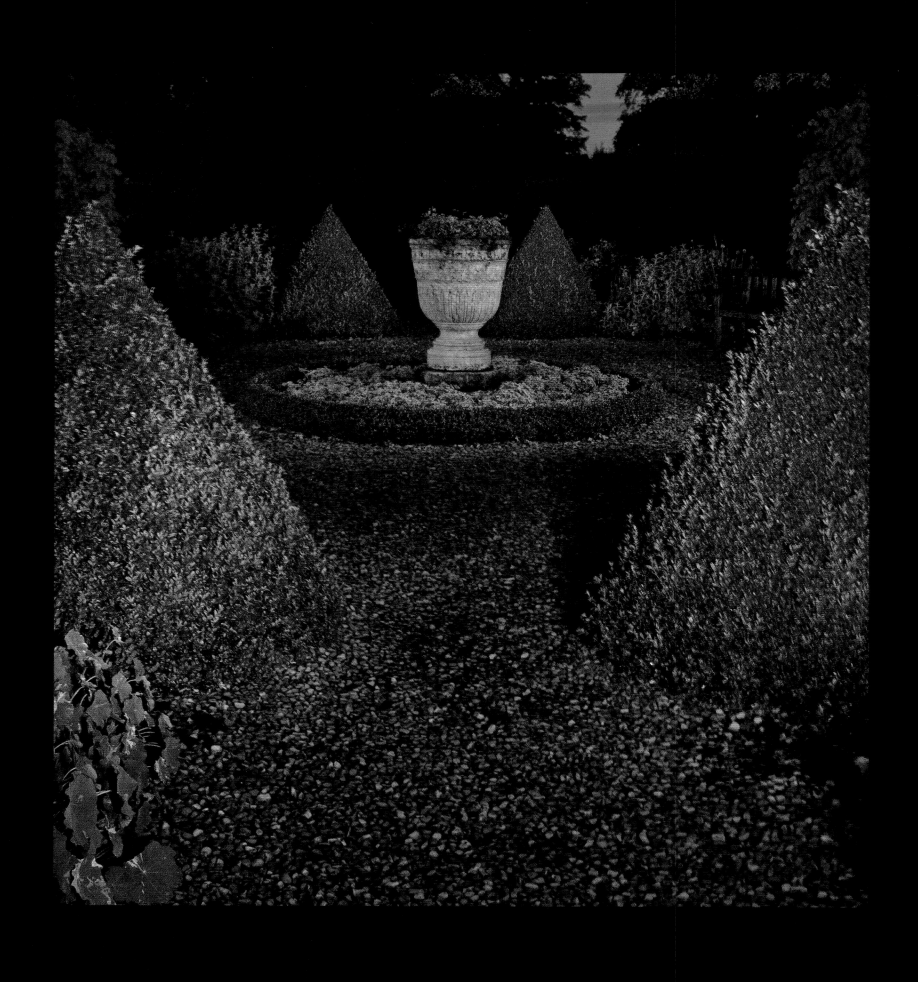

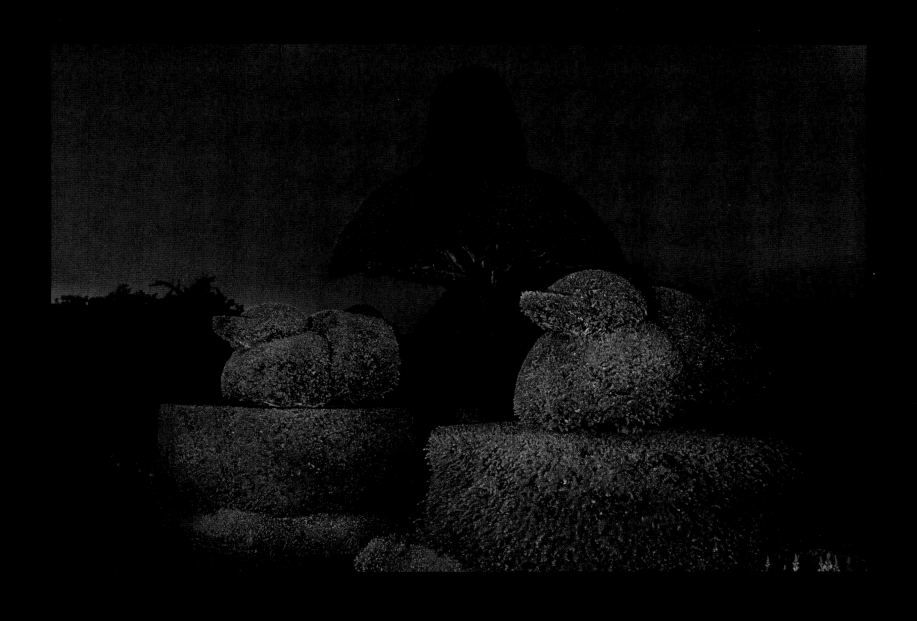

OPPOSITE: The Herb Garden
ABOVE: The Topiary Garden

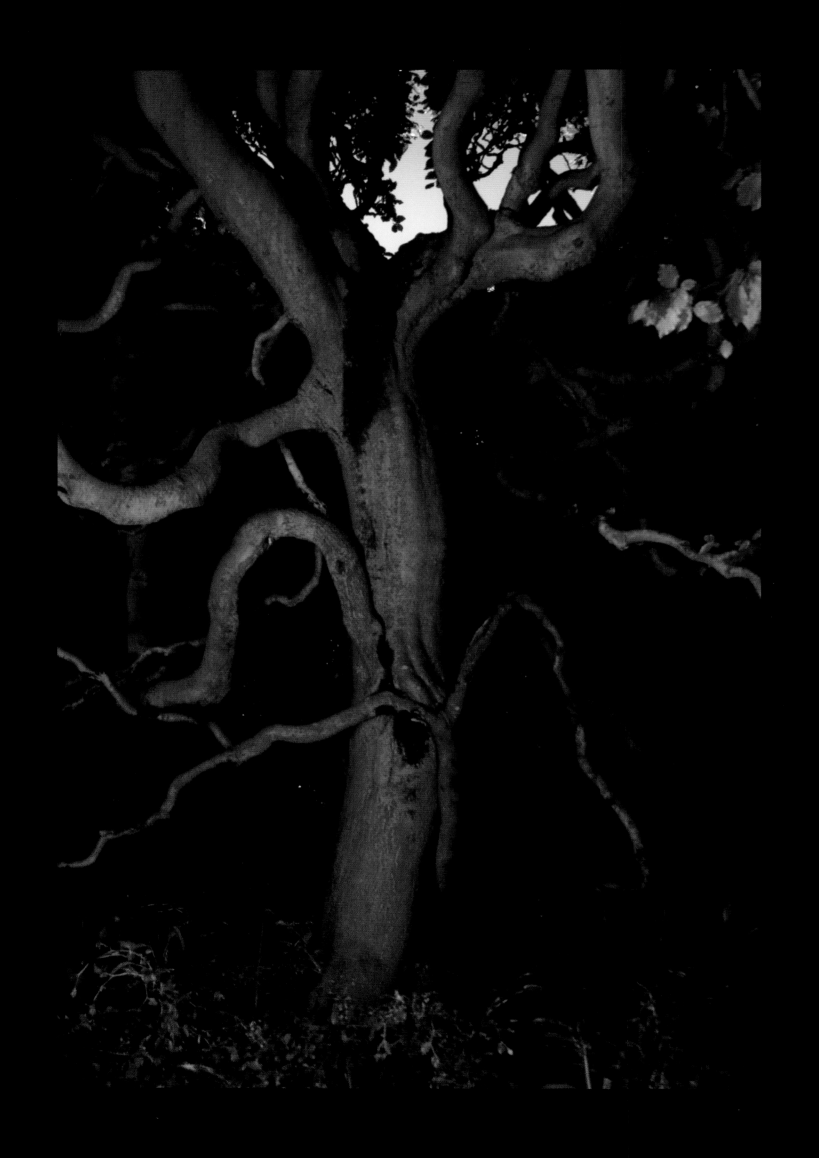

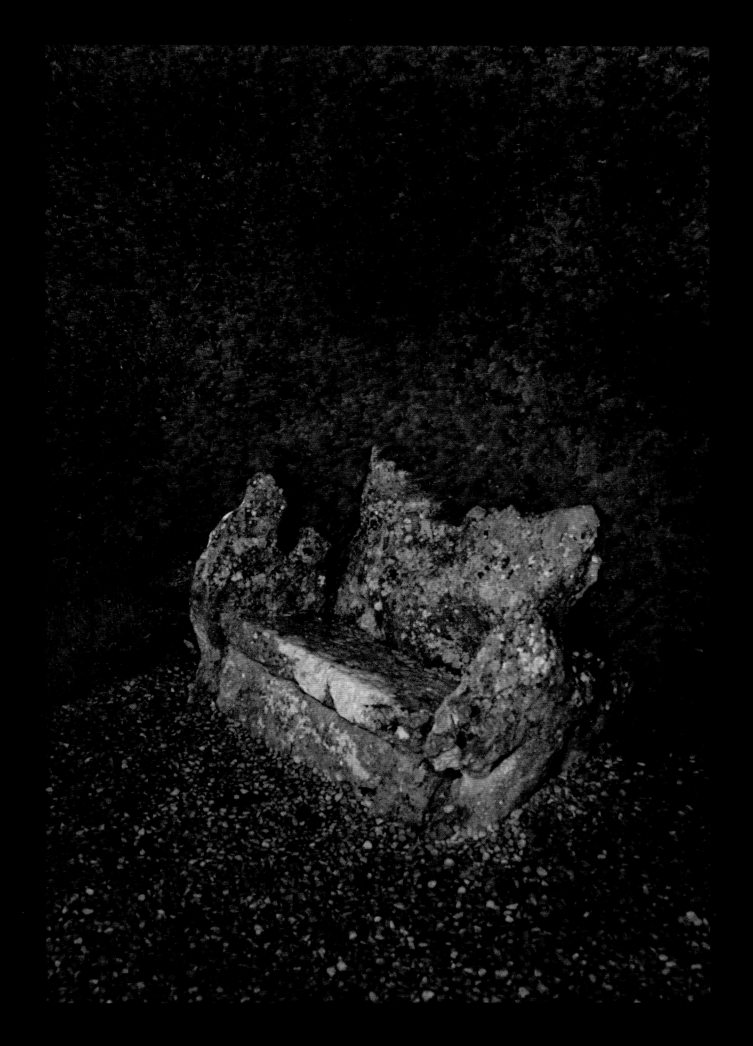

OPPOSITE: Inside the Beech Hedge

ABOVE: Waterworn limestone seat

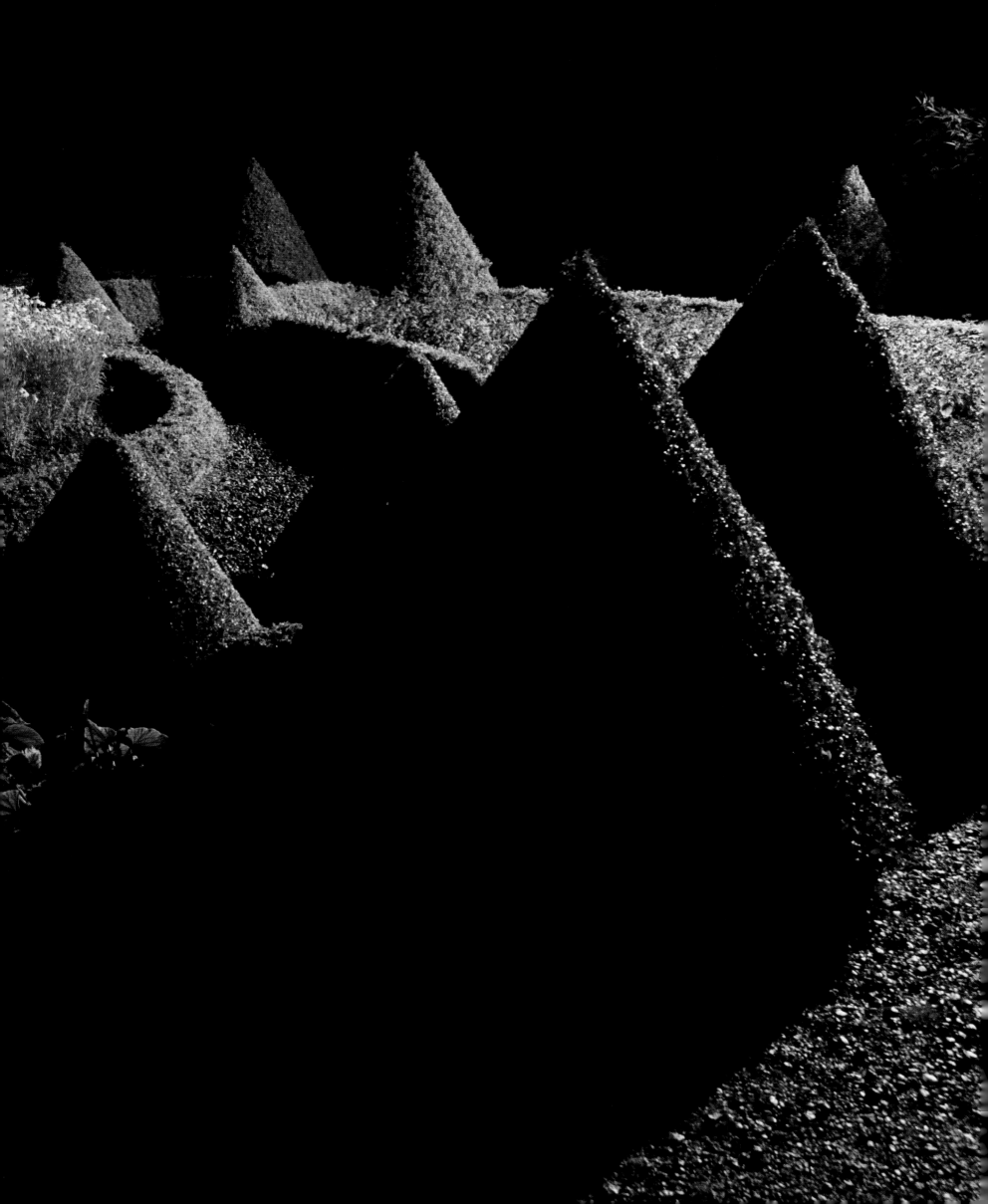

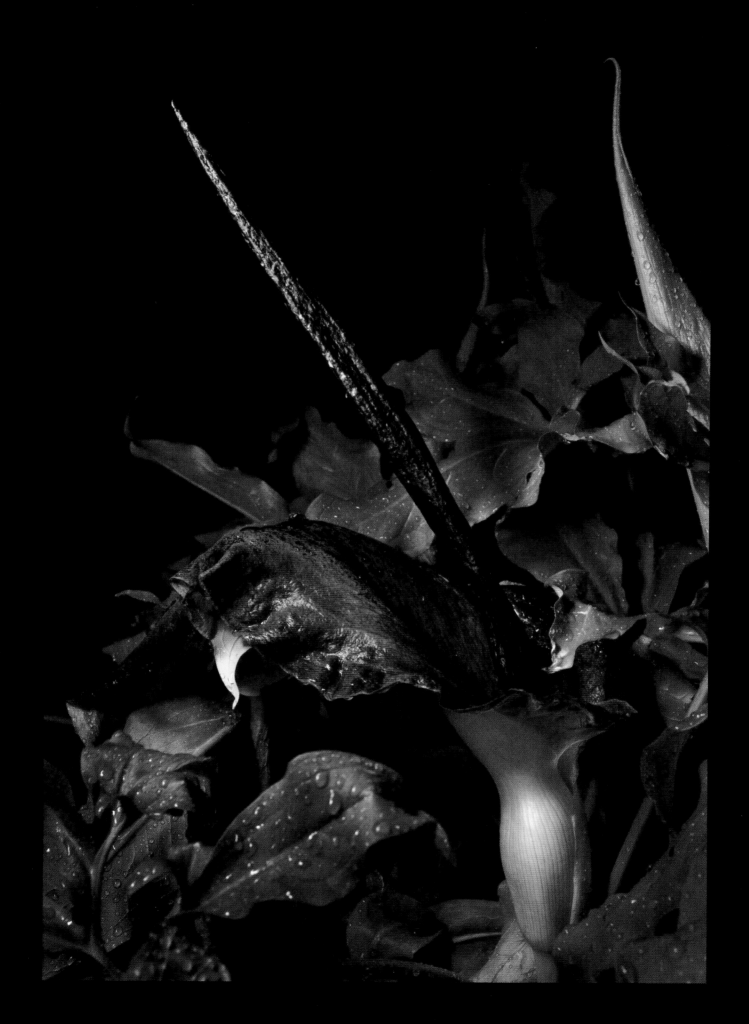

OPPOSITE: The Seventeenth-Century Garden
ABOVE: *Dracunculus vulgaris* Dragon's arum

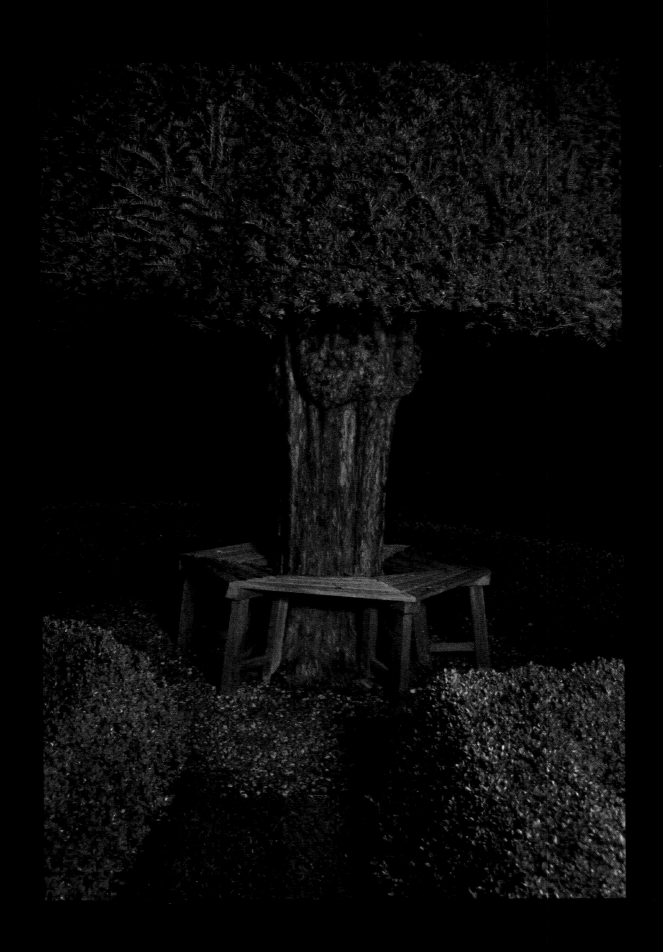

ABOVE: The Topiary Garden
OPPOSITE: Beech Hedge

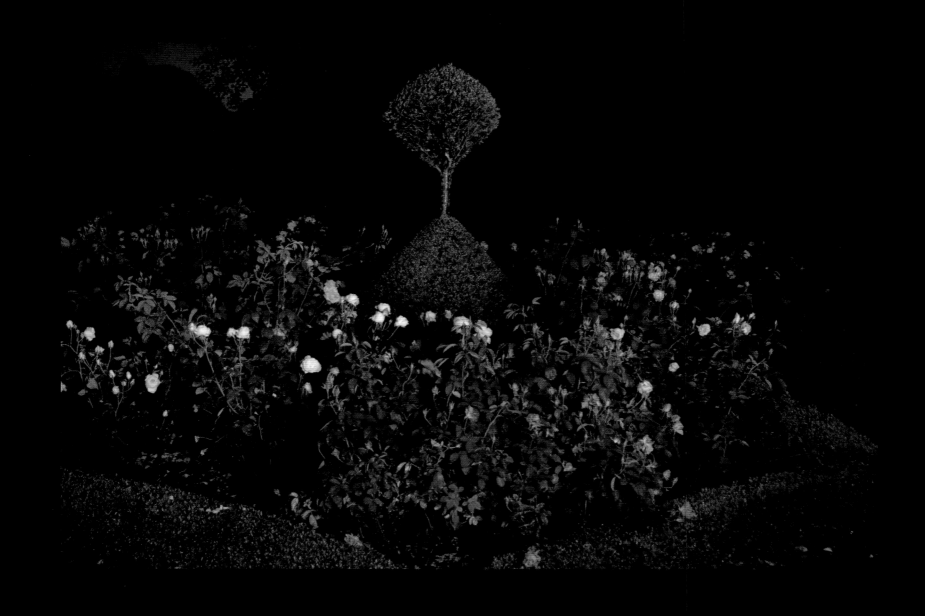

ABOVE: The Rose Garden in the Seventeenth-Century Garden
OPPOSITE: The Topiary Garden

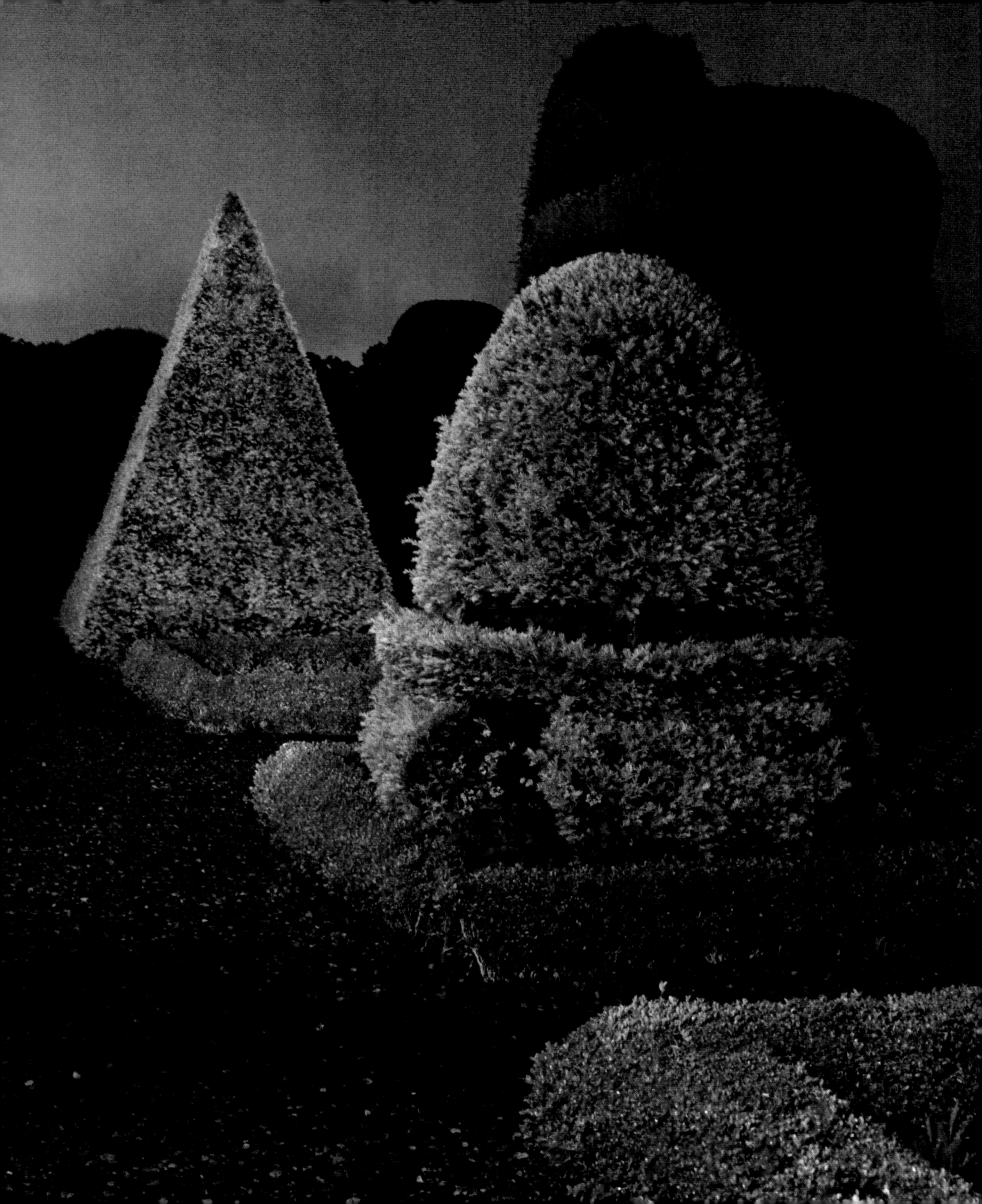

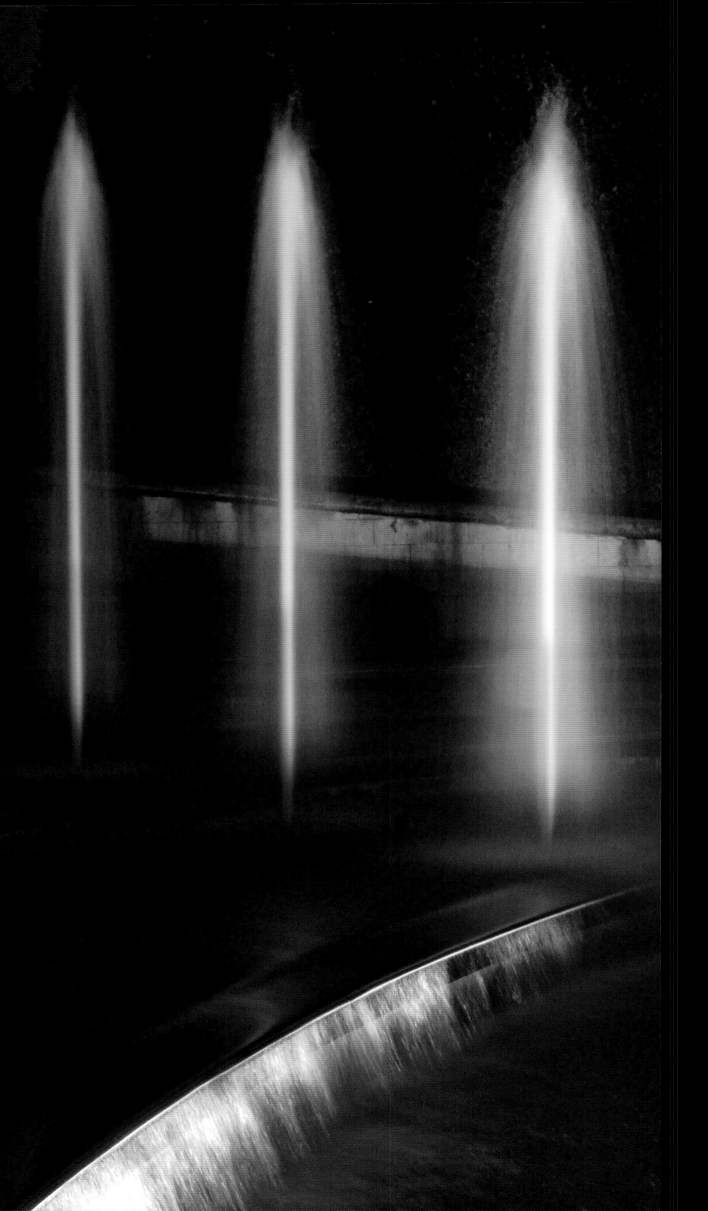

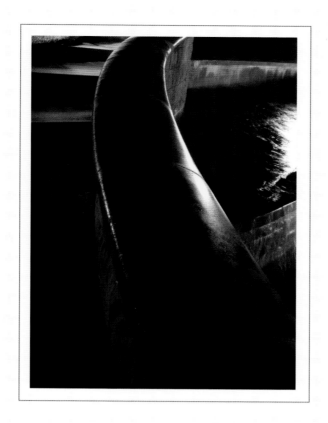

THE ALNWICK GARDEN
NORTHUMBERLAND

JANE NORTHUMBERLAND

I THINK OF THE ALNWICK GARDEN in human terms. Even in dereliction I could sense its soul. The strong arms of the eighteenth-century walls enveloped the sinuous curves of great banks of earth laid out hundreds of years earlier. Archaeological surveys tell us that the remains of six other gardens lie under the present one, so it has evolved as gardens and people do. It was made to conform to the Victorian era, providing rigid gravel paths for smartly dressed visitors to walk upon. It was a workhorse: a provider of fruit and vegetables for the Dukes of Northumberland's stately homes. When it was no longer cost-effective it was cast aside. Its records were lost, burnt with old garden memorabilia from outhouses, potting sheds, and gardeners' cottages. Four beautiful sixteenth-century Venetian gates bought for the garden in 1850 by the 4th Duke were removed to other locations where they decayed and rusted. I remember the Alnwick Garden so well in its derelict state. It was tragic; neglected and sad – but the bones of something majestic were there and I knew it could be resuscitated and made relevant to the twenty-first century.

To view the Alnwick Garden today as we view other gardens in the United Kingdom is a mistake. It has been built to be loved and used by the local community. It is a place of happiness and laughter. Older people sit on benches, smiling, watching children playing and running in and out of the water. These same elderly visitors may have come for a pedicure in the garden the previous week or simply to have their toenails cut with their friends – a tiny service which greatly enhances their quality of life. They may plan to come to a tea dance on a winter's afternoon, to leave their empty houses and their warm televisions behind and join an exercise class, do Tai Chi, or to go speed dating. They join workshops with local children making Halloween and Christmas decorations while assisted by our garden volunteers. Such activity enables children to learn to respect older people and older people to develop an understanding of young people in the twenty-first century.

Children arrive in droves with teachers, school parties, and families. They learn to grow fruit and vegetables, growing them from seed, nurturing them and finally harvesting their produce, at which point they are taught how to turn it into something delicious and nutritious, which they can then eat. Through watching and interacting with the various water features, they learn that science can be fun.

The Poison Garden explains how plants have killed throughout history. Trained storytellers entertain and educate, and they pass on valuable drug awareness messages. All ages love the Tree House, and sometimes I watch a group of elderly people laughing their way along sixty-foot-high wobbly rope bridges and I realize that age is no barrier to pleasure.

The Alnwick Garden gives pleasure in so many ways to so many people from all walks of life. It has become a contemporary pleasure garden, which brings joy to millions. When I see photographs of it in darkness I feel that I am watching it sleeping, resting in preparation for the people it has to entertain the following day. To me a garden without people is dead, and people have brought the Alnwick Garden to life and restored its soul.

OPPOSITE AND ABOVE: The Grand Cascade

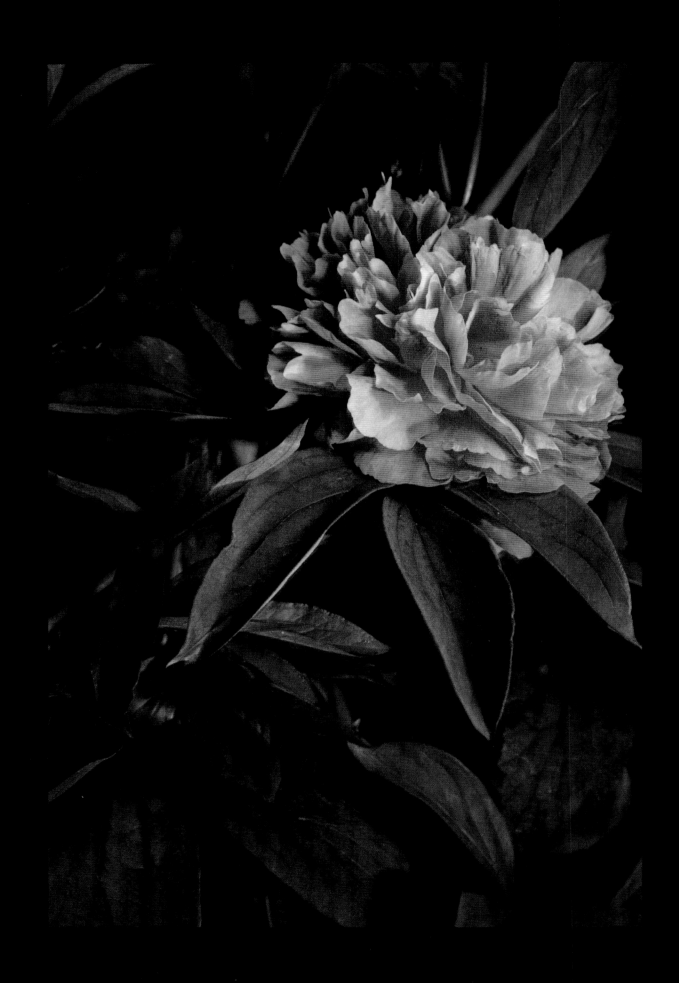

ABOVE: A peony in the Ornamental Garden

OPPOSITE: Entrance to the Ornamental Garden

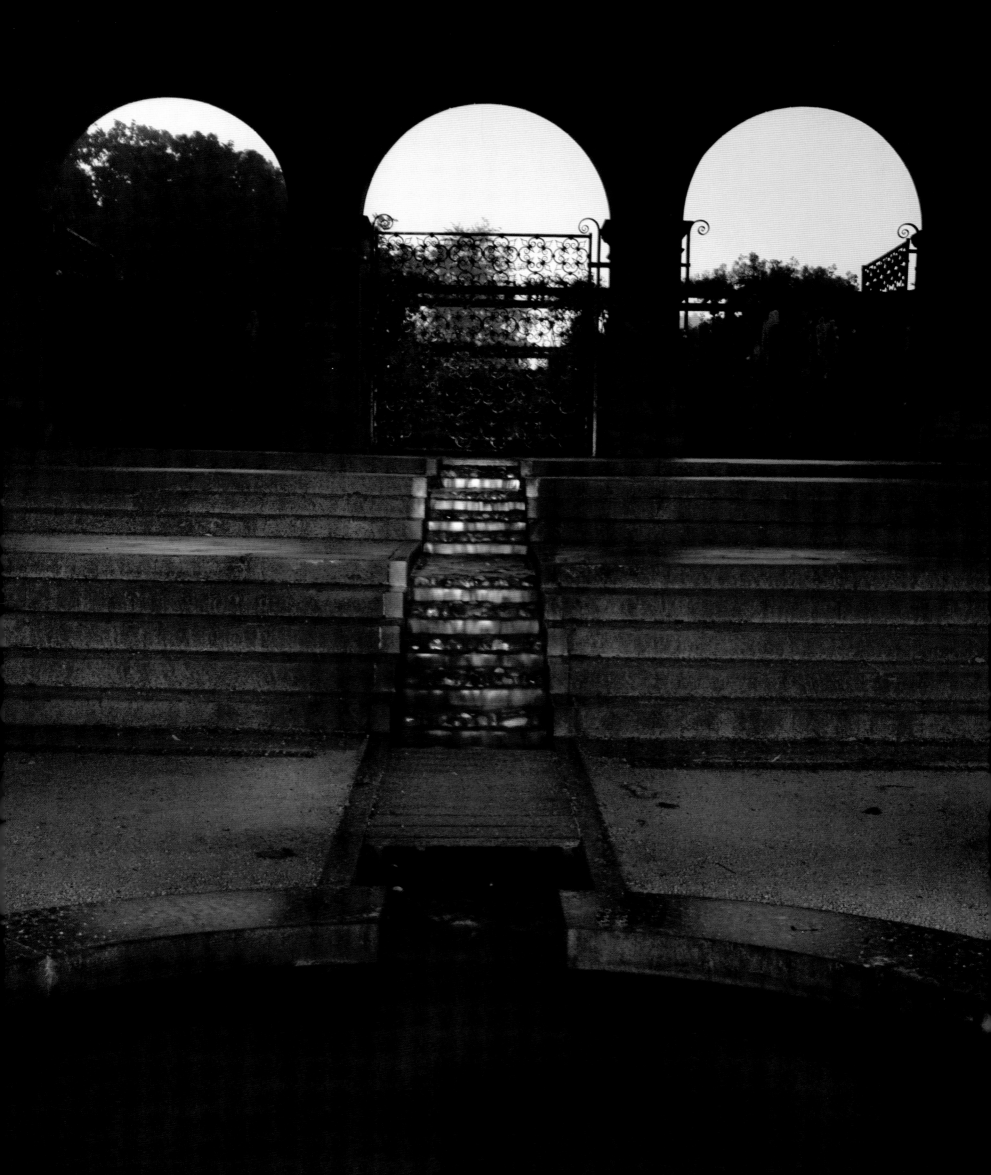

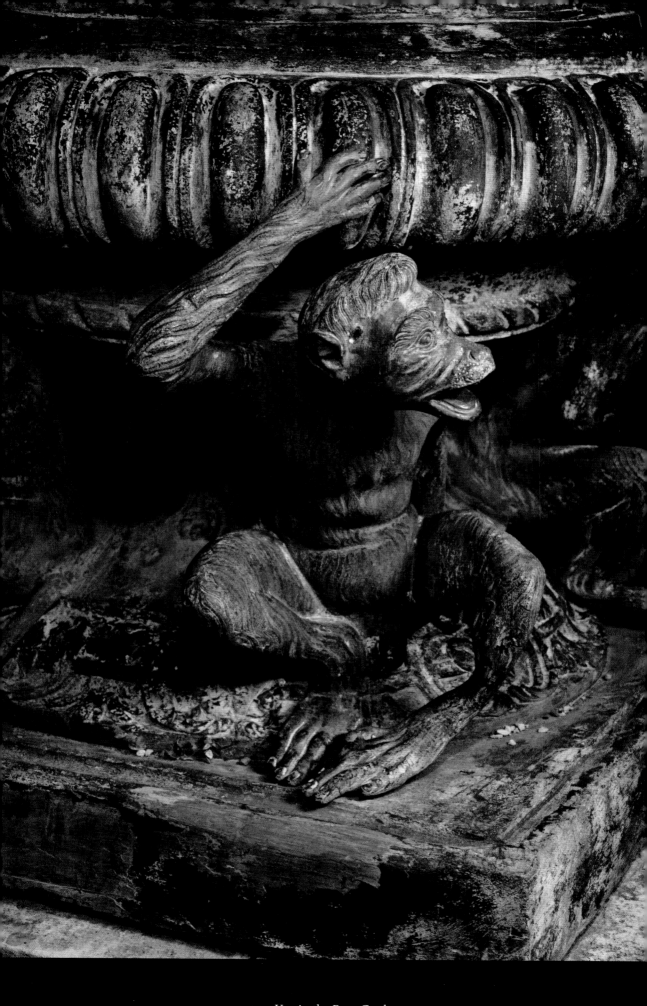

ABOVE: Urn in the Rose Garden

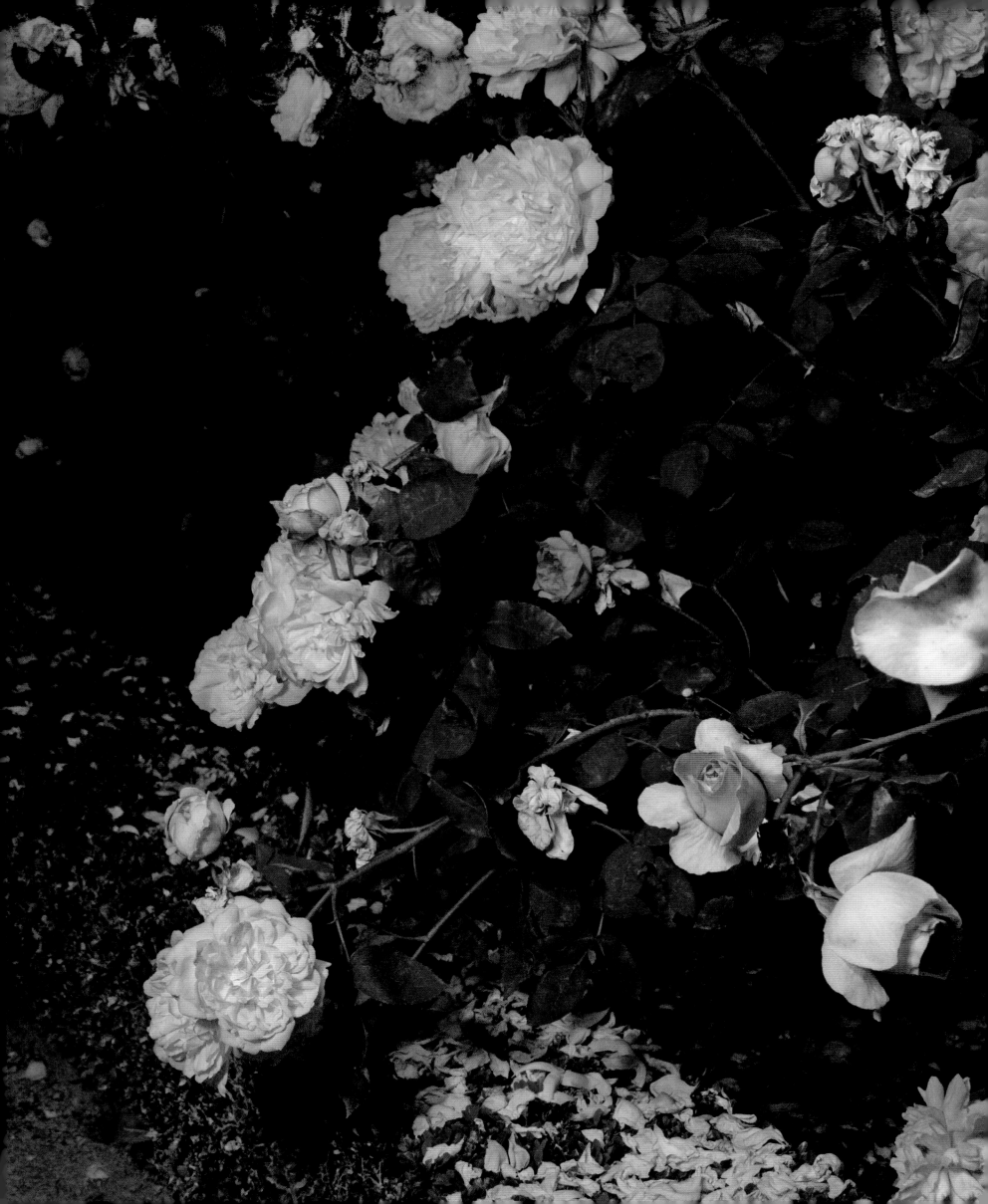

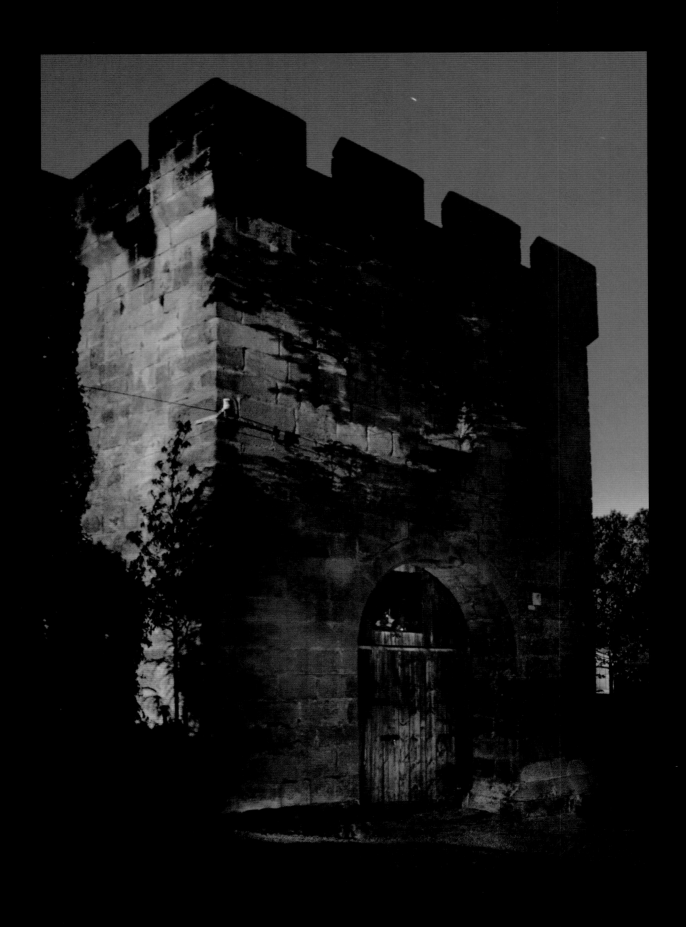

ABOVE: Tower
OPPOSITE: Hybrid tea rose in the Rose Garden

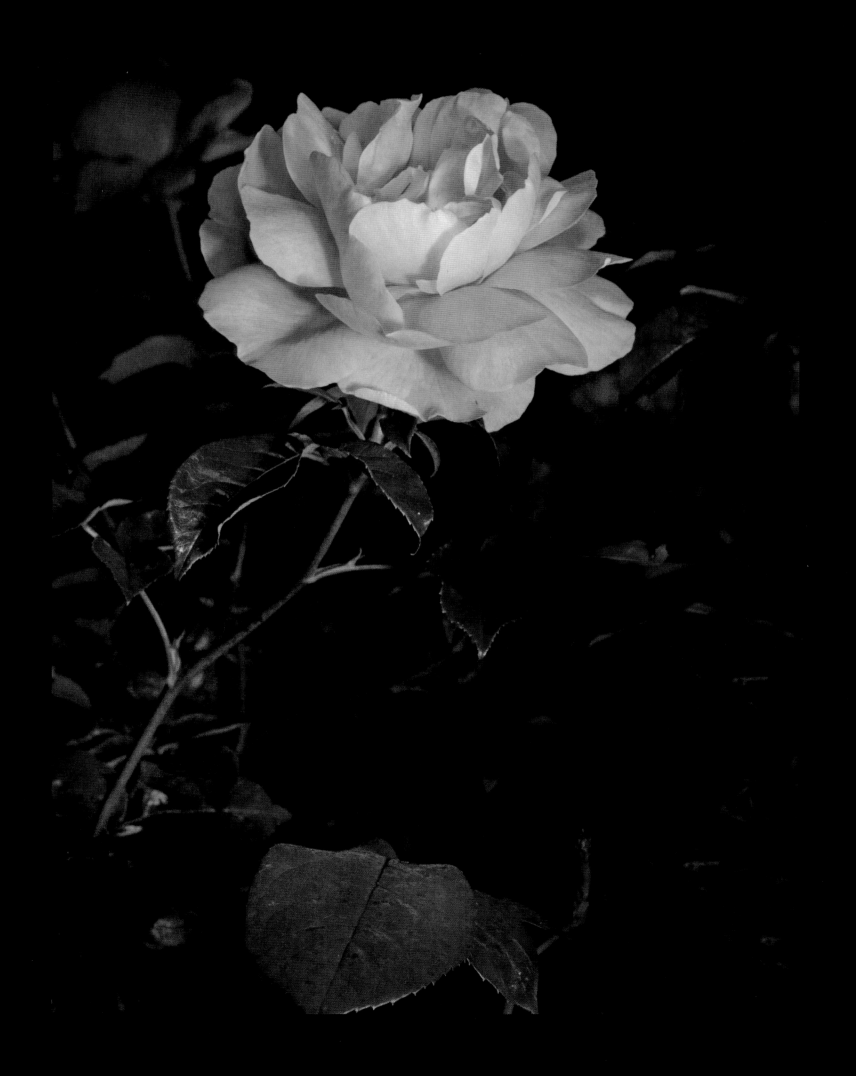

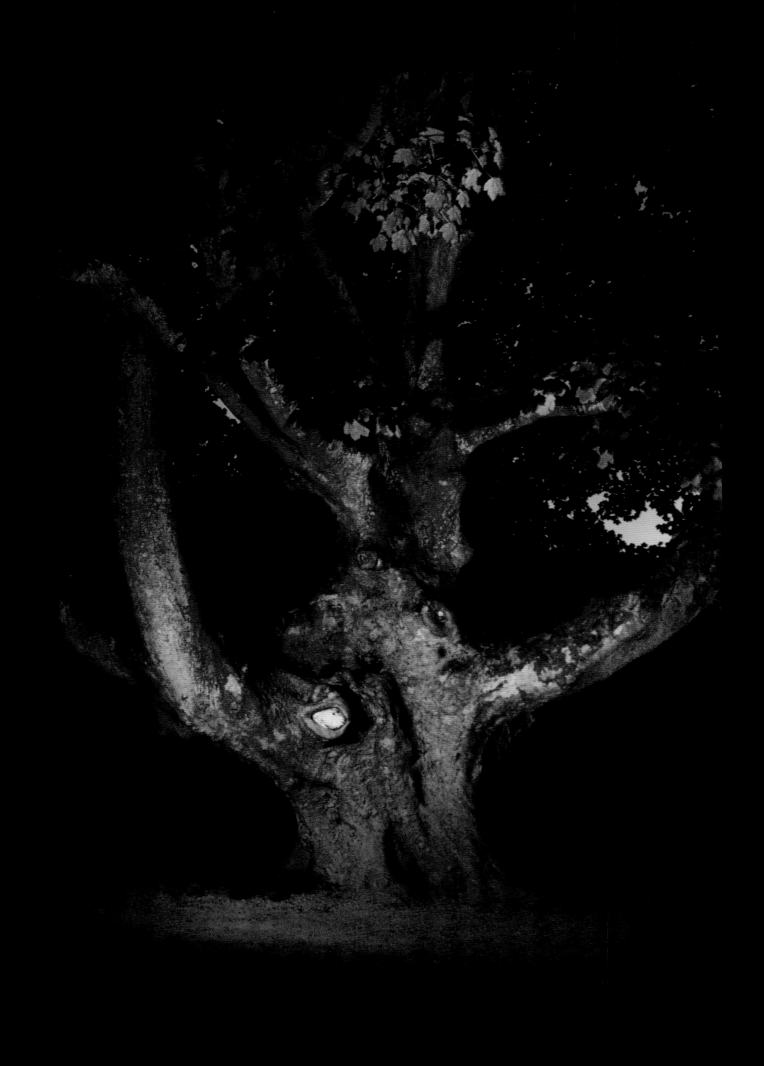

ABOVE: Duke of Northumberland Tree
OPPOSITE: The Bamboo Labyrinth

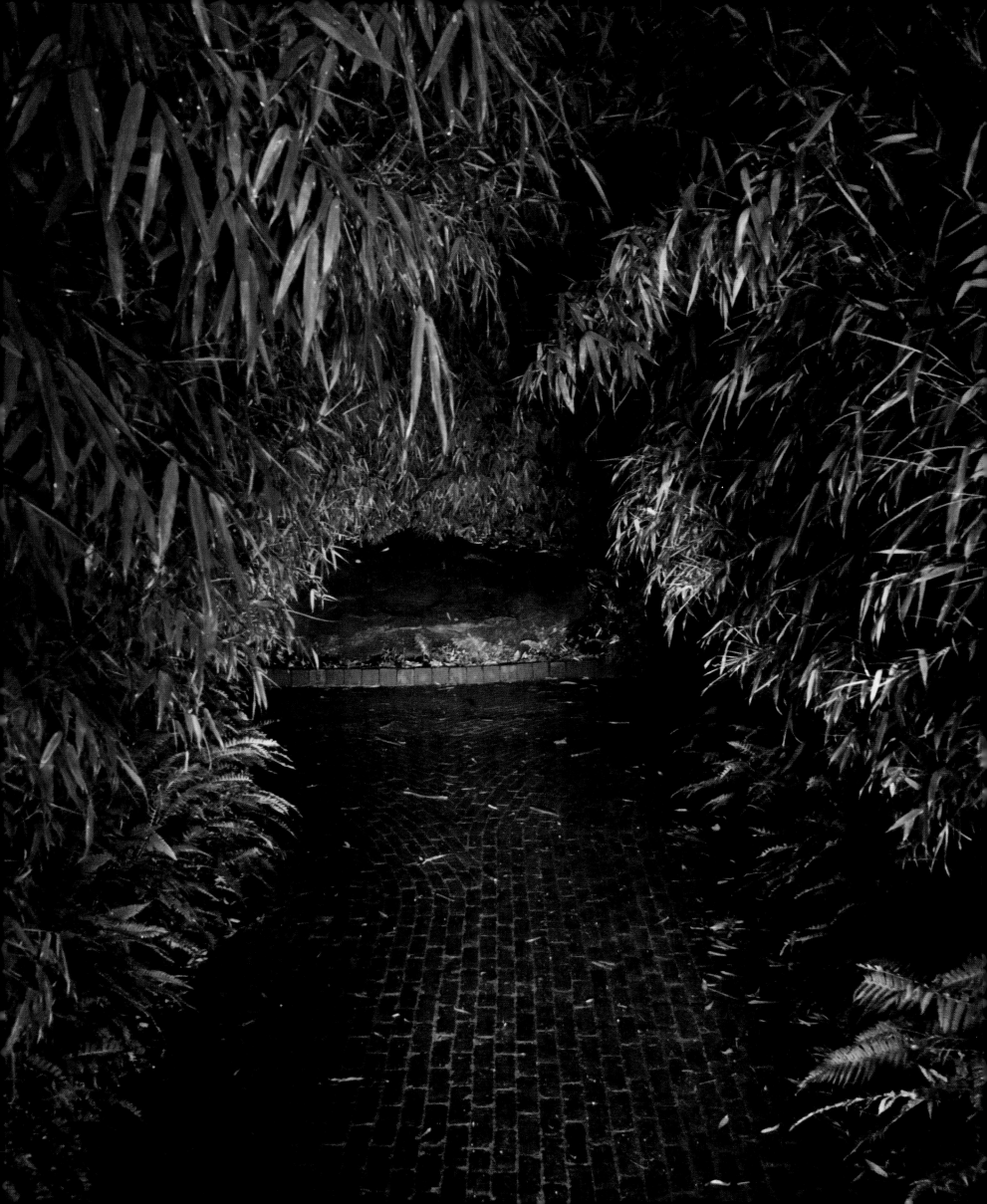

ABOVE: The Poison Garden
OPPOSITE: Arbour in the Serpent Garden

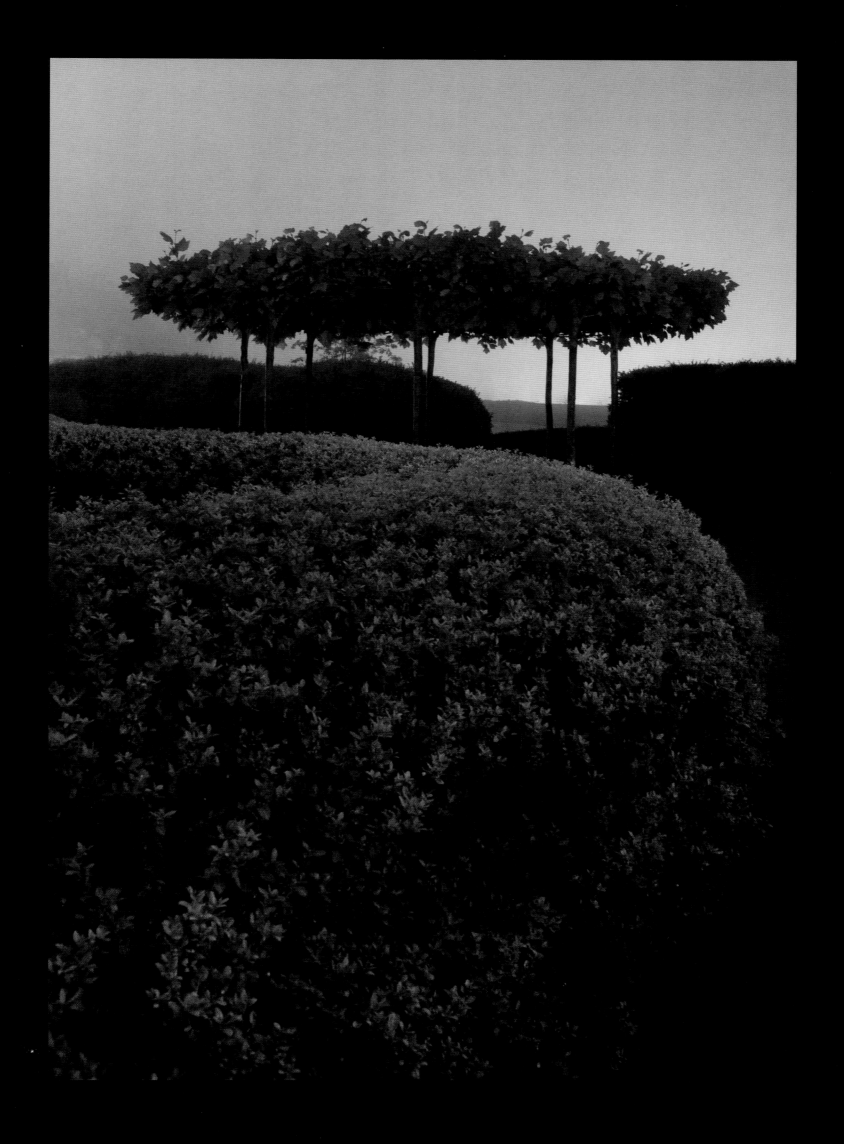

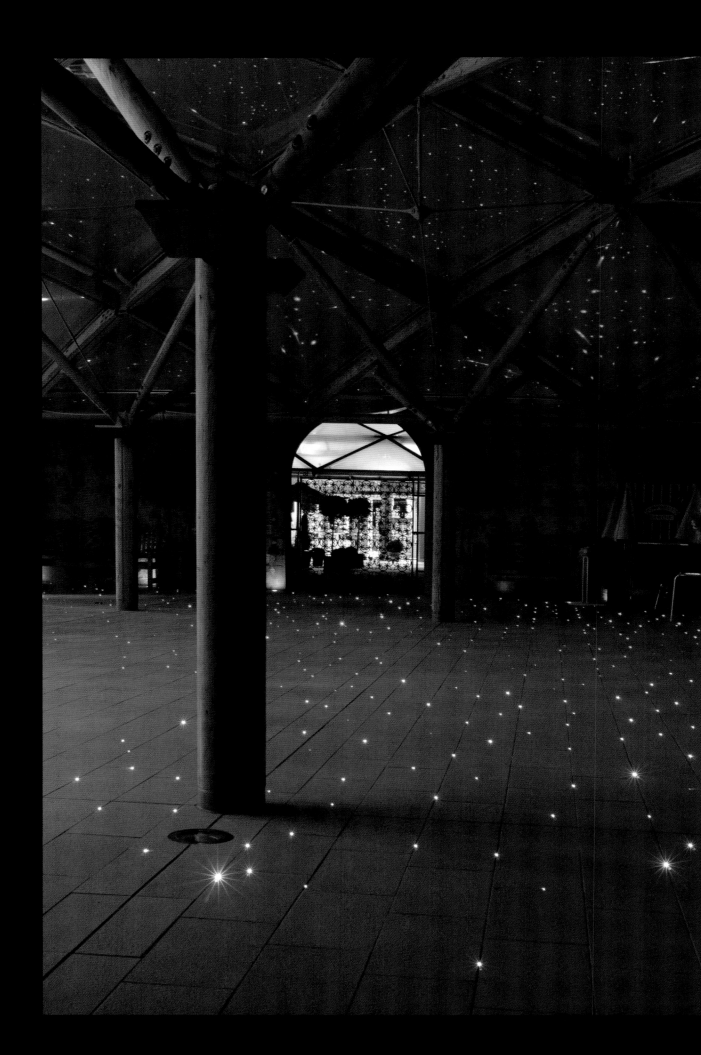

ABOVE: The Main Entrance
OPPOSITE: A fountain OVERLEAF: The Serpent Garden

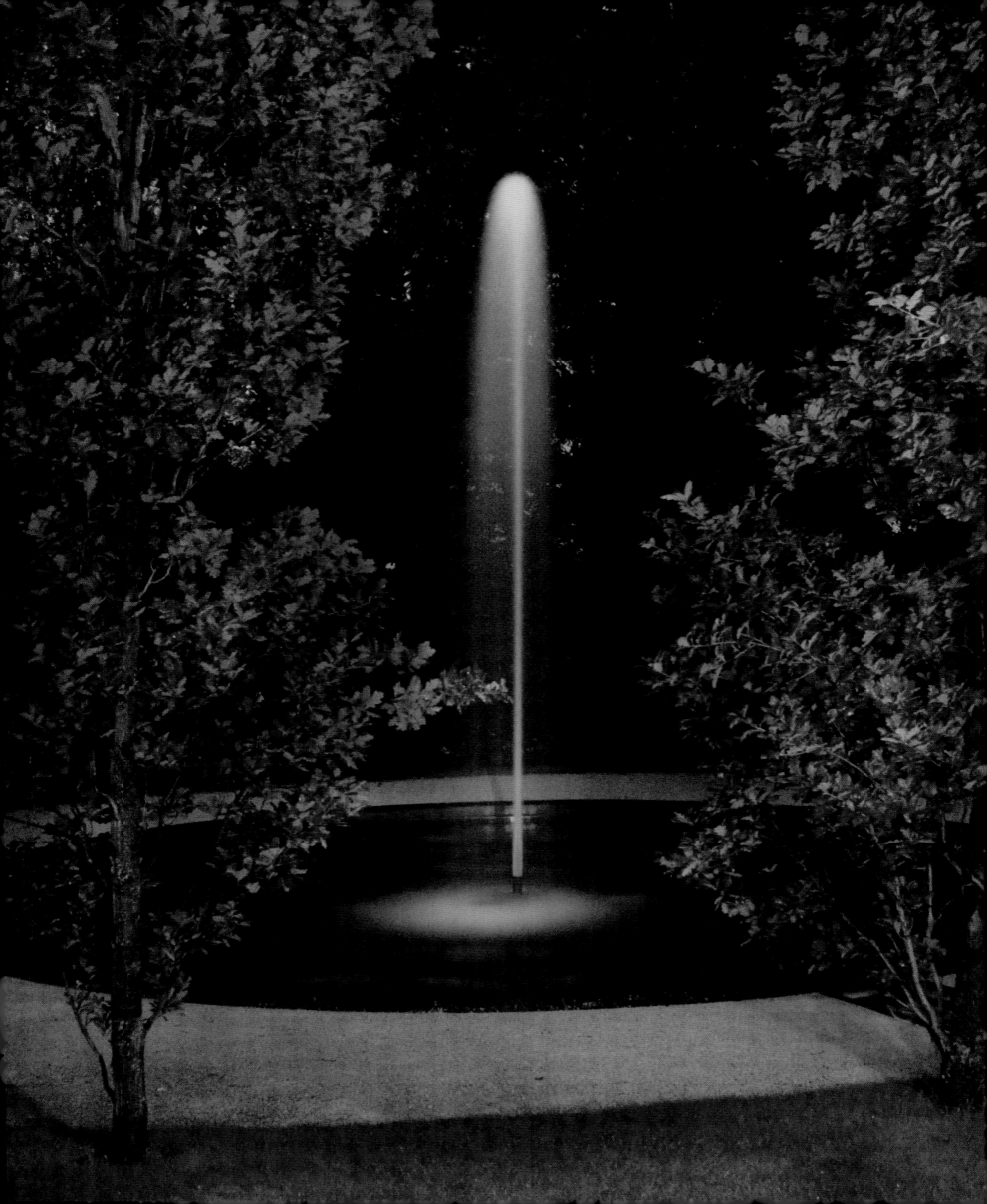

AND ALL THE WOODS ARE ALIVE WITH THE MURMUR AND SOUND OF SPRING,

AND THE ROSEBUD BREAKS INTO PINK ON THE CLIMBING BRIER,

AND THE CROCUS-BED IS A QUIVERING MOON OF FIRE,

GIRDLED ROUND WITH THE BELT OF AN AMETHYST RING.

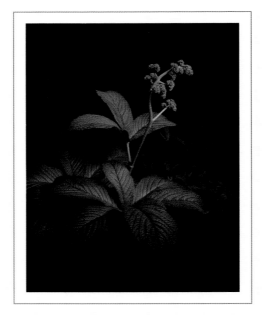

Rodgersia pinnata 'Superba'

ARTIST'S STATEMENT

LINDA RUTENBERG

WHEN I BEGAN THIS PROJECT three years ago, little did I know what excitement and discovery awaited me. There was the pleasure of working after dark, with a tranquillity and peacefulness that were restorative. And then the wonderful fragrances, mystery and sensuality of the darkness which enticed me.

In July 2006 *Landscape Architect* magazine requested a photo shoot at an International Garden Festival at Reford Gardens in Canada where twenty landscape architects from around the world were invited to create contemporary gardens. The director recommended the early morning light and offered to open the garden for me. I in turn requested that I spend the night in his parking lot in my Volkswagen camper, which he agreed to. It then occurred to me that I would be spending the night in the garden, and I asked him if he would mind that I photograph. Once he agreed, I procured several torches and my husband and I began our adventure in the nocturnal gardens. The results were exciting enough to make me want to try more. Several weeks later, the annual Chinese Lantern Festival began at Montreal Botanical Garden and this provided me nighttime access to yet another garden. The photographs I took were spellbinding, and I knew at once I had discovered an exciting and original project.

My first book, *The Garden at Night*, published by Chronicle Books in 2007, showcased twenty of the most beautiful public gardens in the US and Canada. The second book, published in May 2008 by Verve Editions, was devoted exclusively to the Montreal Botanical Garden and chronicled a full year of photographs taken at night. However, it is the present book that was the most anticipated and exciting for me to work on. First of all, the most difficult task was choosing which gardens to include. I read, researched and consulted with people who were familiar and knowledgeable and slowly my list became shorter and more representative. I was particularly interested in significant public gardens that had laid the groundwork for other gardens or had set a new standard in garden design and concept.

My challenge was to capture the spirit and essence of each garden and to interpret and reveal the extraordinary poetic, lyrical and sensory richness of the nocturnal garden.

Whether lit by moonlight, or artistically enhanced by my husband Roger's magical flashlights, the plants and flowers would never fail to astound us with their beauty, variety and spirit. The amazing thing about the night is that even the most ordinary plant is transformed into something mysterious and extraordinary.

To spend the night in each of these gardens is a special privilege. The calm and tranquillity infused with the scent of damp earth has been almost overwhelming. It felt primordial, as if my husband and I were the last two beings on earth, suspended in time. The nocturnal Eden is a spiritual place.

A project of this scale involves many people. First of all, I want to thank all the individuals at each garden who helped facilitate my shoot. Special permissions had to be obtained and often we were greeted by knowledgeable and enthusiastic people who showed us their favourite corners. Garden people, I have discovered, are a gracious and friendly lot. It was truly a pleasure to work with them. Special thanks to Jamie Camplin and his team for facilitating many requests, Tim Smit for his unending enthusiasm, Peter Gabriel for making connections, Candy Smit for her enthusiasm, Anne Jennings of The Museum of Garden History for her help with choosing the gardens.

Once again, my family and friends have been there for me emotionally and spiritually.

My associate Gary Chassman is to be thanked for his hard work, foresight, and wise counsel.

Finally, I would like to mention that this project would not have been possible without the help of my husband, Roger, soul mate and light of my life (literally). Thank you for your friendship and unwavering faith.

GARDEN INDEX

The Lost Gardens of Heligan
Pentewan, St Austell, Cornwall, UK PL26 6EN
Email: info@heligan.com
www.heligan.com

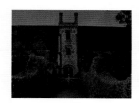

Hatfield House
Hatfield, Hertfordshire, UK AL9 5NQ
Email: c.langan@hatfield-house.co.uk
www.hatfield-house.co.uk

Eden Project
Bodelva, St Austell, Cornwall, UK PL24 2SG
Email: friendsdesk@edenproject.com
www.edenproject.com

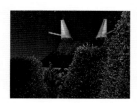

Great Dixter House and Gardens
Northiam, Rye, East Sussex, UK TN31 6PH
Email: office@greatdixter.co.uk
www.greatdixter.co.uk

Hestercombe Gardens
Cheddon Fitzpaine, Taunton, Somerset, UK TA2 8LG
Email: info@hestercombe.com
www.hestercombegardens.com

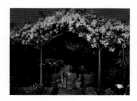

Sissinghurst Castle Garden
Cranbrook, Kent, UK TN17 2AB
Email: sissinghurst@nationaltrust.org.uk
www.nationaltrust.org.uk/sissinghurst

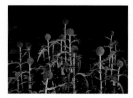

Royal Horticultural Society Garden at Wisley
Woking, Surrey, UK GU23 6QB
Email: colincrosbie@rhs.org.uk
www.rhs.org.uk

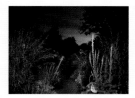

Levens Hall and Gardens
Kendal, Cumbria, UK LA8 0PD
Email: email@levenshall.fsnet.co.uk
www.levenshall.co.uk

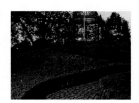

Royal Botanic Gardens, Kew
Richmond, Surrey, UK TW9 3AB
Email: info@kew.org
www.kew.org

The Alnwick Garden
Denwick Lane, Alnwick, Northumberland, UK NE66 1YU
Email: info@alnwickgarden.com
www.alnwickgarden.com

First published in the United Kingdom in 2009 by
Thames & Hudson Ltd, 181A High Holborn,
London WC1V 7QX

www.thamesandhudson.com

Distributed in North America by Fitzhenry & Whiteside
195 Allstate Parkway
Markham, Ontario
Canada L3R 4T8

www.fitzhenry.ca

VERVE
E D I T I O N S

www.verveeditions.com

Developed and produced by Gary Chassman
Designed by Kari Finkler

British Library Cataloguing-in-Publication Data
A catalogue record for this book is available from the British Library

ISBN: 0-9769127-8-3
ISBN: 978-0-9769127-8-1

Printed and bound in China